The Photographer's Guide to Marketing and Self-Promotion

FOURTH EDITION

FOURTH EDITION

The Photographer's Guide to Marketing and Self-Promotion

Maria Piscopo

**ALLWORTH
PRESS**
NEW YORK

Contributing Editor, Danielle Robinson Morookian

14 13 12 11 10 5 4 3 2 1

Published by Allworth Press
An imprint of Allworth Communications
10 East 23rd Street, New York, NY 10010

Page composition/typography by Susan Ramundo

ISBN: 978-1-58115-714-7

Library of Congress Cataloging-in-Publication Data
Piscopo, Maria, 1953–
 The photographer's guide to marketing and self-promotion / by Maria Piscopo. — 4th ed.
 p. cm.
 Includes bibliographical references.
 ISBN 978-1-58115-714-7 (pbk. : alk. paper)
 1. Photography—Marketing. 2. Photography—Business methods.
 3. Commercial photography. I. Title.
 TR690.P54 2010
 770.68'8—dc22

 2010006872

Printed in the United States of America

Contents

SECTION THREE

SECTION FOUR

SECTION FIVE

ACKNOWLEDGMENTS

Welcome to the fourth edition of *The Photographer's Guide to Marketing and Self-Promotion*. This is my sixth book, and what an amazing journey it has been. We interviewed a number of photographers for this book and I hope they will give you inspiration and motivation with their advice and success stories. I have a new appreciation for *creative community*. Thanks to Stefan G. Bucher, my workshops in Europe, and my Facebook and LinkedIn pages, I have discovered that we are all connected as a community, and this is a most exciting time to be in this crazy and wonderful business.

With every book my list of *thank you* credits gets longer and longer so instead of adding another chapter, I will say to all of my extended and adopted family of friends, sisters and brothers, nieces and nephews: Thank you all for your love, support, and encouragement.

Special thanks to my contributing editor, Danielle Robinson Morookian. I could not have finished this project without your help.

I would like to dedicate this book to John P. Bernat and his family, the Morookian, Robinson, Swanson, and Doyle families, my Uncle Charlie Scheulen, and the granddaughters of my heart, Angelina, Sophia. and Isabella. Special thanks to my husband, Patrick Doyle for his love, patience, and unconditional support— "You are my hero."

The Photographer's Guide to Marketing and Self-Promotion

FOURTH EDITION

The Business Side of Self-Promotion

Regardless of your area of expertise, the current market requires that you deal with a permanent change in the photography industry; simply put, you can no longer be just a photographer. The future belongs to the owners of photography *businesses*. If you have recently said to yourself, "All I *really* want to do is be a photographer," you'll need to reexamine your objectives. In any case, your plan for marketing and self-promotion must acknowledge the business aspects of photography.

TOOLS FOR PERSONAL PRODUCTIVITY

The balance between running a business and expressing your creativity often creates conflicts. For example, where do you find the time to both promote and create your work? What are the best techniques for managing everyday stress? How do you balance the goals of a professional life with those of your personal life? When is it appropriate to show assertiveness and when should you be more flexible for clients? The key is to discover the most effective ways to help you balance project management, deadlines, and what clients really want—all of which must be completed while carrying out creative and technically proficient work.

To achieve these tasks with proficiency, you'll need tools that will work optimally for you. Learning those skills will maximize your time and allow you to work in a less stressful environment. Photographers need time and stress management tools as well as goals and objectives specifically tailored to your line of work.

FINDING MORE TIME

Have you ever felt that there is not enough time in the day to perform all of your tasks? Do you ever end the day with a full list of things-to-do? Do you ever complete the workweek with several items still remaining on that list? You need not worry. This is common for creative professionals. It is a classic syndrome of imbalance between time and tasks.

Procuring too much work is a positive. Therefore, the solution lies in the reorganization of time to deliver the best possible product with the least amount of stress.

I first explored this topic when I began teaching my "Managing Creative Services" class for Dynamic Graphic Training. In actuality, this topic had become one of the most popular in the class! The attendees were in situations where they needed basic tools and techniques to manage their time. You might think that the techniques you are about to read seem simple. Truth be told, they are not easy. Implementation requires strong will and discipline to locate the hidden time in your life.

The basic concept requires that you accept the fact that you have dual responsibilities—your *work* and the *job* required to maintain your work. These are two very different things. Your *work* is defined as your paid assignments. Your *job* would include everything you must do to manage your work: project management, estimates, sales calls, marketing, and your personal life!

Most people put their work first and let their job wait until they *get around to it*. This is backwards and a very destructive formula for effective time management. It is common that the seemingly daunting amount of job tasks remain incomplete at the end of every week. The work or creative elements are enjoyable and will take whatever amount of time you choose to give it. As difficult as it may seem, you must reverse your priorities, place your job first, and let the work come in as it will. Remember, if you neglect the job, you run the risk of losing the opportunity to get great work done.

Adopting this concept necessitates that you identify all the job tasks you must accomplish for the day, week, and month. Include both segments of your life, your personal and professional. They will range from everyday activities such as opening the mail and reading trade magazines to the periodic duties of updating your portfolio and drafting an annual marketing plan.

Once you have identified all of your obligations, take your personal planner (or calendar) and schedule them as daily, weekly, and monthly actions. Schedule everything! You may wonder why you should bother scheduling such mundane job tasks as picking up dry cleaning or daily exercise. Here are two good reasons: One, the act of placing them on your calendar increases the chances that the tasks will be completed. The second reason is that lists kept in your head are not a good use of your time, energy and attention. In fact, you can concentrate more on your creative vision (the work) when not distracted by your business capacity (the job).

Once the job tasks are scheduled, you can direct your focus to incoming work. Include all of your creative work—even taking into account rush jobs and last-minute client requests. These are the clients, deadlines, budgets, and projects that arise and sweep away anything else you had planned for that moment—sound familiar? Incoming work tasks will displace job tasks every time. The good news is that they are not doomed to be forgotten, just rescheduled!

An important key to finding more time is to handle everything you touch only once. Eliminate piles to shuffle and lists to pore over. When you face a management issue or an incoming task, either address it immediately or reschedule it for a later time. Do not cre-

ate piles or make lists. They lack a date or time framework and are left at the end of the day or week unfinished. If you choose to make piles or lists, then refer to your planner to schedule a time to address them at a later date.

TIME MANAGEMENT TOOLS

Compile the tasks from your marketing plan, business plan, and daily job into one calendar. Specify what you must do in a realistic time frame. Reduce them to "bite-size" tasks and be careful to allocate enough time for completion. For example, estimate how long it will take to pay bills, process your e-mail, or write a press release. If you're unsure of the proper amount of time, take a mental note the next time it's done. For your calendar needs you can also use computer calendar programs and smartphones. Palm, Dell, HP, Apple, and Blackberry all have smartphones that serve well as organizational tools, especially when they are consistently used and synchronized with calendar programs, such as Microsoft Outlook. Don't forget to schedule your vacations and holidays!

The result of implementing the above is that when an incoming task arrives you will handle it immediately and completely *or* you will schedule a more appropriate time. For example, the Ad Club calls you to discuss your volunteer participation in their Walkathon Fundraiser; this is part of your *job* of being a business owner. Rather than abandoning what *work* you are doing at that moment, you would consult your calendar to find a time that is more appropriate. Another example, when a client calls you to request a project consultation on some *work*, you will reschedule the *job* tasks you are doing at that moment to get to this meeting. Placing everything on the calendar consolidates all of the business aspects allowing you to execute both work and job duties. Eliminate to-do lists that never get done and utilize an all-encompassing calendar that is easily accessible!

An additional and important time-management tool is a tickler file. It is designed to work in conjunction with your calendar. To create this portion of your time management system, get some folders and label them individually from one through thirty-one. Each number refers to a date in the month. Keep these folders close to your workspace. Knowing that your daily tasks will require that you refer to paper documents, learn to methodically place the papers related to your scheduled tasks in the corresponding numbered folder of your tickler file.

For example, you find time on October 30th for that Ad Club committee meeting. You will then write *Ad Club Meeting* on your calendar for October 30th and place all of the paper information pertaining to the meeting in the folder numbered 30. This is a great way to eliminate piles of paper and clear off your desk without losing anything.

The key to this process is to handle everything you touch only once by either attending to it immediately or scheduling a later time. This will not only maximize your time, it will also solve two other things that are integral to a creative services business. First, instead of waiting to *find* the time for the job tasks of marketing and management, they simply become daily chores. Second, adding these chores to your initially blank calendar will always ensure that you have a task to work on to keep you busy and moving towards success.

ADDRESSING THE STRESS

Most stress in a creative service business stems from the attempts to balance conflicting needs. You have this conflict whether trying to reconcile your business persona with your creative persona or struggling with dedication to your work and the desire to spend time with your family. Sound familiar? Any of us could probably compose an endless list of personal and professional stress inducers. The important thing to accept is that these types of stress are normal. Remember that there is a difference between stress and distress. Distress would include issues like suffering through a family illness or a natural disaster. In other words, distress is outside of your control—it can't be managed like stress. If you have determined that you are dealing with stress, try these simple suggestions:

You'll never be truly caught up, so stop punishing yourself when you don't finish everything. There will be a never-ending succession of business and personal job tasks and your client work projects. You need to stop looking for the bottom of your inbox or expecting to see the top of your desk. It should not happen! Release the feeling that you're drowning and will never surface. Business is like the ongoing rush and flow of a river. Don't expect a calm and still body of water. Besides, if the river stops flowing, you have no work, and that is a much worse situation to handle. Relieve your stressful feelings with a good time management system and rid your life of the stress suffered from playing catch up.

You'll never make everyone happy. There will always be clients who want you to jump through imagined hoops to make them happy. In these situations, stop and differentiate between subjective and objective happiness. Subjective is someone's opinion and objective is based on an accountable and measurable goal for the photography project. You must make clients happy on an objective level but you can't always expect clients to be happy on a subjective level. They will have opinions that you don't like and then you have to stop and ask yourself: Do you need to do anything other than acknowledge and recognize their opinion? Recognition of someone's opinion without needing to agree with it will go far to smooth over a stressful situation. If you have met all the measurable objectives, maybe you should not be asking "how high?" if no one has asked you to jump.

Worry is a great producer of stress. To get it *off your chest*, have pen and paper handy so that you can write down a particular worry. Then put it aside to be considered later (this technique is also called *sleep on it*). Often, the worry has resolved itself or is no longer so overwhelming. Motivational speaker and coauthor of the wonderful *Chicken Soup for the Soul* books, Mark Victor Hansen calls this type of stress "stewing without doing" and it is very non-productive.

Learn to say no. Often, stress is created when you say yes when all logic and common sense tells you to say no. Production of a photography job is a perfect example. A client makes a production or pricing request during a shoot and you know that an unqualified "yes" will cause great stress (and reduced profits). So try one of these three options: "No, but here's an *option* to look at," or "Yes, and this is what that will *cost*," or, simply put, "Let me get back to you!" In each case, you have presented further consider-

ations that will reduce the stress of dealing with difficult situations while keeping a professional demeanor.

GO GET YOUR GOALS

Setting goals is too passive an exercise for the success of your marketing plan. Owners of photography businesses need to plan for success and not wait for it to happen. You need to go get goals, not just set them. The key to successful goal achievement is to write everything down. Your subconscious simply does not recognize the unwritten goal. Putting your desires onto paper creates an unrestricted flow of energy and dedication to achieving those goals.

TOOLS FOR GETTING GOALS

Start by stating your objectives. These are the things you want to achieve. Write down all of them—big ones and little ones. Keep adding to this list, and even though you won't take action on everything at once, it's best to have a clear picture of what you want from your business. Be sure to use action statements such as, "I want to sell $150,000 of photography services this year," and not vague statements such as, "I want to be rich."

Then add action statements. Decide which of the written objectives you want to achieve right now. Pull them out of the above list and add the activities required for their accomplishment. Be sure to be specific and break down these activities into *bite-size* pieces. For example, one of your goals might be to hire a graphic designer to help plan your marketing materials. Break that down into: write job description, find place to advertise the job position, write ad, etc. This should be a step-by-step outline of tactics describing how you will achieve your goal.

Next, assign resources. Add to each of the above tasks information regarding the time, energy, attention, and money they will require. Overall, you will need a marketing budget for the business, and some of that can be applied towards specific goals. Typical marketing budgets for photographers are ten percent of your projected gross sales.

Finally, schedule everything. Take your daily calendar and schedule all of the tasks you identified as goal-getting. You can always reschedule when work (a paying client) comes along. This way, getting any of your goals you have set becomes a daily activity and not something you wait to find the time to do.

START ACTING CONFIDENT

The most important thing to know is that you must not wait to feel confident before taking action. You'd wait forever! No, it turns out that feelings follow your behavior. In other words, acting confident and the resulting success will eventually bring the feeling of confidence to you. If you study successful business people, the one thing you would find they all have in common is a very strong, calm, sense of confidence. This confidence is made, not born. It comes from actions, from testing yourself and winning the tests. This is true for your photographic creativity and technical ability as well as your professionalism and business skills.

Don't wait to overcome doubt and fear before facing any business or marketing challenge. Accept that they are part of the process of testing and winning. Anxiety and hesitancy may feel like negative feelings, but you have to look at them as indicators that you are doing something you haven't practiced. For example, the first time you quote a really big job or tell a client you can't shoot that job for their tiny budget, you will feel some fear and anxiety. Don't worry! You are experiencing a perfectly normal reaction any business owner will feel when being assertive.

You have only three choices for a business attitude of confidence and you always make a choice of one, whether you are conscious of it or not. An aggressive attitude means you get what you want without care or concern for the other party. A non-assertive attitude means you give people whatever they want without care or regard for the cost to you (a common problem in photography). Assertion is simply an attitude of confidence where you get what you need and clients get what they need. Being aggressive could drive your clients away. Being non-assertive could put you out of business! Acting assertive may cause you some short-term discomfort, but will ensure you long-term satisfaction and profitability.

The trick is to learn to accept the fear without waiting for it to go away and go on to do the work at hand. The most common technique for this is called visualization. You must see yourself accepting the challenge, mapping a strategy to meet it, and then successfully accomplishing the task at hand. No matter what the situation, this technique works to create your success and the feeling of self-confidence that follows.

WHAT YOUR PHOTOGRAPHY CLIENTS REALLY WANT

Photography marketing and self-promotion is all about how well prospective clients get to know you and what you can do for them. Look at what clients really want to silence the little voice inside most photographers that says, "I'm good, why don't clients just call me?" Your self-promotion needs to reflect what clients really need to know about you to hire you. This personal knowledge of you is necessary because all clients you are marketing to probably already have photographers they work with.

Whether you are selling wedding and portrait or commercial photography, there are considerations and factors that all potential clients need to know before they make the big decision to work with you. Our goal with this fourth edition is to give you tools and techniques to intrigue clients and get them to work with you. Look over these ideas and compare them to your current marketing plan and self-promotion materials. Update now to make sure you have them represented in your future marketing. When you add these factors to your sales presentations, advertising, direct mail, Web site, e-mail campaigns, and promotion material, you help clients *move you* from the vast pool of photographers they have seen to the smaller pool of photographers they would consider calling when they have work. This is your highest objective of marketing, to get yourself on that *short list*. Literally it is the short list of photographers clients call for work.

FACTORS CLIENTS CONSIDER WHEN HIRING

Photographic ability is assumed in today's new marketplace for photography services. It is clearly seen in your work, but at the same time, there are a lot of technically competent photographers out there. When you have a special or unique technical capability it should be identified and added to self-promotion to give you a competitive edge.

You need to give the clients what they want but this is a tricky subject. Lots of photographers would like to show their highest level of creative ability in their portfolios. Unfortunately, lots of clients don't have the time, budget, or creative aesthetic to use it. Before you put together your next sales presentation, be sure to determine whether your clients are interested in *creative collaboration* or a pre-conceived *image fulfillment*. This can be confusing because many photographers are not clear of the distinction between the two types of clients. Neither is wrong or bad but they are very different. Clients who buy creative collaboration look at style, personal vision, and the way you see things. It could be the consumer client who wants a different look for her wedding photos. It could be the product client who wants a background never seen before. Image fulfillment clients want to see what they are hiring you for *before* you shoot it or they want the *straight* shot. This has been called the *red shoe syndrome* in which the photographers who show any other color shoe in their portfolio will not get the job because the client figures they can't shoot red shoes if they don't show red shoes. Do your homework and know to whom you are talking when you present so you can show the appropriate portfolio.

You need to make the clients look good. This is a very difficult subject for clients to discuss openly. Your best bet is to be very aware of how sensitive clients are to how the photos (stock or assignment) will make them look to their peers or their boss. This awareness is a potential competitive edge and creates added value to your photography. To prove your awareness you can add case study anecdotes of client testimonials when creating marketing materials. This will give you a better chance of making the leap to the short list. Remember, you make the short list when prospective clients can *visualize* themselves successfully working with you. Help them with stories of your work with other clients or your work on a public service project. Help the client become the hero. Help them hire you.

Every client's dream photography project is the one that eases their frustrations and meets their challenges. Your marketing should address this issue because all clients are thinking of it, whether they admit it or not. In addition, it provides a counterpoint to the client's objection, "We are happy with our current photographer." There is always something the current photographer has done to frustrate the client or make a shoot or stock photo purchase difficult. This could be your competitive edge.

You need to be flexible. This means you will be easy to work with and solve problems, not make more than your clients already have. Whether it is a wedding job or a Web site product shoot, no client needs more problems. The problem with this, and many other factors, is that they are about the working relationship and not about your images. How will prospective clients get to know you are flexible until they've worked with you, but they won't give you a job until they know you are flexible? The answer is to demonstrate

flexibility in every contact you have with a client. Plan it into your marketing strategy. Add case studies and testimonials to your marketing materials.

Start with the first phone call and follow through to your first job with them.

Remember, you must demonstrate your flexibility before you work together in order to get the job in the first place. The best evidence of your flexibility will be offering project references from other clients in your promotional material. You can tell someone you're flexible, but third-party proof has more credibility. By the way, flexibility *does not* mean dropping your price to get the job. You will learn more about pricing strategy in chapter 12.

You need to work within the client's deadline and budget. Again the case study approach in your marketing materials, sales presentations, and client testimonials is the best way to demonstrate this very important factor. Think about it, can a client tell the photo shoot came in at budget and by deadline by just looking at your work? No! You've heard the old saying, "The portfolio speaks for itself"? It does speak to your creative and technical ability but does not speak to your ability to meet deadlines or budgets. Failing to meet a budget or deadline is most likely to happen on the first job together, so always ask what the concerns or restrictions are for a project. It's better to assume clients have some. Be very specific with your questions. Instead of asking, "Do you have a budget concern?" ask, "What are your budget concerns?" You can't always get an exact answer, but you will get enough information to plan your production to meet the client's needs. You can also discuss project references during your portfolio presentations. For example, you can mention how satisfied the client was on a portrait shot because you were able to soothe all the different personalities in the family and make the image come together on time and within budget.

Another example, mention the client's satisfaction with your delivery time and cost control. Don't say things like, "Here's an eight-page brochure I photographed." They can see that. You need to talk to your prospective clients about what they can't see—your ability to manage their time and money.

Being able to trust you and to know your work together is confidential is very important. You can demonstrate your trustworthiness with your marketing presentations. Some ways to do this are: not talking badly about other clients you have, not putting down your competition, and not having other clients' work lying around in full view when the prospective clients visit the studio. Above all, make sure you consult with a client before using his image or product in any of your self-promotion. Yes, you own the copyright to your photos, but clients own the trademarks on their products or the privacy rights to their recognizable likeness.

For many commercial photography projects, you need to show how you will help clients get their job done—better, quicker, faster—by hiring you. Time is money. A clear competitive edge can be gained when you can demonstrate to your prospective clients that they can be more productive or profitable because they work with you. Again, case studies and client testimonials make good demonstrations and additions to your marketing plan.

COMPUTER SOFTWARE RESOURCES FOR PERSONAL PRODUCTIVITY

- SuccessWare (*www.successware.net/*)
- PhotoOne Software *(www.photoonesoftware.com/)*
- StudioCloud (*www.studiocloud.com/index-2.html*)
- PhotoByte (*www.zimberoff.com/photobyte.htm*)
- FotoBiz (*www.cradocfotosoftware.com/fotoBiz/index.html*)
- HindSight Ltd. *(www.hindsightltd.com/)*
- Photoshop Lightroom (*www.adobe.com/products/photoshoplightroom/*)

BOOK TITLES/AUTHORS FOR PERSONAL PRODUCTIVITY

- *Time Management from the Inside Out,* by Julie Morgenstern (Macmillan)
- *The Personal Efficiency Program: How to Get Organized to Do More Work in Less Time,* by Kerry Gleeson (John Wiley & Sons)
- *Getting Things Done: The Art of Stress-Free Productivity,* by David Allen (Penguin Publishing)
- *Profitable Photography in the Digital Age: Strategies for Success,* by Dan Heller (Allworth Press)
- *The Real Business of Photography,* by Richard Weisgrau (Allworth Press)
- *Starting Your Career as a Freelance Photographer,* by Tad Crawford (Allworth Press)
- *The Business of Studio Photography Third Edition,* by Edward Lilley (Allworth Press)
- *How to Grow as a Photographer: Reinventing Your Career,* by Tony Luna (Allworth Press)

Getting Started in Business

Start by finding an accountant, preferably a CPA working with other photographers, and get organized. Thanks to current software packages, you will be able to do your own bookkeeping (tracking the money in and money out), but you will want to work with a professional to determine the income tax liabilities incurred with your photography income. Whether you are just starting out or making the transition from hobbyist to professional, it is important to follow the standard business practices for photography professionals for financial and legal factors. Some of this information can be found in books from Allworth Press such as *Business and Legal Forms for Photographers, Fourth Edition* by Tad Crawford, *The Business of Studio Photography, Third Edition* by Edward R. Lilley, *ASMP Professional Business Practices in Photography, Seventh Edition* by American Society of Media Photographers, and *Starting Your Career as a Freelance Photographer* by Tad Crawford.

It is also good to use the budgeting checklist from this chapter that will help you plan for your start-up budget. When starting a business—even part time—there are hidden costs that can be anticipated and planned for so there will be no surprises later on. Then you will need to determine your *Marketing Message*. It is a description of what you are selling and to whom you are selling it—also known as your direction. Bookmark this part of the chapter as you will be referred back to "marketing message" repeatedly throughout this book. Finally, you will find another checklist at the end of this chapter of how to write an overall business plan.

FINANCIAL FACTORS

You will want to make sure that your photography business is set up to be a valid business entity and not a hobby. The Internal Revenue Service (IRS) has a set of *hobby loss rules* to uncover tax abuses. Some people with a lot of expensive camera equipment will

try to declare the equipment and expenses as a business depreciation or deduction when they are really hobbyists. This will lower their tax liability and possibly trigger an IRS audit. Check with your accountant, but the main factors the IRS will consider are the separation of business and personal funds (so you will need two checking accounts), the efforts to market your photography, and generating a profit in at least three of five years. Other factors include:

- Developing a written business plan that shows how the business can be profitable

- Keeping good business books and records

- Consulting with experts in the field; document their advice and how it was implemented

Being audited and declared a hobbyist by the IRS could disallow your business depreciations and deductions. Since this could raise your income tax liability, you should be highly motivated to avoid IRS scrutiny and maintain all the financial factors of a business.

FORMS OF A BUSINESS

Next, you must decide on the form your business will take. Even a part-time business has to have some kind of structure. The three most basic forms (there are variations, talk to your accountant!) to choose from are: corporations, partnerships, and sole-proprietorship.

Corporations may or may not have the many advantages they used to, depending on what part of the world you live in! For example, every state in the United States has different rules for corporations. The primary reason for incorporating your business when starting out is for protection of your personal assets against liability. To avoid the time and money a corporation takes, you may prefer to protect your assets with a personal liability insurance plan. Check with your accountant for recommendations to incorporate for any tax advantages or other benefits.

Partnerships are not unusual in photography but you must start with a financial and legal partnership agreement. Even if you have known the other person since childhood, differences and dissension later on will have tremendous potential financial impact. Don't start a partnership without one! The primary reason you really need a partnership agreement is for the termination of the partnership—something no one thinks about at the beginning of a relationship. But the worst time to negotiate terms of partnership dissolution is at the time you are splitting up. Partnership agreements are fairly standard legal contracts; don't hesitate to investigate the cost of a consultation with an appropriate attorney. The most successful partnerships seem to be a joining of the two sides of the brain, left and right—left being oriented to language, logic, and math, and right being oriented to visual imagery. When you have one business partner and one creative partner, the work is more easily split between the two. One partner handles the photo assignments and the other runs the business.

Sole-proprietorship or sole ownership is the most common form of photography businesses. They are by far the easiest and least expensive to start and run. A sole proprietor, or sole owner, legally is not separate from you so you will bear all the liabilities (and all the assets), all of the profits (and all of the losses) of the business. Unlike corporations and partnerships, you will continue to file an individual tax return but with additional schedules to account for your business income and expenses. As the only one bearing all business liability, you have the option of forming a limited liability company (LLC) to minimize your risks but still be a sole proprietor for income taxes.

BUSINESS CHECKING ACCOUNT

This is a most important piece of evidence of your seriousness as a business and essential for the accurate estimating of your income tax liability by your accountant. It should be a real business checking account, not a second personal checking account. Check with your bank as there are dozens of different types of business checking accounts and you want the one best suited for you. It will probably be based on a keyword phrase such as *small business, home-based professional service* since banks deal best when they understand your situation. Your business checking account information will be used to create the required Schedule C on your Form 1040 income tax return (and state tax return if you file one) to calculate your income tax liability. Keep your personal checking separate so the funds going in and out of your business are clearly from your business.

BOOKKEEPING RECORDS

Good records are an essential part of starting a business and an important piece of evidence to the Internal Revenue Service that you are serious about your business. The most basic records are Cash Receipts Journal (funds received) and Cash Disbursements Journal (funds disbursed). Always check with your accountant before deciding on the best bookkeeping system for you to use. It is best done with a computer software program. Whether the software is a stand-alone program or built into a photography business software program, you will want to keep the bookkeeping simple. Since these records will be used to calculate your income tax liability, you want to be sure to use a software program your accountant is familiar with, or you will pay much more for your tax return preparation.

LIST OF ASSETS

Every business is allowed a maximum yearly deduction for new equipment or assets—this is called a schedule of depreciation and is prepared annually by your accountant with your tax return. Unlike business expenses that are deducted when you spend the money, you can bring these non-consumable and even previously purchased assets into your business no matter when you purchased the car, computer, or photographic equipment. These items can be depreciated as a form of deduction against your tax liability. Check with your accountant as to how much you can depreciate over how long a period of time.

BUDGETING CHECKLIST FOR A START-UP OFFICE

1. A business phone number will be picked up in the print and online telephone directories' business listings, but with voice-over-Internet-protocol (VOIP), all that's needed is a broadband Internet connection for voice, messaging, and fax; no phone line!

2. Many virtual telephone numbers come with a telephone answering system that allows the use of one telephone line that connects your voicemail, fax, cell phone, and e-mail and can be accessed from any phone as well as your computer.

3. Many photographers use a computer for the business management and marketing separate from a computer for their digital imaging.

4. Add up all the costs of starting a photography business such as marketing materials including logo design and printing letterhead package, portfolios, Web site, and promo pieces.

5. Don't forget buying sourcebook directories for research and paying your professional association dues. You may even want to write your marketing plan before committing to a final start-up budget.

6. Plan ahead on any expense for office or studio improvements. Even if the addition or expansion is not immediate, better to plan for the money when you can get it.

7. Don't forget about automotive and studio security systems. It can lower your insurance costs and save time and money in the event of loss or damage to property.

LEGAL FACTORS

When you live in an incorporated city, you are usually required by the city to obtain a business license, to be renewed annually. Find out if this is based on a calendar year or an anniversary year. Some cities also require a one-time permit or application for a home-based business. The business license is issued at your local city hall but check the city Web site first. In addition, some of the major metro cities offer programs for small businesses that will get you a license but hold off on charging a fee until you are in business for at least a year. Since every city is different, you will need to determine what is involved for the fees and evidence of residency.

For photography businesses, city business license offices are sensitive on two points. One, will your new business generate lots of foot traffic or need exterior signs? You may live in an area not zoned for these factors. Second, will your new business create noise or odors or use hazardous materials in excess of those normally associated with a residential use? You will need to be prepared if questioned in these areas.

FICTITIOUS NAME

Getting a fictitious name permit, also known as a DBA (Doing Business As) is needed when the name of your business does not include your legal surname such as *Photography by Maria*. If you plan to use a fictitious name, you will have to take this step first because banks will not let you open a business checking account without the DBA permit in hand. Some states do require a name check before filing a DBA form to determine if your name is currently being used. You may then decide whether you wish to proceed with the filing or try a different name. In most states, DBAs, unlike corporations or LLCs, do not guarantee exclusive use of a name. In most cases, the state or county will file any correctly prepared fictitious business name statement, regardless of name conflict, so you should check their listings first. To file a DBA you can go the local county office or use the filing services of your community newspaper.

RESALE NUMBER

When you start a business in a state that charges sales tax, no matter how small the business, you may need to charge, collect, and pay the appropriate state sales tax on all your photography sales. You charge this sales tax to your client on the entire subtotal of your invoice. Contact the State Board of Equalization office or check the Web site *in your state* for the rules and regulations in your state. There are exceptions for some areas of business that use electronic delivery for sales or sell to companies that are then reselling the images as their own products. It will probably be a guide titled *Tax Tips for Photographers, Photo Finishers, and Film Processing Laboratories.* You may also try the Nationwide Information Center toll-free number: (800) 400-7115.

For a low dollar volume of sales, you will probably file and pay yearly, but many photography businesses file and pay quarterly. Remember, when you get paid for a photography job, the invoice total includes the sales tax. This is not your money! Find a way to set the amount aside on a regular basis so that filing and payment of the sales tax is not such a shock to your business checking account.

In addition, the resale number you are given can be used for resale purchases of photography supplies. This means you do not pay sales tax on items you purchase that will physically transfer ownership to your client. For example, you can use your resale number when purchasing photographic processing, but can't use it when buying equipment. Again, check with your State Board of Equalization in your own state for the latest information.

FEDERAL IDENTIFICATION NUMBER

For the sole-proprietor, this is could be your social security number. An employer identification number (EIN) is a federal identification number issued by the IRS to identify a business entity. An EIN is also known as a Federal Tax ID number. Legally, you are required to identify your business with one of two numbers: either your social security number or an employer identification number. Furthermore, most banks require a federal identification number in order to open a business bank account. If you are a sole pro-

prietor, your social security number can be used on all of your government forms and other official documents, but most small business advisors recommend that you apply for a separate EIN for business documentation.

BUSINESS INSURANCE

The moment you start your business, whatever renter's or homeowner's insurance you had on your photographic equipment as a hobbyist may no longer be applicable. You will need a separate business insurance policy for your equipment loss or damage as well as personal liability insurance. This *studio insurance* package can be purchased from any private insurance company or at a discount through membership in one of the professional photography associations that offer this benefit. Check out American Society of Media Photographers *Prosurance*, Professional Photographers of America (a membership benefit), or Advertising Photographers of America.

IDENTIFY YOUR MARKETING MESSAGE

What is a marketing message? Photographers often use the terms *direction* and *marketing message* interchangeably. It may also be called *target your market*, but all three terms mean finding new clients and new revenues. In today's broad but shallow economy it has become a normal business practice to target more than one market for your services.

In order to identify a marketing message for your work, first answer this question: Do you want to do more of the same work but for better clients with bigger budgets? Or, do you want to do different types of photography projects and take on an entirely new direction? This will help guide your next step and the types of clients you target.

Once you have answered this most basic marketing plan question, then you go to the next step. Most would ask the question, "What do I do?" and that is the wrong question when marketing your services. You must always market for what you *want to do*, not what you do every day. If you ask the question, "What do I do?" the answer is "photography" and that is too broad a marketing message to target a client base (and create marketing materials). To get a more focused marketing message, you must ask yourself the question, "What do I want to do *more of?*" When you answer this more specific question, it will guide you to your new clients and your marketing message.

There are four ways to answer this question and target a marketing message for your photography services.

BY A PARTICULAR STYLE OF WORK

Style is based on how you perceive the world and the way you approach creative problems. Style is based on the way you solve photography issues for the clients with your own brand of individual creativity. Marketing style is very personal; it is how you see the world. It is not specific to any subject but crosses over many subjects and different industries. Also, the work tends to be used by high-end clients (bigger budgets), clients in cutting-edge industries such as editorial or entertainment, and advertising clients. It

takes either a very secure or risk-tolerant client to hire for a personal style marketing message instead of taking the safe, conservative route.

BY A SPECIFIC INDUSTRY

This is based on who the client is and it is one of the most common types of marketing messages because it is so easy to identify potential clients. Standard Industry Classification codes are a U.S. government system for classifying industries by a six-digit code. It identifies the type of product or service the client sells and is the method used to organize information on clients for almost all resource books, research, and list sales.

The U.S. Department of Labor Web site has Standard Industrial Classification (SIC) System Search at *www.osha.gov* and *www.naics.com*, or you can try the free online search at *www.webstersonline.com*.

The beauty of this marketing message is that it builds on itself. For example, once you have done work for a financial services client, you can use your experience and expertise in the industry to market to other financial services companies. Another nice benefit is that the usage of your work is very diverse. Every industry has a great variety of photography needs.

BY THE USE OF THE WORK

This marketing message is based on what the photography is used for (the usage). There are many categories of usage for you to choose from and to target. For example: corporate communications, Web sites, packaging, advertising, editorial, paper products, and books to name a few uses. These are good examples of targeting your marketing message because it helps you clearly identify potential clients. It also is extremely helpful when buying your marketing lists. With this marketing message you are not locked into any particular industry. For example, industries that use packaging photography include such diverse products as food, beverage, pharmaceutical, and beauty products.

BY THE SUBJECT

You can target your marketing message based on the subject of your image. Again, this is a very popular marketing message because your potential client base is readily identified. Examples include: automotive, people, food, architecture, products, locations, and landscapes. By targeting the subject, you will also find great diversity in the use of your work, and your clients will range from advertising to editorial and everything in between. The one thing in common is the subject of the photography.

WORKING WITH YOUR MARKETING MESSAGE

It is extremely important when developing your marketing messages that you set up a specific target with a broad client base to get enough work. If you target a specific marketing message too narrowly, you won't find enough work and you won't be maximizing the potential of this profit center approach.

For example, when you target with a specific style (technique or approach) your base should have a broad range of industries represented.

When you target a market by type of industry, you'll find that the broad base will be represented by the various uses of your creative services. You don't want to be too specialized. For example, if you focused only on Web sites for entertainment industry clients, you are too narrowly focused. You would need to broaden that to working on all the different photography needs an entertainment firm has for you.

When you target your market by the use of the work, your base can gain diversity (and profit!) from a broad range of industries, much like the targeting by style.

For a marketing message by subject, you will want to identify every type of use of the work you are doing. For example, if you selected food photography then you would target ad agencies with food clients, food clients directly, editorial use of food photography, and even such publishing clients as calendars, greeting cards, and cookbooks.

SAMPLE BUSINESS PLAN OUTLINE

A written business plan is an essential part of the legal and financial planning of a business. It is useful for managing an overview of your business and your long-term goals. It is essential if you are looking for financial assistance.

A written plan will give your new business focus and direction and help you to identify the marketing for which you will later plan (see chapters 21 and 22 for writing a marketing plan). There are dozens of formats for writing a business plan. Check with your local Small Business Administration office or their Web site for their publications on the *www.sba.gov/smallbusinessplanner/*.

Another option is to make an appointment with a SCORE consultant, a division of the SBA. SCORE (Service Corps of Retired Executives) offers free business consultations on any subject—including writing a business plan!

Here is a sample outline for writing a business plan. Note that your marketing plan is *contained within* and is a part of the overall business plan.

- Business description

- Market analysis

- Vision statement

- Mission statement

- Business objectives

- Product/service delivery

- Customer service/support

- Marketing plan

- Competition in this market
- Key competitive capabilities
- Key competitive weaknesses
- Legal structure of business
- Studio/office facilities plan
- Support personnel
- Profit-and-loss projection
- Cash flow projection

CASE STUDY: IRA M. GOSTIN, MARKETING STRATEGIST (*WWW.GOSTIN.COM*)

Q: Discuss "working on" versus "working in" as a business philosophy.

A: One of the most important business concepts that photographers traditionally overlook is the fine line between running the business and creating images. Making pictures is the part we all love, but the business has to be managed. Small business guru Michael Gerber (*www.e-myth.com*) describes this as the fine line between *working on* the business and *working in* the business.

Freelance photographers must look at themselves as business owners and entrepreneurs, not just photographers. Creating images is the working *in* the business, while being the business owner (all the hats—CEO, controller, office manager) is working *on* the business. The sooner the photographer sees these two equally important roles, and understands the symbiotic relationship between the two, the sooner he or she will be on the road to success.

Q: In your own marketing workshops, what are your Ground Rules for starting a successful photography business?

A: I was heading up the Long Beach Freeway in Southern California many years ago and saw a sign that read: The most dangerous phrase in the English language—*But that's the way we've always done it.*

I have to agree with this as far as business is concerned. Change is part of life and part of growth. If a business is not constantly growing, it's sliding backwards. I recently spoke with six business owners and asked them each the same question: How much money do you budget each year for strategic planning and development? They each had a blank look on their face. Business owners are no different from large corporation executives in that they need to be constantly looking for opportunities and strategies to garner greater market share in an effort to grow the business. A successful commercial

photographer in 1980 could not be successful in this era without having made changes. Change and growth are critical to building and sustaining a successful business.

Another area that is important is to be positive and take your business seriously. Be the entrepreneur, the creative professional, but also be the CEO and CFO and look carefully at how your business performs financially and strategically, as well as photographically.

Q: Please explain the Marketing 4 Ps you teach in your workshop.

A: In marketing, there are four primary concepts that are known as the 4 Ps. They are: Product, Price, Place, and Promotion. We traditionally just think of the promotion component when we think about marketing, which contains advertising, and other promotional activities.

Product refers to a clearly identified product in the market, with a deep understanding of who buys this, known as the target market.

Price is the component that identifies where the business or product fits into the marketplace, identifying the "position" of the service or product.

Place (or delivery) determines how the product gets to market, and how that affects the pricing and promotion.

Promotion can be developed by understanding the product he or she creates, and how it gets to the client, a pricing strategy and marketing message. All of these will guide how the promotion will be handled.

Q: Please share your thoughts on what is a brand and how to build brand equity.

A: For photographers, their brand is extremely important in growing the business as the brand is the emotional response that prospective clients have when they see your name or logo. A brand is merely a promise from one business to another. It is a promise to *deliver the goods* as the photographer has represented through marketing, proposal, or in-person presentation. Brand equity is the perceived value of that promise over time.

Think about brands that you know. Does the Chevy brand mean something different than the Mercedes brand? Does the Macy's brand mean something different than Wal-Mart? The photography-buying community is relatively small (except when you are in the middle of it!), so how a photographer conducts him- or herself, and how the business is projected are all very important concepts. A brand is much easier to build from scratch than repair when it has been damaged. By building your brand into a meaningful entity, you will build brand equity. This happens over time and with a constant reminder of that promise to your clients.

The Ethics of
Good Business

Like any other business, there will be ethical considerations in photography that confront you on a daily basis. You can make a difference by being prepared. You prepare by thinking through potential situations that could arise and having some idea of how you would handle the situation. Joining an association of your peers is one of the best ways to learn about good business and ethical practices. One of the advantages of peer associations is that you can meet and network online or in person with other professional photographers and compare notes.

First, what is ethics? Ethics are characteristics that will help you make good choices of behavior. The characteristics that are the foundation of ethical behavior include: integrity, honesty, trustworthiness, truthfulness, commitment, awareness or sensitivity to the situation, responsibility, fairness, and a sense of compassion. Being ethical for a photographer does not mean you are weak or non-assertive! Ethical behavior is the basis of successful and profitable business practices.

Why is this important to you? Because your clients and peers will expect as normal your good business practices but will never let you forget the one time you behaved dishonorably. Because you will find it is practical. Clients who don't feel treated fairly or honestly won't come back, and it is very expensive to constantly be looking for new clients. Finally, you will feel good when you do the right thing.

ETHICS ARE NOT ALWAYS BIG DECISIONS

You are probably making good day-to-day ethical decisions without a second thought. Your behavior every day forms a code of conduct. Often, it is inspired and directed by the feeling of wanting to do the right thing. Here are some examples of photography situations you may encounter that could test your ethical behaviors.

You deliver on all contracts, even verbal, whether it is with a client, vendor or an assistant. Always do what you say you are going to do. You bill fairly for expenses for jobs, getting the markup you need to make a profit while not taking advantage of your client. You maintain confidentiality in the client/photographer relationship. Your client should be able to trust you to shoot proprietary or restricted products and not have any images or discussion about the project outside your studio. You make honest and accurate claims in your advertising and marketing. You deal fairly in your agent or rep relationships and abide by the contracts you both agreed to. You are honest in your creativity, and if you are inspired by someone else's work, you get permission to use it.

As a rule, you know that you are facing a decision based on ethical behavior when you can identify the following three factors: your personal happiness would be achieved at the expense of fairness or honest treatment of another person, other people that will be affected by your decision are not considered or consulted and their voices are not heard, and the long-term gain of your decision is taken as a more important consideration than the immediate gain or benefit. In other words, doing the right thing may not yield its benefit right away.

How do you know you are on ethically thin ice when you are facing any decision? The best test is to watch out for rationalizations you verbalize (or think to yourself) that you believe will allow you to move ahead with ethically poor behavior. Here are some common rationalizations:

- I'm just fighting fire with fire

- It's not illegal, is it?

- Everyone is doing it

- It's just how you play the game

- No one is really going to get hurt

- Whatever it takes to get the client

- I'll only be as ethical as my competition

ETHICAL ISSUES WITH CLIENTS

While we are on the topic of ethics, let's explore three of the most common ethically challenging situations you will probably encounter when dealing with your clients. Whether you are in business two minutes or twenty years, these are situations that could make you stumble and fall—especially in tougher economic times. If you are grabbing at every job that comes by, at least stop and see where it may lead you.

The *Low Paying Job* comes with a catch, usually that you will be trading your fee for a promise of great exposure—maybe. This is not the same at all as the pro-bono

project for a nonprofit client. This is a case of someone telling you "shoot this for me now for free and you will get all our work later." No matter what the clients is saying—"we are just starting out" or, "you will make more money later"—you can at least be skeptical of the outcome and find out what the catch is first.

Another possibility is to use my favorite script when someone I do not know asks me to work for free to get "all their business at a later time." I consider this request to be ethically a bit backwards! My response is, "Thank you for asking, but we only give special price considerations to our regular photography clients." Think about that for a moment—translation anyone? Yes, you got it. I am saying "first you become a regular client and then we discuss a consideration on the price!"

Even if a low paying photo shoot were legitimate, accepting it has disadvantages. Primarily, the project could take time away from hours better spent on marketing efforts to get the market-rate paying jobs. The only possible advantage is that you're just starting out and really need this to build your portfolio or you are doing a regular client a huge favor. If you do take it, be sure the invoice has *one time only* expressed very clearly.

The *Audition Job* is really spec work. Clients ask you to audition by doing their photography, and if they like it they will pay you. A lot has been written in industry and association trade publications about spec work. Most agree that while it may not be an out and out scam, it is a poor way to do business for both the photographer and the client.

The *Easy Job* is a slippery one and very common when the clients do not realize all that is involved in creating the images they need on a project. Some jobs seem simple until you are so deep into the project that you cannot get out. Though it may seem hard to identify this kind of job, a very big clue is the scope and extent of the project description supplied in advance by the client. As soon as you feel your client is not able or willing to give you a full, thorough, and complete job description of his photography needs in advance then you can start to worry and may decide to pass on quoting a price. To avoid ethical dilemmas on photo projects, always evaluate and discuss the needs with the client before any work begins or any contract is signed. This will help to protect you from any surprises before you start working.

To learn what standard ethical business practices are and to give you something to share with your clients, we received permission from the Graphic Artists Guild to reprint the *Code of Fair Practice;* you will find the current code on their Web site, *www.graphicartistsguild.org.*

The Joint Ethics Committee (not in service as of this publication) published and compiled a Code of Fair Practice that has been in use since 1948.

A few organizations have kept the Code updated as needed and, since it covers business practices between clients and creative professionals, it applies to you as a photographer. The Graphic Artists Guild has an excellent explanation of all of these articles in their own book on business practices, *Graphic Artists Guild Handbook: Pricing & Ethical Guidelines, 12th edition.*

Photographers should decide on their own how to do business; these guidelines can only give you the industry boundaries and standards of professional conduct. Anything can be modified by your written contracts once you know the code!

Here is the text of the current Code of Fair Practice: The word *artist* should be understood to include creative people in the field of visual communications such as illustration, graphic design, photography, film, and television. This code provides the graphic communications industry with an accepted standard of ethics and professional conduct. It presents guidelines for the voluntary conduct of persons in the industry that may be modified by written agreement between the parties.

CODE OF FAIR PRACTICE

ARTICLE 1: Negotiations between an artist or the artist's representative and a client shall be conducted only through an authorized buyer.

ARTICLE 2: Orders or agreements between an artist or artist's representative and buyer should be in writing and shall include the specific rights which are being transferred, the specific fee arrangement agreed to by the parties, delivery date, and a summarized description of the work.

ARTICLE 3: All changes or additions not due to the fault of the artist or artist's representative should be billed to the buyer as an additional and separate charge.

ARTICLE 4: There should be no charges to the buyer for revisions or retakes made necessary by errors on the part of the artist or the artist's representative.

ARTICLE 5: If work commissioned by a buyer is postponed or canceled, a *kill-fee* should be negotiated based on time allotted, effort expended, and expenses incurred. In addition, other lost work shall be considered.

ARTICLE 6: Completed work shall be promptly paid for in full and the artwork shall be returned promptly to the artist. Payment due the artist shall not be contingent upon third-party approval or payment.

ARTICLE 7: Alterations shall not be made without consulting the artist. Where alterations or retakes are necessary, the artist shall be given the opportunity of making such changes.

ARTICLE 8: The artist shall notify the buyer of any anticipated delay in delivery. Should the artist fail to keep the contract through unreasonable delay or non-conformance with agreed specifications, it will be considered a breach of contract by the artist. Should the agreed timetable be delayed due to the buyer's failure, the artist should endeavor to

adhere as closely as possible to the original schedule as other commitments permit.

ARTICLE 9: Whenever practical, the buyer of artwork shall provide the artist with samples of the reproduced artwork for self-promotion purposes.

ARTICLE 10: There shall be no undisclosed rebates, discounts, gifts, or bonuses requested by or given to buyers by the artist or representative.

ARTICLE 11: Artwork and copyright ownership are vested in the hands of the artist unless agreed to in writing. No works shall be duplicated, archived, or scanned without the artist's prior authorization.

ARTICLE 12: Original artwork, and any material object used to store a computer file containing original artwork, remains the property of the artist unless it is specifically purchased. It is distinct from the purchase of any reproduction rights.* All transactions shall be in writing.

ARTICLE 13: In case of copyright transfers, only specified rights are transferred. All unspecified rights remain vested with the artist. All transactions shall be in writing.

ARTICLE 14: Commissioned artwork is not to be considered as "work for hire" unless agreed to in writing before work begins.

ARTICLE 15: When the price of work is based on limited use and later such work is used more extensively, the artist shall receive additional payment.

ARTICLE 16: Art or photography should not be copied for any use, including client presentation or *comping* without the artist's prior authorization. If exploratory work, comprehensives, or preliminary photographs from an assignment are subsequently chosen for reproduction, the artist's permission shall be secured and the artist shall receive fair additional payment.

ARTICLE 17: If exploratory work, comprehensives, or photographs are bought from an artist with the intention or possibility that another artist will be assigned to do the finished work, this shall be in writing at the time of placing the order.

ARTICLE 18: Electronic rights are separate from traditional media and shall be separately negotiated. In the absence of a total copyright transfer or a work-for-hire agreement, the right to reproduce artwork in media not yet discovered is subject to negotiation.

ARTICLE 19: All published illustrations and photographs should be accompanied by a line crediting the artist by name, unless otherwise agreed to in writing.

ARTICLE 20: The rights of an illustrator to sign work and to have the signature appear in all reproductions should remain intact.

ARTICLE 21: There shall be no plagiarism of any artwork.

ARTICLE 22: If an artist is specifically requested to produce any artwork during unreasonable working hours, fair additional remuneration shall be paid.

ARTICLE 23: All artwork or photography submitted as samples to a buyer should bear the name of the artist or artists responsible for the work. An artist shall not claim authorship of another's work.

ARTICLE 24: All companies that receive artist portfolios, samples, etc. shall be responsible for the return of the portfolio to the artist in the same condition as received.

ARTICLE 25: An artist entering into an agreement with a representative for exclusive representation shall not accept an order from nor permit work to be shown by any other representative. Any agreement which is not intended to be exclusive should set forth the exact restrictions agreed upon between the parties.

ARTICLE 26: Severance of an association between artist and representative should be agreed to in writing. The agreement should take into consideration the length of time the parties have worked together as well as the representative's financial contribution to any ongoing advertising or promotion. No representative should continue to show an artist's samples after the termination of an association.

ARTICLE 27: Examples of an artist's work furnished to a representative or submitted to a prospective buyer shall remain the property of the artist, should not be duplicated without the artist's authorization, and shall be returned promptly to the artist in good condition.

ARTICLE 28: Interpretation of the Code for the purposes of arbitration shall be in the hands of the Joint Ethics Committee or other body designated to resolve the dispute, and is subject to changes and additions at the discretion of the parent organizations through their appointed representatives on the Committee. Arbitration by the Joint Ethics Committee or other designated body shall be binding among the parties, and decisions may be entered for judgment and execution.

ARTICLE 29: Work on speculation; Contests: Artists and designers who accept speculative assignments (whether directly from a client or by entering a contest or competition) risk losing anticipated fees, expenses, and the

potential opportunity to pursue other, rewarding assignments. Each artist shall decide individually whether to enter art contests or design competitions, provide free services, work on speculation, or work on a contingency basis.

* Artwork ownership, copyright ownership, and ownership and rights transferred after January 1, 1978 are to be in compliance with the Federal Copyright Revision Act of 1976.

Photo Representatives, Other Agents, Hiring and Working with a Marketing Coordinator

What are photo representatives and what do they do? Art/photo representatives own their own businesses. They usually represent a group of non-competing illustrators and photographers (also known as the talent) who own their own businesses. The relationship is that of an independent contractor and not an employee and employer. Agents usually work on a commission that is a percentage of the fee and seek to find work within a geographic territory. The photographer and the rep will work together to promote the photographer to potential new clients and the photographer pays 25 percent to 35 percent commission on the fees of jobs in the rep's territory. You do not pay commissions up front but you will spend money on other marketing materials the rep will need to get work.

ART/PHOTO REPRESENTATIVES

Photographers often maintain their own clients as house accounts not subject to the rep's commission. Many photographers, however, want the rep to work with all of their clients and will give all or part of their house accounts with commissions to the rep.

The photographer's general business and office management are not usually part of a photo rep's job responsibilities. Reps work in three important ways to build your business. They find new clients for the kind of assignments you want to do and they negotiate the best pricing and terms with these clients. They keep these clients coming back again and again.

For each talent they represent, reps usually work a geographic territory looking for a specific kind of photography assignment. Geographic territory can be limited to a city, a region, a country, or regions of the world (North America, Europe, and Pacific Rim). Many photographers have different reps in each of the major advertising markets around the world divided into these geographic territories. Though most photographers can do any kind of assignment, to avoid conflict with their other talents, a rep will sell each one

as a specialist. For example, a rep might have a people photographer, a food photographer, a product photographer, and so on.

An art/photo rep works most successfully and profitably when he or she works in one of the commercial photography markets that hire many different types of photographers and illustrators—clients such as an ad agency or design firm. In other words, to bring in one hundred photo assignments from ten to twenty clients makes a rep more profitable than when he or she has to bring in work from one hundred different clients! Time is money. Because of this, you'll find most reps in major metropolitan areas where they have a large pool of advertising agency and design clients. Because they have many different kinds of clients and creative needs, these clients will work with a rep who has a variety of photographers and other talent to match those needs.

OTHER TYPES OF REPS

In addition to the art/photo rep bringing in assignment clients, there are other types of agents for photographers who do not compete with the art/photo rep because they look for different types of clients.

Here's a quick glossary of other agent types:

• A gallery can become the rep for the photographer. Instead of an individual rep, it is the entire gallery or gallery owners who rep you. Instead of carrying around a portfolio for you, they show your work at the gallery or on their Web sites.

• An art consultant is somebody who goes through your work, selects the best images, edits the work, and plans the promotion—what to show and who to show to. Art consultants usually function more like brokers.

• A fine art corporate rep finds artwork for corporate clients for public and private spaces and they act like art dealers for corporations.

• Art dealers take on the pool of fine art talent or fine art work from estates and deal mostly with private collectors or interior designers. They act like a gallery without the building. They have a talent pool of images and a large clientele and seek work for their talent pool.

Author's note: These terms are not universal in meaning or understanding but hopefully will provide some clarification to the reader.

HOW DO YOU KNOW IF YOU ARE READY FOR A REP?

Here are some clues to determine if you are ready to look for any kind of rep. You're probably ready for a rep if you are too busy with photography assignments and self-assignments to make the personal contacts to find new clients and work to keep the ones you have. You're ready for a rep if you have enough repeat business from a stable client

base of house accounts. You are ready for a rep if you have a strong style or specialty that a rep can sell to advertising agency or design clients. You are ready if you consider yourself first as a business then as a photographer. Reps like to work with photographers who appreciate the business aspects of their work. You are, after all, in business to make money! You are ready for a successful rep/photographer relationship if you are open to new ways and new ideas to promote your business and need a rep's time and expertise to help you. You are ready if you have a portfolio ready to go out the door and it represents the kind of work that you want to do more of. Working on commission, reps can't stand by without work to go and show.

You're ready if you have the budget for the promotion pieces and marketing plan to support the rep. You will not spend less money on marketing when you have a rep. An average budget for self-promotion is 10 percent of your projected gross sales. You are ready if you are willing to spend the time to assist the rep in selling your work. You will not spend less time on your marketing by having a rep. You just won't do the same things, for example, instead of calling the clients; you will be creating new portfolio pieces for the rep to show new clients.

HOW DO YOU FIND A REP?

Finding a rep is very similar to the search for clients. You must research the reps, present your portfolio, and do the regular follow-up required to build a relationship. Reps are a lot like clients in that they may already have someone who does the kind of photography you want to do, and good research and consistent follow-up is the only way to break through this barrier to working together.

Knowing with whom the rep already works allows you to approach the rep in a way that will make the very best impression. Perhaps you find out the rep does not have a people photographer and may need one. Your approach will be to help the rep by being his people photographer so that he can offer their clients a better, more complete service. Perhaps the rep already has a people photographer; then you could offer to be available as a back-up and will work on a job-by-job basis. There are many possibilities.

WHERE DO YOU FIND INFORMATION ABOUT REPS?

First, most of the creative source books list the names and addresses of photography reps. For example; The Workbook (*www.workbook.com*) lists the talents reps represent and their specialties. You can buy a mailing list or directory of reps who belong to the professional association, Society of Photographers and Artists Reps (SPAR) (*www.spar.org*). In addition, Writer's Digest Books (*www.writersdigest.com*) publishes a book that lists the reps, how they work, and what type of photographers they are looking for. This book, *The Photographer's Market 2010* is updated each year so be sure to get the most current year when you buy the book! There are more resources listed at the end of this chapter.

THE REP/PHOTOGRAPHER RELATIONSHIP

Many problems in the rep/photographer relationship can be traced to new reps just getting into the business or photographers unaware of the formula for a successful rep business. What doesn't work very well are reps who struggle to survive on the new clients from just one photographer without getting a percentage of house accounts. The reverse is true; reps can't make good profits when they have such a diverse and disparate group of talent that it takes fifty clients to get fifty jobs. It is hard to show the portfolio when the rep allows the photographer to borrow back the portfolio and does not have his or her own. When these situations exist, you have an unhappy photographer saying, "Reps don't work." Not in these situations, but they didn't have a chance in the first place.

Another factor in the unhappy relationship of a photographer and rep is the result of the major client shift from selling photography to marketing photography. When reps could rely on getting enough (eight to ten) appointments a day with clients, everyone was happy. A rep's job has always been to sell, to go one-on-one with the client. Though this is still true today, many photographers are using more non-personal tools of marketing, such as advertising, direct mail, publicity, e-mail, and Web sites to get clients. Though personal relationships are still important, the reality is that personal appointments are much more difficult to get. How do you compensate a rep working on commission when he or she is writing a press release, planning an e-mail campaign, or updating your mailing list? These are all important tasks and can be delegated to a rep along with the job of one-on-one selling as long as there is compensation to the rep.

As the marketplace for photography becomes global with Internet marketing, more photographers may question the wisdom of committing with a rep to a single worldwide territory. With the technology today, photographers can work with a client in another country as simply as they can work with the client down the street. While a rep needs and wants this kind of very broad geographic territory of clients, photographers are less and less happy about giving them an exclusive to it. Someone does need to manage this broader scope of client potential; whether it is a rep in each major city or a marketing coordinator on staff will be the deciding question for the photographer.

Finally, as more clients shift to new technology marketing tools, less money is spent on traditional print advertising. As more clients make this shift and advertising agencies give out fewer print jobs, the rep has to find more clients to bring in the same amount of jobs. Suddenly, that art director with one or two jobs a week for the rep falls back to one or two jobs a month, or merges with another agency, or disappears altogether. The other problem with this shift is the effect it has on the way a client works with a photographer. In the past, a rep would present a pretty tight comp to the photographer from the client. With newer technology and clients more unsure of their needs, the photography is often much less defined and the client may need to have a much closer, consulting relationship with the photographer to get what he or she wants.

CASE STUDY: RHONI EPSTEIN, RHONI EPSTEIN PHOTO GROUP (*WWW.RHONIEPSTEIN.COM* AND *WWW.PHOTOTHERAPY.COM*)

Q: How does a photographer know if he is ready to look for a rep?

A: Most photographers can benefit from the vision, direction, contacts, and marketing acumen of an established representative. It is extremely important to find a rep that is passionate about her client's photography and desires to be the marketing partner and outside voice to the world. Both the photographer who is extremely busy with assignment work and requires marketing management and the photographer who has developed style and a body of work but needs a plan of action can grow with professional representation. The passion a rep has for the photographers she is working with can carry her through both the slow and busy times.

Q: What do you recommend to a photographer about the things he must do to find and approach reps?

A: Our business is about relationships. To research reps I recommend attending professional meetings, questioning photographers you admire, and consulting with art buyers and photo editors. Finding the right rep is the same as researching a prospective client. Try to understand the rep's style and see if there are any needs in the group that you can fill. Google can give you lots of information about a rep's involvement in the photography community. Once you have narrowed your search, contact the rep via e-mail and ask for feedback on your Web site or a few images to try to get the connection started. We all want to work with people we like. Also, stay open to honest feedback, keep your sense of humor or get one, be appreciative for the time and expertise, and show what you have to give.

Q: To you, what are the best and worst aspects of the rep-photographer relationship?

A: The best aspect of working with photographers is the visual and verbal communication. Being a partner with someone you respect and who respects you is priceless. Seeing the imagery grow and develop is creatively fulfilling and collaborating to build an exciting, well-edited, and paginated portfolio results in great self-satisfaction. All the hard work is rewarding when you see the photographer achieve visual and financial goals.

The difficulties come from a non-supportive environment. If you do not agree upon goals you are not the right match. Complete honesty and trust about imagery and finances are essential. Some photographers think that working with a rep is their way to immediate fame and fortune. However, the photographer must be able to build infrastructure and manage money for self-promotion. Unrealistic expectations are the hardest part of the rep-photographer relationship. Building a lasting career takes investment, time, and trust in the process. Patience is truly a virtue and then anything is possible!

HIRING AND WORKING WITH MARKETING COORDINATORS

When photographers or photo studios want a rep's undivided attention for their business, they will have to employ someone to act as their rep exclusively. These in-house reps are employees of the photographers. Because they are employees, they usually do not represent any other photographers or talents and often include office or studio management in their job responsibilities. A bigger photography studio (especially with multiple shooters) is the most likely to need this type of job position due to the greater range of everyday tasks to do. The marketing coordinator job description covers everything from office management, database management, writing press releases, and researching to developing new clients. Compensation can be salary, salary plus commission, or a partnership agreement.

Though I have seen this concept work very successfully, often different job titles are used for the position. Some job title options are marketing coordinator, sales manager, producer, or partner (depending on the financial/responsibility ratio). The title of photo rep would not be used for in-house marketing people because it implies they represent multiple talents when they do not.

Traditionally the photographer has worn all the hats in the business. Just because you are a sole proprietor does not mean you have to work alone! Today's photography business owner may need to employ a full (or even part time) person to help with the daily chores of marketing and business management. You could even have an independent photography representative and still hire a marketing coordinator. The rep will have his or her own business and other talent to promote and you will have the undivided attention and control over an employee.

Before you say, "I can't afford to hire someone," think again. Maybe you can't afford not to get help. In the past, you could be just a photographer and survive nicely on whatever came in the door. That is no longer true. Now, you need to be a business owner and learn to delegate the marketing and management work you don't have to do yourself.

Maybe you can do the work yourself better, quicker, faster. Yes, but at what price? Here are the steps to follow to learn and practice the delegation skills you know will pay you back tenfold!

1. Analyze the job at hand and write down a detailed job description. Take your time with this step. Some tasks are so automatic that you'll forget an important item and your marketing coordinator will not be successful. Not only is this lack of detail frustrating, it is very discouraging.

2. Decide what parts of the job you need to keep control over and what you can delegate.

3. Plan the performance standards you will hold your employee to. Be sure to explain what your expectations are and what results you are looking for.

4. Follow-up reviews should be scheduled to catch any mistakes or problems before they get out of control.

There are many tasks you can give to someone else to allow you more time and energy to work on self-assignments and business owner responsibilities. Once you have a complete job description, categorize these tasks into an outline of marketing, office management, and photography production.

Here is a sample task outline:

Marketing Tasks

• Organize client/prospect database

• Research new leads/update database

• Organize materials for portfolios

• Prepare materials for cost proposals

• Manage direct mail/mailing outside service

• Inventory promo pieces/publicity reprints/tear sheets

• Keep master calendar of marketing design and production updates

• Respond to requests from Web site/ads/mailings

• Send/return traveling and drop-off portfolios

• Write/mail press releases on a schedule

Office Management

• Billing, bookkeeping, and filing

• Updating vendor files and samples

• Inventory and order office supplies

• Stock photography filing and research

• Answer phones, e-mails

Photography Production

• Order and inventory supplies

• Research props and background supplies

• Test equipment on maintenance basis

• Shoot tests for portfolio promotion

• Organize and maintain location packing lists

• Prepare, pack, and unpack location shoots

• Pickup and shop for props, backgrounds

• Organize and assist with digital post-production

• Janitorial/maintenance

Finding the right employee is critical to the success of working with a marketing coordinator. Remember, he or she often has the first encounter with current and potential clients and will probably be recording deposits and receipts. You are looking for someone trustworthy and responsible. Concentrating time on the search for the right individual will pay off in the long run.

WHERE TO LOOK FOR MARKETING COORDINATORS YOU CAN AFFORD

Once you have a good idea of the job description and hours required, start looking! Here's a list of possibilities: students at local colleges (business departments, of course!), customer service at local print shops and photo labs, referrals from your professional associations, the vast and highly qualified pool of early retirees (check local AARP chapter), and sharing the marketing coordinator with your studio mates.

For salary, you'll pay the going hourly rate for general office or administration personnel. Check with any local job placement agency to find out what is fair for your geographic area. The greater the client contact, the more money and incentives you should create for your marketing coordinator. In addition to a salary, high-level client contact or working on sales can be compensated with salary plus commission. You'll find that you could hire someone for as little as fifteen to twenty hours a week at the beginning. Not only is this more affordable, but it is easier to find part time help among students or even retirees. Next, talk to your accountant about becoming an employer and the financial responsibility, taxes, and paperwork that will involve.

INTERVIEWING BASICS

This may be the first time you have interviewed and played the role of employer! Here are a few tips for conducting an interview. Your objective is to do the most careful job at this step to avoid disaster and heartache down the road.

Prepare in advance and use an employment application. Check online, plus your local office supply store should have generic forms that you can customize. Call your state office of labor relations and make sure that you get the information on state labor

standards enforcement laws. Review the applications you get and call and check the references. Ask open ended questions when you are interviewing such as, "What are your career goals?" not "Do you have career goals?"

Explain the written job description even though you have everything in writing, because discussing the responsibilities will bring out any questions now (better than later). If you run into trouble at this point, be careful of making any hiring decisions. Remember, in most cases it is a lot easier to hire someone than to fire them.

Explain how you will make your decision and let the applicants know if you will call them, e-mail, or send letters. Also, give a time frame so that they don't have to keep calling you for your decision.

The state labor office will also be able to help you with the legal considerations of equal opportunity employment and questions you can and cannot ask. Take appropriate notes as there may be state laws regulating the hiring and firing of employees that will affect your conversations and notes at the interview stage. Make sure anything you keep will not come back to hurt you.

EMPLOYEE MANAGEMENT
It will be very important from the start of your new relationship to communicate policies and practices and spell out the working relationship. Not only will this basic knowledge help your new employee to do his or her best work, but also it will make sure the work gets done in the most efficient manner. Put together your policies and practices manual. It should include: your mission statement and objectives as a business owner—for example, "My goal is to establish Smith Portrait Photography as the premier portrait studio in my local market." Now, everyone is working towards the same goal! Explain employment policies such as work hours, overtime, performance reviews, vacation, holidays, sick leave, leaves of absence, and injury on the job. Employee benefits included should be detailed as well; these items could be health insurance, disability, worker's comp, and additional training. Also discussed should be employee conduct such as telephone and client handling, workspace maintenance, and reporting problems or concerns.

MOTIVATING YOUR EMPLOYEES
Sometimes, you can't compensate for work above and beyond the call of duty with financial rewards. There's no question that money is motivating but it is not the only motivator. The value of recognition and attention can never be overestimated. Many employees in the clerical area look at getting into the market as a motivator (especially if there is commission involved). Offer workshops or photo conferences that your employee might like to attend but may not be required for work. A better work environment is always an option, be sure to ask for their thoughts on improvements in their work space before making any changes. Finally, something as simple as unexpected time off is a wonderful motivation for an employee to work above and beyond the call!

RESOURCES: PARTIAL LIST OF RESOURCES FOR FINDING REPS

- The Workbook (*www.workbook.com*)
- The Society of Photographers and Artists Reps (*www.spar.org*)
- *2010 Photographer's Market*, Writer's Digest Books (*www.writersdigest.com*)
- ArtNetwork (*www.artmarketing.com*)
- Photo Directory (*www.photographydirectory.org*)
- Talent Networks (*www.Talentnetworks.com*)

Types of Clients

As a rep and a marketing consultant, I see the universe of photography clients as divided into two client types. One is the commercial client. The second is the consumer client.

I base this distinction on how the photography is used by the client. Commercial clients have business reasons for buying the use of your images. It could be a low-end level of commerce, for example, to communicate with their employees. It could be a high-end level of commerce, for example, to sell their products or services.

Consumer clients (often called wedding and portrait clients) have personal reasons for hiring you. There is no commerce or profit-making use of the images. If there is, then they become commercial clients.

Stock and fine art photography are not separate categories of clients and can be either a consumer or commercial client. If the stock or fine art photography is for display in the home of an individual for non-commerce purposes, then it is a consumer client. If the stock or fine art photography is for display in the office and lobby of an individual's business, then it is a commercial client.

DIGITAL PHOTOGRAPHY

There are two distinct client markets for digitally produced images but it would not be accurate to call them digital clients. Since they could be consumer or commercial clients, it is important to recognize that the subject matter is not at issue. The determining factor of client type is *how they will use the photos*, not the subject. A digitally produced portrait can be consumer client (family portrait to hang in the living room) or commercial client (executive portrait for an annual report).

The first type of client hires you to create illustrations, images that no longer look like photographs. For example, one popular style of photography for consumer clients is to take photographic portrait images and digitally paint over them so they look like fine

art paintings. To market your work as an illustrator you need to create a unique, new expression of your personal style. Because this is style and not a subject-specific marketing message, there will be many different types of clients. So, like any illustrator, advertising in a creative source book (print or online) is probably the best marketing strategy because it exposes the greatest number of clients to your style. Clients can then call from your Web page ad or print ad when they have just the right job. The most common response by this client is, "Great work! I can't wait to find the perfect project to try you on."

The second type of client hires you to create a photographic image, just enhanced in some way. For example, the commercial client that hires you to photograph his product and digitally compose the image with different backgrounds, maybe even some retouching of the product. As a photographer using digital technology, this second kind of client hires you to get to something that still looks like a photograph, but you create the final image instead of an outside service the client previously used to put all the pieces together. The most likely client is the client you already have! This is the client who used to tell the photographer, "Shoot this so I can go have the photograph retouched and assembled later." Now, the photographer can do the image enhancement and assembly. The best marketing tools here are direct mail campaigns and sales calls. Since your studio will do the image enhancement and assembly, this expands your services and billings on jobs to existing and new clients. Many photographers expand digital billings and business by working on supplied photos.

CONSUMER CLIENTS

Will you remember the times of your life? Yes, they are the lyrics from a song recorded by Paul Anka for an old Kodak advertising campaign but they are also words to live by for the consumer photographer. As people move through different stages of their lives, photographic records of these events are the mainstay of the consumer photographer's business model.

The idea of hiring a professional photographer to capture life's important moments will never be replaced by relying on family or friends to "just take a picture." There are many differences between hiring a professional and depending on a friend with a camera besides the obvious reason—quality. As a professional you can make sure people will look the absolute best, capture spontaneous and beautiful moments without people even realizing it, recreate magical moments otherwise lost to the hectic pace of the event, and save people time and energy trying to do it themselves.

And of course, don't forget the entire line of profitable products in the sale of Photoshop services, prints, framing, and albums.

Though most photographers can do both portraits and weddings, many prefer to specialize in one or the other for their marketing message. The differences are important when you are considering marketing in one direction or the other. The portrait photographer asks the client to pose and can spend lots of time, attention, and energy

getting just the image desired. Wedding photographers have to be more spontaneous and often capture the image the second it appears, often without a second chance.

When you start to research potential clients in the consumer market (see chapter 9) you will find the most direct route is mailing houses. All the information you could ever dream of needing to build your consumer photo client database has already been compiled. These compiled lists are for sale. For example, you could have access to 215 million consumers in 110 million living units with a search/sort that includes: geographic selection, age, estimated income, gender, homeowner status, marital status, net worth, and purchase amount ranges. Added to the above, some firms compile and sell lifestyle information—exactly what you are looking for when marketing to consumer type clients. Lifestyle purchasing information uses over sixty behavioral indicators and consumers are rated by the strength of their attraction to each behavior, so you will be able to choose your best prospects by their likelihood to respond favorably to your marketing message.

TYPES OF ASSIGNMENTS

Whether you choose portraits or weddings, you will be marketing images that tell the story of life's many passages and stages. Your photo assignments will range from engagement portraits to weddings and pregnancy portraits to baby's first birthday, and grandpa's ninety-fifth birthday.

Here is a partial list of potential photography assignments to help you evaluate your readiness and willingness to market your work to this client type.

- Portrait: individual, family, high school seniors, pets

- Wedding: engagement, ceremony, reception, anniversary, vow renewals

- Children: pregnancy portraits, mother and newborn, birthdays, school programs

- School Portraits: graduations, team sports photography, performing arts programs

- Events: Quinceañeras, classic car (or boat) shows, memorial services, funerals

Photographic bottom line: people need pictures of moments in their lives or when it is time to "Hatch 'em, match 'em, and dispatch 'em."

COMMERCIAL CLIENTS

A commercial photography client has a non-personal use for your images. Commercial photography clients can range from editorial, Web sites, multimedia, brochures, advertising, graphic design, corporate communications, public relations, annual reports, sales presentations, retail products, and décor.

The specific types of clients depend on what the client is using the image for, so it is most important to know all the players before entering the game.

Corporate in-house departments, also known as client direct, will purchase photography for their internal use. If that company has an in-house ad agency, will also purchase for its ad campaigns. Even though it is an internal purchase, the advertising photography is still a high-end usage. If the company uses an outside ad agency, the ad photo purchasing goes through the agency. Corporate photo buyers tend to be organized by departments (advertising, public relations, corporate communications, research and development) so you could have one company but with a variety of photo clients who work there.

Art buyers and art directors working at advertising agencies, freelance art buyers, design studios, multimedia firms, and marketing/public relations firms all buy photography based on the clients they represent. They buy for many different uses, most specifically (but not limited to) those requiring concept and photo direction such as ad campaigns, direct mail campaigns, packaging design and photography, Web sites, and transit ads. Their needs often are specific to photographic expertise in a subject such as product, people, food, fashion, automotive, architectural, healthcare, and medical.

Photo editors working at magazines/newspapers (editorial clients) have the very specific need to illustrate their articles with images. I am surprised how often students in my workshops are unclear about the distinction between editorial and advertising photography in a magazine or newspaper! They are two completely different types of clients and each with a very different purpose. The editorial client hires you to *tell a story* and the advertising client hires you to *sell their client's products or services.*

Photo buyers working at greeting card, poster and calendar publishers, book publishers, and novelty licensing have different needs from all the other client types. These clients need photos for illustrating cards and posters for sale, illustrating text in books, for book covers, and other promotional material. Don't underestimate the size of this market. According to the Greeting Card Association and in the United States alone, consumers purchase approximately seven billion greeting cards each year, generating nearly $7.5 billion in retail sales. These greeting cards range in price from $.50 to $10.00, although photography cards typically cost between $2.00 and $4.00. Photography cards featuring special techniques and new technologies are at the top of the price scale. Despite their higher cost, the realism and artistic uniqueness of these cards continues to win the favor of many card purchasers. Although e-mail, text messaging, Skype, and phone calls are valuable for communicating with family and friends, the majority of people surveyed by the Greeting Card Association say they still use the old-fashioned handwritten card. Interestingly, the increased use of electronic forms of communications seems to be bolstering rather than reducing sales of printed greeting cards.

Finally, licensed artwork for clothing, tableware, giftware, office products, and home furnishings creates a broad and diverse pool of products representing an approximate $6 billion in retail sales, according to *The Licensing Letter,* published by Entertainment, Promotions, and Marketing (EPM) Communications (*www.epmcom.com*).

BUT WHAT ARE YOU REALLY SELLING?

Whatever type of commercial client you decide to target for your photography marketing, you need to consider the value you can deliver. All of these clients only really care about one thing—what are they going to get? To set yourself apart from your competition, take a look at these qualities needed for a commercial photographer and what you are really selling.

You need to spend time getting to know clients and their true needs (not just what they say they want!). You will bring all your knowledge and experience to their project. If you are just starting out, then you have your fresh vision and life knowledge to offer your client.

You need to balance all the essential elements—people, places, things—needed to create a professional photographic image. The image subject is important—or what you call *the hero*—but there is also the balance of the background, the lighting, the composition, styling the photo shoot, and the relationship with the commercial client.

You need to offer a greater understanding of light and how to capture images in any kind of light. One of my favorite client stories is the company coming to us with their own attempts at interior design photography asking, "Why are these green?"

You need to create the best post-production services (in-house or outsourced by you) to enhance the images for color, exposure, retouching, background, and delivery media needed.

Finally, you need to prove to your potential commercial clients that hiring a professional photographer—hiring you—offers far greater value and quality than any alternatives.

Marketing to Commercial Clients

You always need to begin with your marketing message (see chapter 2). It is the verbal statement of the visual—the work you are selling. It identifies the photography work you want to do more of and the photo clients who will hire you. It is the *hook* for prospective clients to hang you on so they remember you when they are hiring.

For example, if you want to do more executive portraits, you will focus on this as your marketing message. For your prospective clients, you will look to a clientele that needs executive portraits to do what they do (annual reports, Web sites, brochures). Only when you know *what* you are marketing will you be able to identify *who* buys it. Given the great number of photographers to choose from, this targeting or positioning in the marketplace will help the client remember to contact you and not your competition. It must be consistent throughout all print and electronic promotions.

ONCE YOU HAVE YOUR MARKETING MESSAGE

There are two important features to the success of any marketing plan for commercial clients. One is that you break down every task into small pieces. Second is that you take these bite-size tasks and cross-reference them to your daily planner. This is the key to *plan the work and work the plan* and the most basic foundation of your self-promotion success.

Another fundamental is to *find a need and fill it*. This is important to your marketing strategy. You can try the shotgun approach and blast ads and e-mails and promotion into the marketplace and see if anyone is interested. The better approach (more cost-effective) is to identify your potential commercial clients by their need for the work you want to do more of.

When you look at marketing overall, this umbrella term covers many different tools of self-promotion but the most basic difference is between personal marketing and

non-personal marketing. Personal marketing is anything that requires you to reach out and contact clients on a one-on-one level (also known as selling!).

Non-personal marketing is a mix of all the tools you can use to broadcast your marketing message to your audience, such as ads and direct mail, and have them contact you. Web sites are a hybrid marketing tool because you can use them for personal marketing (as a portfolio) or non-personal marketing (as an ad).

Commercial photography clients are unique in the way you market to them. Unlike consumer photography clients, you can actually identify the companies you strongly suspect are potential commercial clients once you have focused on your marketing message. Data and lists of commercial clients are readily available, making your approach more targeted and effective. This allows you to use personal marketing tools more effectively *to contact potential clients*. With consumer clients you are more likely to use the opposite approach of non-personal marketing to broadcast your message and ask the *potential clients to contact you.*

USE ALL THE TOOLS

Marketing commercial photography should use all the tools available to you to get a good mix and build your 3-Rs: repetition, recognition, and response. As an overview, here are your different marketing plan tools to find commercial clients.

Advertising is designed to reach very large groups of people. It is best used when you want to broadcast your marketing message and have the clients call you. With print ads, you will expose thousands of people to your marketing message. With a Web site, the reach is broader in geography and larger in potential visitors to your site. Your objective should be to impress your audience with your marketing message and then ask them to respond in some way. Your print ads must refer clients to your Web page and your Web page must refer clients to your print ads. Use this cross-referencing to build marketing equity; don't waste any chance to build repetition of your marketing message with a potential client. Remember that a client is looking at your ad page or your site because they are looking for something they don't already have. Your design objective is to give clients a strong and distinct impression of your photography marketing message and to ask them to respond. You will want to find and work with a design and copywriting team for design. Be sure to add people who respond to your mailing list.

Direct marketing by mail or e-mail is another form of promotion very popular with commercial clients. You will need to research a mailing list and decide on the frequency of the mailing. Direct mail is becoming more and more sophisticated with *call for action* copy added to your images as necessary, not optional. At least two objectives are to get responses from purchased mailing lists to create a personal marketing database *and* to send traffic to your Web site. Don't forget about the visual impression you want to make! Choose images that remind clients of your marketing message. Always include your contact information of all types on your mailer and give clients a really good reason to

visit your site or contact you. Be open to using both e-mail and stamped mail as a good marketing mix for direct mail campaigns.

With your public relations campaign, you will want to send press releases to commercial clients' media, photography media, and local community media. You need to plan quarterly project press releases to the entire media spectrum. Consider entering awards programs for both self-assignment and published work. Think about submitting self-assignments to industry publication awards annuals like *Communication Arts* magazine. Be sure always to list your Web site in the press release as an additional method of contacting you. Mention it again in the body of the press release copy. For cross referencing, add a gallery of recently completed project press releases to your Web site as a publicity technique. When writing project press releases, add quotes from clients. All clients love to be included in any publicity and will check out your site to see their project.

For your personal selling efforts, you will research lists of potential clients that match your marketing message along the lines of the *find a need and fill it* technique. Your database will come from past commercial clients, past prospects for commercial work, responses to direct mail and ads, and leads from your Web site. Using the techniques in chapter 11, you will get appointments, make presentations, and plan follow-up. You will concentrate quality time on your better prospects for commercial assignments and plan monthly or bimonthly calls for presentations and follow-up. You can successfully integrate your Web site by making sure prospective clients have the option to visit your site to view your portfolios. They can also visit the Web site while talking with you. Literally, this is a *virtual* portfolio presentation for your prospective commercial photography clients.

CASE STUDY: WORKING WITH COMMERCIAL CLIENTS, LON ATKINSON (*WWW.ATKINSONSTUDIOS.COM, WWW.FACEBOOK.COM/LON.ATKINSON, WWW.ATKINSONSTUDIOS.COM/BLOG/LONBLOG.HTML*)

Q: What steps do you take to handle each commercial photo assignment job efficiently (for the client) and profitably (for you)?

A: The answer to this question literally is communication. Number one, you have to understand what it is clients really want. In order to be efficient you have to have all the information for the job. Are they in a big hurry for it? Do they want it beautiful, fantastic; take all the time in the world to get it for them. You've got to understand where it is, what it is they want you to do, in order to be efficient for them. In our mind, efficiency is having all that information before we start the job. What is the client's expectation for that particular job? This also is profitable for us . . . we don't want to be wasting any time, *spinning our wheels* as they say, we want to get the job in here, do it the way clients want it, get it out to their expectations, and move on to the next thing.

Q: How do you make sure you are meeting your client's real needs?

A: Keep in mind in my particular business, I'm a product photographer, a very simple product photographer. 90 percent of the time, I don't have a client in the studio. I've got

major clients here; we literally get products shipped to us. Usually it comes with some information as to what they want and when they need it. And so our job is to take that info and to ask whatever questions that we need. The reason we are in this situation is that we have been able to prove to these clients that they don't need to be in our studio, they don't need to be standing . . . looking over our shoulder.

We just gained a new client (not even in San Diego) that came to us . . . they wanted to find somebody that they could send their products to, have a conversation over the phone, and go away. In the past, the marketing manager has sat there and had to be the stylist. So, if we could prove to them that we don't need that input from them, the client will work with us. We do that by asking all the questions and being intelligent about what their needs and expectations are. I do this also because I have staff, I have a stylist. We take away the responsibility the client thinks is theirs and take it upon ourselves.

Q: So you take away the client's responsibility?

A: Yes, this is a dangerous game, because you can't make clients think you don't want them here. We don't mind the clients being here, but most of the clients that we have don't want to be here because they're marketing people, they're corporate people, they are busy doing their work. If we can take away the things that they've had to do in the past, it's more efficient for them, it's easier, and that's better for us. Then we're working on our own, we don't have that pressure of the client here, and we're able to be more efficient in how we work. Now you can't do that if you're not capable of taking these responsibilities and doing it well.

For instance, I have a stylist, so clients don't need to be here to prop up their products or to stuff their clothes, or whatever they want to do. We have someone who will do that for them. We have a complete digital department; they don't have to think clicking tabs, they don't have to worry about preparing images for the Web or preparing images for print. We do that for them, so because it is efficient for them, that becomes profitable for me."

Q: How do you know what the commercial client really needs?

A: One way you know if you're meeting your needs is if they come back. So you've got to listen to them and that need is a different thing to different people. The same client could have different needs for different products. So again, you're listening carefully as you talk to them and we spend a lot of time talking to them to find out if their needs are quick and dirty or their needs are the most glamorous thing you've done in your life or their needs are efficiency, quick turn-around, or do everything for them so they don't have to do anything.

I'll use this new client that we had as an example. He came to us; he found us through our Web site. When I sat down at the meeting, I was completely familiar with what his product was; I looked it up on the Internet, went to a store and looked at it. I knew what it was. So at the meeting, I had my stylist with me, introduced them to my

digital people, and we started talking to them about his experience working with his previous photographer. The client had brought the products with him, and I said, "Would you like me to do a test shot of those products?" He said, "Do I have to be here?" and I said, "'No.'" Well, he said, "When I worked with this other photographer, I had to be in the studio the entire time!" And I could tell that that was a hot button for him. He didn't want to be in the studio, so we told him that we're very comfortable in getting his information and we asked a number of questions of course; he showed us what he liked, and what he didn't like, and this sort of thing. So when he left, we did a test shoot for him, and we sent him the images, and two days later I got a big box with a couple of day's worth of photography.

I had another client who came in the other day and said, "'We have no graphics people at all, and I need you to just do everything on these images so I can just drop them in to what we're going to do." I said, "Fine, these are our services, we'll do all this for you," and he was thrilled. To me, that's meeting the client's needs by understanding what the needs are.

Q: Describe how you prepare to work with a commercial client.

A: I sat down and determined everything that I needed to know about a client for a general type of job and created a form. We started out with a form and we've used that for a long time. We don't use it much anymore because the person answering the phones knows what she is doing! There are very specific things you need to know. It drives me crazy when we're doing a job and nobody knows how the image will be used. For digital, you have to know how they're using the image. Is it for their Web page, is it going to be a printed piece, or is it going to be a trade show graphic? You don't want to go back to your client asking these questions later.

I mean there are times we actually get the job in here and we find that's not what the guy talked about. And we do have to call him back up and say, "Ok, let's start over, I see that we have this problem, how did you want to fix it?" So you have a secondary set of questions, but you want to come off as being intelligent and capable.

Q: What is the best way to handle conflict with a client?

A: There's a simple question you want to ask yourself, "Do you want this client?" That's the first thing you've got to ask yourself. "What's the client really worth to you?" The previous example of the new client, we really want his product, we really wanted this client, and we really wanted to do this. I had to reshoot his product three or four times to get what he wanted if I didn't do it the first time. Then there are clients who come in and we literally will send them on their way. You know the type, they say things like, "You don't have to charge me sales tax; we can just let that go." Do I really want this client? I'm fortunate to be in a situation where I can say I don't want to deal with this client.

In this time that we're in right now, you want to keep your clients. You know the old adage, it's much easier to keep your client than to get another one, so we're going to go under the assumption that we want to keep them.

I go back to that other adage, that the client is always right. I remember a few years ago, I was shooting for this ad agency. They called me up one day and said, "You just sent us this invoice, and we really need to cut a thousand dollars off of it because of this and because of that and because of this . . ." And I said "Sure, no problem, I'll send you a new invoice today." I've had this client for fifteen years; I'm going to have this client for fifteen more years. You learn to work with them so if there is a conflict, you erase what the problem is, and you take care of it.

New clients? It's a little different because you have to judge again if you really want that client and how far you're willing to go. There is that point where you'll feel that you're being used and you will stop talking with them.

Sometimes it's nothing more than a misunderstanding of what they thought we were going to do or what we thought they expected us to do. So you've got to keep that communication open. We've done jobs where we've literally delivered the jobs and they've said, "This isn't what we wanted." Sure you can sit there and say, "You sent me a comp and we copied your comp, so this is exactly what you wanted, what's wrong with you?" That client is gone.

You don't have to be submissive, you have to say, "We looked at your comp, this is what we thought you wanted, we tried to do this, what do you expect us to do now? Where do you want us to go? Do you want us to reshoot it? Can we retouch it to make it work for you?" Sometimes you can actually get them to understand that their comp was terrible and we misread it. You learn from that by deciding next time this client sends you a comp, you have to make sure you understand what he's drawing!

Q: So you start conflict resolution with what went wrong, then you ask where do you want to go from here?

A: You also need to determine whose fault it is. If you blew it, there's nothing better than accepting responsibility. The client is going to love you. I'm a prideful guy; I think I do a good job among everything else. But I will admit pretty quickly if we screwed up. If it's not your fault, you have to discuss it with them and try to get them to understand why you misread their comp. It's that communication again. It always comes back to communication. If you're just starting out, you're going to bend over for the clients, and you're going to do whatever they need until you can . . . replace them with a better client."

Q: How do you keep commercial client's loyalty?

A: I have always felt, and I mentioned before, it's much easier to keep a client than to find a new one. I'll give you an example: I used to shoot for the largest running shoe catalog in the nation. We shot for them for six years. And during those six years we went through several catalog managers. We'd shoot 60 days a year for them. We lost them because vice presidents changed and they went to their own sources. It's not our fault that we lost them. But we kept them as long as we did by doing things correctly. When clients come to us we want to know:

1. Why are they coming to us?

2. What do they not like in their previous photographer?

If you can figure these two things out, it gives you an idea of what you can do to retain that client. I am dumbfounded at some of the reasons people leave their photographers.

My secret marketing plan is bullet proof. Anytime clients are in my studio, they get lunch. Now that sounds really stupid, but we have had clients tell us they have spent 8 hours in a studio without ever stopping. In my studio, we ask what they want and order lunch. We sit down, all of us including my employees, and eat lunch for an hour. Let me tell you what happens during that hour, what makes it work. All the tension is broken; you are up there sweating and trying to get this job right. Suddenly you stop, and you have a break. The other thing that's amazing is you sit around this table and just talk about things—the dog, kids or grandkids, your car—and if you're smart, you let the client do the talking. What happens is you become a person to them. I don't want to say friend but you find this common ground. You become a person, an individual with a personality and all these dynamics happen because all the pressure is off!

Q: *For the client, this turns you into a person instead of just a vendor, doesn't it?*

A: Yes! I have clients who of course have come to me for years, and they know this and expect it, and we have the hot sauce they like here and all of that. But clients who come for the first time, and we say, "Would you like to stop and have lunch with us?" They say, "Yes, sure," and you know, that lunch doesn't show up anywhere on their bill. I mean it's a $4 sandwich from the deli for crying out loud. I've had clients walk out of here and say, "Hey, thanks for the sandwich," and you want to say, "But how about the good photos?!"

Marketing to Consumer Clients

Just as you would for commercial clients, you always need to begin with your *Marketing Message*, a statement of the work you are selling. When you identify the work you want to do, it is simpler to target prospective clients.

For consumer photographers, it is both a visual marketing statement and an identification of your particular subject area. Consumer clients will gravitate towards promotion that reflects their subject need (i.e., portraits might be marketed as *children's portraits* or *family portraits*). Wedding photography comes in different styles and packages. Like the commercial photographers, your marketing message must be consistent throughout all print and electronic promotions.

THE BALANCE OF PERSONAL AND NON-PERSONAL

The primary difference between commercial and consumer marketing is the balance between the personal marketing (selling) and non-personal marketing (advertising, direct mail, and public relations). For the commercial photographer, the emphasis is on personal marketing because it is easier to identify prospective clients and knock on *their* doors. For the consumer photographer, the emphasis is on more non-personal marketing tools, such as advertising or direct mail. These tools broadcast your marketing message and bring the clients to *your* door.

Unlike the marketing plan for commercial clients, which assumes you can knock on a client's door, marketing for consumer clients usually focuses on non-personal broadcasting of your marketing message. Because they are more difficult to target, it has been customary to use tools such as advertising, public relations, and now Web sites to broadcast your marketing message and bring the clients to you—then you can sell your consumer photography services to them. You could always buy a list of commercial clients but it was not easy to buy a list of people *thinking* of getting married and needing wed-

ding photography *in the future*. List management has embraced new technology, and you can now buy that list!

Who are your consumer clients? From the discussion in chapter 5, they can be any individual who hires you for photography services for personal use. The usual suspects are your wedding and portrait clients but they can be so much more—for example: team sports, school events, family events. Also, consumers are very likely to want both the still and moving image so you can add videographer services to your marketing efforts as an additional profit center.

Even though you can now effectively do more direct non-personal marketing (such as stamp mail or e-mail promotions) you will still need to look at the bigger broadcasting aspects of your marketing plan. You need to bring the potential client to your door with advertising, Web sites, and public relations promotion campaigns.

PLANNING YOUR BUDGET

Since you will need to spend money to accomplish this, you will start with planning your marketing budget. The marketing budget is a matter of simple math. After establishing your personal goals and requirements, and figuring a breakeven analysis, the overall consumer client marketing budget will be about 10 percent of your projected gross sales. *Projected sales* means look at what you want your sales to be, not what they have been. You want to move forward and not stand still or slide backwards.

Why use a percentage for planning your marketing budget? Because there is no magic amount of money you can budget for spending. Because the tools you use, the market position you take, your sales goals, and the maturity of your business all will determine the amount of money needed for effective marketing. For example, if you want to buy lists and ad space, you will spend more money than if you stay low-key with mailings and phone calls. If you have a brick-and-mortar building as a studio, you will budget and allocate for marketing much differently than a home-based business. If you are just starting out, you will take a marketing position and spend less money than someone well-established.

REFERRAL MARKETING

Wedding and portrait clients respond very well to the referral or *word of mouth* marketing techniques, so your name recognition is very important when planning marketing promotions. Name recognition is the process of taking your consumer client from where your name has no meaning all the way to having a certain comfort level in your name. Remember, in photography, clients cannot exactly *look before they buy*. To get hired to photograph a memorable (no do-over possible) wedding day, that client has to have a lot of trust and faith in you. In consumer marketing, name recognition lends a certain credibility that could give you a competitive edge. Consumers are faced with many choices for wedding and portrait photography and will often hire a name they recognize. Referrals combined with your overall marketing can make that happen.

REPEAT YOUR MESSAGE

Repetition is the key to recognition. Research from Direct Marketing Association (*www. the-dma.org*) still finds that it takes between six to sixteen repetitions (exposures) of your marketing message to bring a consumer client to a comfort level with your marketing message. In other words, repeating the message brings credibility and trust for the client that, yes, you can be trusted to photograph the most important day of his or her life (weddings, christenings, Grandpa's 95th birthday, etc.). Because people can only retain about one third of what they hear and see, your prospective clients will need to see and hear your message a minimum of eighteen times (six exposures multiplied by three). So the frequency of your marketing message repetition needs to be calculated into the budget, the timing, and your marketing plan for the consumer client.

To make sure your message gets repeated without getting ignored, you will need to depend on a strong diversity in your marketing mix. You can't just run the same advertisement eighteen times. Variety of your message exposure is the key to building frequency. For the consumer client, your marketing mix choices will include:

- Display advertising

- Free listings

- Web site

- Referrals

- Personal selling (consultations)

- Public relations

- Entering competitions

- Hosting events

- Professional association membership

- Promotion pieces and portfolios

- Buying lists

- Direct mail

- E-mail marketing

- Retail connections

THE RETAIL CONNECTION

All of the items on this list are discussed in this book's many marketing technique chapters but I would like to highlight the last one, retail connections. This is a marketing tool you can set up that uses a retail outlet as a channel between you and your consumer

client. A retail outlet is literally a store (brick and mortar or online) where your potential clients are already shopping for goods and services. Your challenge is to find the best retail match to your marketing message. For children's portraits you would look to high-end children's clothing stores or boutiques, furniture stores, specialty toy stores, and children's gyms. For wedding photography you can connect with wedding planners, venues, caterers, cake stores, florists, jewelers, and invitation designers. Think outside the box! For mother and newborn portraits or pregnancy portraits, you can contact a local gym offering special pregnancy exercise classes.

In each case you are looking for a business that sells goods and services on a retail level to make a connection for you. You can barter store (or online) display space for your business cards and promotional pieces in exchange for discount coupons for their customers. You can offer to give them beautiful display prints for their retail space (with your name prominently displayed) in exchange for their permission-based mailing list. In every retail connection, you are using the company to gain access to potential clients already in the market for services—including photography—targeted to your marketing message.

THE NEVER ENDING CYCLE

Of course you will never stop marketing, even after you feel you have reached the magic number of exposures. Truth is there is no magic. Marketing to consumers is a never ending cycle of repetition of your marketing message to your target audience. Over time, you may shift your emphasis given to the mix and put more time, money, and attention into one area over another, but you will always be marketing.

Much like the commercial photographer must do, you identify your type of photography (target market), identify the clients (target demographic), and then plan how you will reach them. You will use broadcasting tools (such as direct mail and advertising) and plan on frequency of contact to develop the recognition that brings response. It is client response that brings the work and success with your self-promotion.

CASE STUDY: ANDY MARCUS, FRED MARCUS PHOTOGRAPHY (*WWW.FREDMARCUS.COM*)

Q: What has been your key to marketing strategy?

A: Our style has always been the key to differentiating us from everybody else around. The biggest part of this is the consistency and the quality of work that we do, something other studios seem to lack. People come to us because they know that they will have beautiful photographs and they know that we will handle their wedding as if it were our own.

In this business you can't be an absentee owner. When clients call, they want to speak to the owner. I've always found that being here and being available for our clients

has led us to greater success as opposed to a photographer who was not around. You need to be at the studio, you need to make sure that what's coming in and what's going out is fantastic quality, and that the service that you have is ultimate service. The service that we provide our customers is above and beyond; *we under promise and over deliver.*

Q: What are you working on for marketing?

A: Today it's a whole new electronic age, and brides are looking for pictures they can put on Facebook. You have to be aware of current trends in photography and how you get your images out there for more and more people to see. People hire us from all over the world. We just did a wedding in Australia. They came to us through recommendations and through our Web site. It was a wedding for 600 people at the Waldorf Astoria and it was a fantastic wedding. I credit our very high-end Web site and staying on top of things when the clients are requesting information.

 Our current Web site is completely different from our previous one. It's much more interactive. We have Facebook pages, Twitter pages, a blog now. We will be able to have all our clients' photos online. When I calculate this considering the amount of business we do online, I'd say within three years I'd pay for the entire Web site just from that alone. We're going to be doing some new and interesting things like a bridal registry, so instead of guests buying them a pot or pan or a knife they'll be able to actually purchase photographs from our Web site. So the bride and groom can register for their photography! It's a cool thing because clients want hundreds of photos in their album, but they can't always afford it. This way guests can pay for a part of the album or pay for a large portrait for their wall. There's no guarantee that just because you put up a fancy Web site you are going to get business. The only thing that you can do to get your name out there is do the best possible work, have the best customer service, and then you have somewhat of a shot of doing well.

Q: How do you feel about referral marketing for this type of client?

A: Referrals are still my biggest thing. If you do a good wedding, you may get two or three referrals from a bride. If you do a bad wedding, your name will be mud in two seconds. You always have to do well, there's no excuse for not doing it. To me doing wedding photography is a tremendous responsibility that is given to you by a bride and groom and their family to record one of the most important days of their lives. It's not the easiest thing to do; it's not just instant money. If you're not going to produce photographs that are wonderful and brilliant, that capture the day . . . you're not going to be in the business for too long. It's all about the quality and producing something that's special.

Q: How do you handle pricing and keeping clients?

A: I lose weddings because of price; some people think we're too expensive and are looking for a bargain. Today a lot of photographers are almost giving away photographing just to sign a contract, which, in my opinion, is not the smartest move in the world. We've held our prices; we explain the value clients are getting in the services we offer. If I cut

my prices in half, I could do much more business, but you can't recover from that. I'd rather hold my price; people understand there is a difference in quality. No, I will not book every single wedding, every single bride that comes in. But that's okay! I'm here to do a certain level of work, for a certain level of clientele, the high-end market that I've dealt with for the last thirty to forty years. A lot of people hear about us and they come in curious. I know right away we're not going to get the wedding, but they leave talking about us. They will say, "I wish I could afford them," and someone else might say, "I think I can afford them, let me go see them," and this is where it's good getting your name out there.

You want only the best; don't cut corners. That's why you shouldn't be embarrassed about charging for your work. Because to provide the best, it costs money, and people understand that. We're looking for a certain quality of bride and a certain level of bride and of wedding, and we're trying to keep that level going by giving people exceptional customer service. I have a staff here of eighteen people, and so far I haven't let anyone go, even in this economy. I need every one of them to do what they do to be able to keep this business going. That's really the bottom line.

Marketing on the Internet

In every workshop I give, someone asks, "How important is the Internet for marketing my work?" Keep in mind that the field of Internet marketing is still relatively new technology compared with all the years of print marketing photography services. From the photographers I have consulted with, most agreed that the Internet is an addition to the marketing mix and does not replace any other marketing tool. We are all still learning from our failures and our success stories.

It is, however, no longer a question of *do you need an Internet presence?* The better question is *how should you present yourself on the Internet?* Everyone wants to be on the Internet but you need to know where you are going and why. Is your audience in the consumer market for photography (weddings, portraits)? Or are you seeking the attention of commercial clients? Do you want to sell your work as assignment or stock images? What is your expectation of visitors to your site: to contact you for more information? Call you for jobs? Sign up to be on your mailing list? The first step is to know your audience and then set some goals for a presence on the Internet so you can get your Web site designed with these goals in mind.

WHERE TO PLACE YOUR WEB SITE

As an overview to the more technical discussion below, your Web site should be a true hybrid and work as an advertisement, as a portfolio, and even as a lead development tool. The usual goal of an ad is to make an impression and get the photography client to respond for more information. Your Web site should bring clients in, capture their attention, and then show them what to do next (it's an ad!).The usual goal of a portfolio is to deliver your marketing messages. With thumbnail photos and text description, prospective clients can click to their area of interest (it's a portfolio!). When you have a way to identify the people that respond, you can build on that response (now it's a lead develop-

ment tool!). You should also be able to add ten images to your site in less than ten minutes—a good measure of site effectiveness.

You will probably be best served by having a page on a portfolio directory site with other professionals *and* having a site of your own. Existing online sourcebooks and photography directory Web sites have the advantage of handling all the marketing to bring the traffic and get clients to come to the site to then find your page. Building traffic, as you will see below, is an often underestimated task. It is actually very time-consuming and expensive to build traffic to a site. These existing sites have already registered with the major search engines, market by direct mail, and are listed in all the client print sourcebooks. With your own site, you will do all the work to promote your Web site and get clients to come and visit. With both your own site and a page on a portfolio directory site, your Internet presence is assured. You can build marketing equity when clients get to know your name, your work, and return to visit both sites. As with any of the traditional marketing tools, success is based on the frequency of these multiple exposures to your marketing message.

Web sites can give you a competitive edge or be a marketing black hole. Just having an Internet presence does not replace the need for the basics of marketing. You must first have a compelling purpose for clients to visit your site and define what you are selling. Second, you need to identify your client base and how they make photo-buying decisions. Third, you must look at factors that will help them make the decision to work with you. Only when you know the answers to these three basics will you be ready to hire a professional Web site design service.

A Web site is not just a digital version of your promo piece or portfolio. The electronic medium is different from print use yet I still see many sites obviously scanned from printed pages and thrown up on the Web site. With today's fast-moving market and changing technology, you really do need to work with a design professional or service with at least a few years of success in Web site and page design.

Note the use of the word success, because simply having years of design experience is not sufficient. You need to work with a firm that has happy and satisfied Web site clients! To find a Web site designer, start with members of your local ad club or chapter of AIGA (American Institute of Graphic Arts). Look at Awards Annuals such as *Communication Arts Magazine* (*www.commarts.com*) for their Interactive Annual for Web designers and the work these designers are doing.

Maybe the best option is to work with a service that can offer packages for Web design services. Firms such as liveBooks offer professional photographers Web site packages that incorporate marketing and management solutions. Michael Costuros, Founder/VP Special Projects at *www.liveBooks.com*, explains why working with an independent Web designer or creating your site yourself is not a good idea.

"In my opinion, you should go with a company that specializes in providing portfolio Web site services rather than use a do-it-yourself solution, or hire an independent Web designer. Many of our new clients are photographers who

have invested a lot of time and money into an independent Web designer who over-promised and under-delivered. These days there are very few, if any, independent Web designers or small Web shops that understand enough about SEO, branded design, intuitive navigation schemes, and the coding necessary to create the Web site editing administration system that makes it easy to update your images. All of these skills and more are necessary to have a Web site that truly meets the needs of a professional photographer. Even if you cannot afford the best solution on the market, the cheapest portfolio Web site service provider is better than starting from scratch with a Web designer, or building it yourself. Even if a cheap solution, like Flickr, does not provide your potential clients with a professional viewing experience, you will at least be able to update and edit the image portfolios yourself, which is a fundamental key."

BETTER WORKING WEB SITES

Your Web site pages need to download fast. Prospective clients—consumer and commercial—do not have patience for five seconds of downloading; they will give up and go away. Also, the intuitive navigation from page to page and the way you keep people inside your site needs to be simple and easy to figure out. Both are fundamental rules!

Many photographers assume fast broadband and computers make up for bloated page download times. Big companies with hundreds of employees sharing a T3 line can deliver individuals download speed lower than home DSL. In addition, the move to Internet access using a cell phone or smartphone may slow things down.

Make sure that your site displays properly using multiple browsers: Internet Explorer, Firefox, and Safari at a minimum. Don't assume that the client can display larger than 1024 by 768 pixels. Make sure that your Web pages print properly too, to both color printers and monochrome laser printers. Avoid designing pages in which the margins get clipped off during printing, or the text is illegible due to size or lack of contrast, or the size of images overflows printer buffers. For image protection, use lower resolution images on your site; they are faster loading and a less likely target for theft. You can also use image watermarks, embedding your copyright information and photo credits. Use PNG or JPG formats and avoid RAW files.

Navigation is a tougher issue. Put a link to your contact information, your home page, and your bio page on every page. Keep the navigation intuitive; don't make the client guess where to click. Unlike printed books (title page, table of contents) there are many different ways to organize a Web site, and the lack of a single standard gets in the way of clients using your site easily. If your site is very large and spread out, try using a site map to guide a client's navigation.

Use a site logo to display your company name clearly. Discuss with your designer using a favicon (favorites icon) with your company logo. Web browsers will add this branding tool when displaying your site address.

Your site's navigation also helps users and search engines. Make sure the links on your site use the keywords that are mapped to them. This tactic also should be used for any global navigation on your Web site. Navigational links that appear below the page header and provide a trail for users to follow back to starting/entry points are another great tactic that allows users to easily move between different levels of pages on your site.

Your contact page should include all of the various ways to reach you. Clients have different levels of risk of personal contact they are willing to make so choice is important. Include your phone number, e-mail link, fax number, and mailing address (not your home address). Many people print out your contact information so be sure the page looks good when printed on a monochrome printer. Consider adding a form clients can fill out to increase the requests for more information on your photography services.

Update your site on a regular basis. Clients won't come back to a Web site unless they know it is going to be different. If you can't keep updating with new images, have a *news page* you can update monthly with client projects or self-promotion images. Another option is to link to your blog as your news page since the blog is much easier to maintain.

Flash-designed Web sites sometimes encourage garish and pointless pages that revolve too rapidly or change continuously. If you are only using Flash animations to attract attention, then beware; it rarely works and you want the attention focused on your images not the Web site design. If you use Flash, add a *skip this* option so clients can get to your images.

You may want to add traffic-logging software that tells you which domains your visitors came from, how they moved through your site, the search words they used to get there, and if they arrived from a search engine. Check out *Google Analytics,* it is a free tool that will tell you everything you need to know about your site traffic. Evaluating this information will help you update your Web site on a regular basis to be more effective.

Legible and printable text is another design issue; I have seen dark-blue text on a purple background, dark red on a black background, grey on a white background, and lots of different colored text on busy patterned backgrounds. Don't make it harder for clients to read text that's nearly the same shade as the background or gets lost on the background. A good Web designer will deal with these issues or you can go to a service like liveBooks for predesigned or custom designed sites.

ADD USEFUL INFORMATION

To make your Web site more than just a showcase for your photography and give clients a reason to come back, try adding useful information (content). You can write the pieces yourself or hire a copywriter. Some examples of interesting and useful content on photography Web sites: *Bridal Guide* for a wedding photographer or *Trade Show calendar* for a product/industrial photographer.

Prospective clients are always interested in the *back story* of the image and this will give you an opportunity to talk about the benefits of hiring you and will add key-

word content to your Web site—not for every image on your Web site but a select few that have a story. Yes, users can see it is a beautiful family portrait but who are the people? How did they find you? Why did they hire you? Where was the photo taken? What factors came up when creating the image? What technical problems did you solve? Show the image and tell the story; there will always be something you can say about an image.

As we discussed in previous chapters, give clients options for responding from your site and offer a clear *call to action*. This will not increase your search visibility, but it will help clients respond by telling them what you want them to do. For example: call for consultation, e-mail an RFP (request for proposals), get on your mailing list, or refer a friend.

Fancy or plain? Depends on your target audience. Your consumer clients (brides for example) are accustomed to sites with fancy slide shows and music. Your commercial clients are looking for information and how you can help them. In both cases, your site is not designed for pure entertainment and fancy artwork rarely makes any difference. You need to deliver value and information to people visiting your site. Use clearly written text, images focused on your marketing message, and clearly labeled links that spell out exactly where they will take your visitors without taking them away from your site.

DRIVING TRAFFIC TO YOUR WEB SITE

Perhaps the most important and inexpensive strategy is to rank high for your preferred words on the main search engines in organic or natural searches (as opposed to paid ads). Search engines send robot spiders to index the content on your Web site so begin with steps to prepare for optimal indexing.

Include your URL on stationery, cards, estimates, invoices—everything! Make sure that all your printed materials, promos, stationery, brochures, literature, and e-mail signature block contain your company's URL. And see that your printer gets the URL syntax correct. In print, omit the http:// part and include only the *www.domain.com* portion.

Write a descriptive title for each page of five to ten words and remove as many filler words from the title (such as "the" and "of"). This page title will appear hyperlinked on search engines when your page is found. Entice searchers to click on the title by making it a bit provocative. It also shows on the address bar at the top of your Web browser. This title is nearly *your entire identity* on search engines. The more people see that interests them in the hyperlinked words on the search engine, the more likely they are to click on the link to your Web site.

Follow this with a description and keyword meta tag. The description should be a sentence or two describing the content of your Web site and using the main keywords and key phrases. If you include keywords that aren't used on the Web site, *you will decrease the effectiveness.* Your maximum number of characters should be about 255; just be aware that only the first sixty or so are visible on Google, though more may be indexed later. Every Web page in your site should have a title and meta description tag.

For the keywords meta tag, take out the common words and include the most meaningful words and phrases. Though the keywords meta tag is no longer used for ranking by Google, it is currently used by Yahoo! and Bing, and other search engines may consider it important.

Use different keywords for different pages or portfolios on your site. Develop several Web pages on your site, each of which is focused on a different keyword or key phrase—for example, a separate Web page for children's portraits, family portraits, and senior portraits. These pages will rank higher for their keywords since they contain targeted rather than general content. Choose the most relevant and highly queried keywords that potential clients are searching on. Google offers a number of free tools, such as Google Trends (*www.google.com/trends*) and Google Insights for Search (*www.google.com/insights/search/*), to aid your keyword research.

Submit your homepage URL to the important Web search engines that index the Web. Look for a link on the search engine to "Add Your URL." At the time of this writing, the most used search engines are: Google, Yahoo!, MSN, Bing, and Ask.com, and some of these provide search content to the other main search engines and portal sites. Because of this, it is usually not cost effective to pay another company to submit your site to hundreds of search engines.

SEARCH ENGINE OPTIMIZATION

Google has enhanced its search engine's capacity to index Adobe's Flash files, which are very popular on the Web but tricky for search engine spiders. Google's search engine can now index external content that a Flash file loads, such as text, HTML, XML, or Flash content itself (but only if designed using the latest Flash). Links to your site from other sites bring additional traffic, and since Google and other major search engines consider the number of links that point to you (link popularity) as an important factor in ranking, more links will help you rank higher in the search engines. Check out the free listings offered by Open Directory Project (*www.dmoz.com*), Yahoo!, About.com, and Business.com. Beware of link farming—the practice of linking sites solely to increase link popularity score. Google hates link farms and labels the links they generate as spam. In fact, Google hates them so much that some sites get removed from the index if they're affiliated with link farms, so be careful! For photography-specific sites check out all the associations you belong to, the creative sourcebook sites as well as free local community online directories.

You can increase your Web site's visibility when you write articles in your area of expertise and distribute them to editors of online newsletters. Just ask that a link to your Web site and a one-line description of your photography services be included with the article. This is an effective viral approach that can produce dozens of links to your site over time.

Michael Costuros (*www.liveBooks.com*) shares one of the keys that make live-Books sites rank so well in search engines: "We keep our clients up to date on the latest

SEO tips, and make it easy for them to give every image on their site a title, description, and keywords. Having a lot of information attached to each image is one of the keys to a successful SEO strategy. "

SOCIAL MEDIA AND THE UBIQUITOUS BLOG

Is social media bringing a change to the business and marketing of photography services? Does every Web site need a blog? How can these tools actually work for you? Social media is a very different means of marketing, one that you join and participate in rather than direct and control as you can with your traditional marketing media. New technology and the changing and developing expectations of your clients are driving this change. So many photographers have a blog and a Facebook page for marketing today; you will want to take a look at social media before you dismiss it. If you do take it on, you will need to be willing to commit the time to it. You can blog, you can have your Facebook page, you can have a Twitter account, you can have a YouTube channel, but they all have to work together. If you offer excellent content and regular industry commentary, people are likely to link to your social media, increasing your overall searchability. As with every major technology change to hit the business of photography, it is up to you to figure out how to adapt and leverage these new tools into new marketing resources. You can use social media tools to create a network of information about you and your photography. Every site should have links to the others. Potential clients who are interested in working with you can dig deeper by finding your links to LinkedIn, Facebook, and Twitter on your Web site and learning more about you. Ultimately, it is still about *relationship selling* but now in a different media.

As we go to press with this chapter, your choices (in addition to a blog) for social media marketing and new technology for interacting with clients and potential clients include Facebook, Skype, YouTube, Twitter, and LinkedIn.

CASE STUDY: MARKETING WITH YOUR WEB SITE, GIL SMITH (*WWW.GILSMITH.COM*)

Twenty-seven-year photo veteran Gil Smith is an internationally recognized advertising photographer specializing in high-action automotive and sports-industry images. Gil is currently one of Canon U.S.A., Inc.'s prestigious "Explorers of Light," a small group of professionals chosen to push the boundaries of existing film, digital, and printing techniques.

Q: When did you launch your Web site and how did you come to select liveBooks (www.liveBooks.com)?

A: I launched my first Web site in 1995 as part of an artist's group led by graphic designer and Creative Director Joe Spencer with an Internet group called *www. opticnerve.com*. I soon went to Network Solutions to register *www.gilsmith.com*. I worked

on several different designs on the Web with various Web consultants and experimented with what was then an emerging medium.

In 2003, I launched a site designed by graphic designer Michael Standlee of the *www.standleegroup.com*. We did this as part of his development for a new Web design class at Orange Coast College (Costa Mesa, CA). It was a beautiful site. We were written up in magazines and received many positive comments about its form and function. What it lacked was a way to edit and modify the message easily. The students who wrote the script became unavailable, so updating was also closed.

I saw the liveBooks' promotions and met some of the principals from liveBooks at an APA Seminar in Los Angeles. They provided the missing link from my previous Web sites—the script for editing and updating. At that time liveBooks was in 4.0 and working on 5.0. We have now worked together for the past two years and I am looking forward to many more years of participation with them to market my work.

Q: How often do you update your Web site, and how does it tie into any other marketing (ads, postcards)?

A: I update every few weeks. I don't keep a strict timetable. I usually go there when I have several new collections of photographs. I will do this in the quiet time without interruption. This way I can reload the site and play it until I like the pacing. I am currently adding digital video pieces to my offered services and integrating this into my photography Web site.

The postcards and/or direct communications to specific clients is a constant drum beat of effort with moments of flourishes when my research has found an interesting client and/or project to propose and estimate. Due to my successful marketing, I am making proposals to clients directly for entire programs for marketing and advertising (unlike my earlier years as a new photographer in advertising).

Q: What recommendations would you make to a photographer looking to get a Web marketing presence up and running?

A: First, register the name for the new site. Browse the Web for sites that you like and write down the reasons that you like visiting those portals. Evaluate these observations and try to answer these questions: Will this feature work to market my work? Will I be able to build and maintain the site easily? Your first site might be designed through iWeb or liveBooks.edu (about $99 per year). There are also several Web portals that can create links back to your home site that are very important for your own Web site search engine optimization such as Facebook, YouTube, MySpace, flickr, and others. I feel that each individual needs to experiment with these portals and simply make choices based on your desire to be a contributor and have fun with it.

Q: How do you feel about your past marketing efforts?

A: There are many tools available to the photographer today that didn't exist when I first broke into the business. My aims today are also different from my aspirations as a young

gun. As a young shooter, I admired the work of both Art Kane and Bert Stern. I also thought that their images and personal contacts with impressive artists of their time gave me a great course to follow. In those years, we also believed that paid spreads or multiple spreads of your work in sourcebooks such as *The Black Book* was comparable to reaching the marketing pinnacle.

Q: What are the big changes you see today?

A: What was true about marketing then in principle is still true. One must make a sincere effort to continue with "a picture is worth a thousand words." The vehicles to spread that word have changed. Today, I consider this eco-friendly self-promotion because I use the Internet extensively for marketing. My liveBooks' site is now the centerpiece in place of doing the previous 2,500 letter mass mailing (the old fashioned type with a stamp). I also do selective and customized e-mail marketing that does not appear as spam. Finally, I am developing editorial work for specialty magazines that carry my byline as part of my updated marketing strategy. A total immersion in the pursuit of the work is something that I must demand of myself to be considered for the next big job.

SECTION

3

Researching New Clients

Once you have decided on your specific marketing message you can then start researching for new clients or developing leads. The marketing message comes first because when you know what you are selling and who buys it, it provides the direction for your research.

You will look for new clients in two phases: the primary research to build a leads database and the secondary research to upgrade and maintain new lead development. For photography clients, it is very important to use both steps. It is especially important because commercial and consumer photography is dependent on reaching the right audience, and you want to be certain you knock on the right doors. Marketing to a photography client who does not buy the type of work you want to do is a waste of time, money, energy, and attention. In addition, the rejection factor is very high.

You will use a combination of directories and databases for this research. While commercial photographers can research both to knock on *clients'* doors, the consumer photographer is more dependent on marketing for developing leads to bring prospective clients to *their* door. New technology today is changing this factor, and though there are still no good directories for finding consumer clients, you can now research databases for this information. For example, consumer photographers looking for leads on people that want a family portrait can buy databases that will give very good leads for that type of work.

PRIMARY MARKET RESEARCH

Some of the directories you will be able to afford to buy, but most of this research for commercial photography clients will be done at your public library or online. The business reference section and librarians will be most helpful when you can tell them what you are looking for. After a visit to the library you can do the rest online.

From manufacturers to advertising agencies to book publishers, there is a directory for every market for commercial photography services. Many of these reference books are now available on CD or you can download the information for making sales calls or mailing labels. Some of them even offer online subscriptions to their directories,

Look specifically for directories that have some kind of qualifier for a company to be listed in their directory. When you are looking for new clients, you want to work with the highest level of information possible. Some directories will list book publishers simply because they exist, while others will list only book publishers that answer an annual survey of what kinds of photography assignments are available (and this is better qualified research).

ADVERTISING AGENCIES

When looking for advertising photography clients, there are two ways to research prospects. One, you are researching advertising agencies based on the type of clients they represent, which will dictate the type of photography they buy. For example, food photography is purchased by an agency with food clients. Even subject categories as broad as people or product photography can be broken down into specific client types. For leads on people photography you will look at ad agencies that have service sector clients such as healthcare, financial, or insurance. For product photography, look at agencies with manufacturing clients such as computers or electronics. True, you do see people in computer advertising, but when doing primary research you are taking your best guess at the most likely leads for the work you want to do.

Two, you can sell your personal style to an advertising agency and this kind of research is not specific to any industry or subject category. You can make an educated guess, however, and take a close look at agencies with consumer advertising clients and ad agencies winning creative awards as more likely to use style in their advertising photography.

Examples of directories: Standard Directory of Advertising Agencies (*www. redbooks.com/*) and Adweek Directory (*www.adweek.com/directories*).

CORPORATE CLIENTS (ALSO CALLED CLIENT DIRECT)

These are just a few of the dozens of directories that list the names of companies to develop into photography leads. Watch for more qualified information, such as a Chamber of Commerce or a trade association directory (the client has to be a member to be listed). Again, the value of this level of information is that it weeds out the less aggressive companies not doing marketing and leaves you with firms that are actively promoting their products and services. What can you guess from this qualifier? If they have joined these groups, they are probably doing more marketing and promotion and need more photography.

Examples of directories:
Standard Directory of Advertisers (*www.redbooks.com/*)

Chamber of Commerce Directory (use the county chamber in your area)
Brandweek Directory (*www.adweek.com/directories*)
Services Directory/Manufacturers Register (*www.thomasnet.com*)
Business Journal Book of Lists (*www.bizjournals.com*)

DIRECT MARKETING

Direct marketing agencies are firms that are responsible for the design and production of promotions—primarily direct mail. Since so many companies have found direct mail more cost effective than some forms of print or electronic advertising, millions of dollars in marketing budgets have been taken away from print ad budgets and given over to direct marketing agencies. This is particularly good for catalog and other consumer photography projects. Books like *The Directory of Major Mailers* are available on a CD so you can search by company name, industry category, or geographic area.

Examples of directories:
Directory of Major Mailers (*www.majormailers.com*)
Direct Marketing Marketplace (*www.dirmktgplace.com*)

EDITORIAL/MAGAZINES/PUBLICATIONS

Though the photo fee rates are usually fixed by the publication at a page rate, many photographers pursue editorial clients because of the credibility of having published work, the contacts they can make with the advertisers, and the creative freedom to pursue their personal style.

Be sure when you pursue editorial clients you have thoroughly read and reviewed copies of the publication so that you are familiar with the magazine's own style—what they call their *focus*—since this will dictate the direction of their photography needs. Some are cutting-edge; some are conservative; know what the magazines are looking for before you knock on their doors.

Examples of directories:
Standard Rate & Data Service (*www.srds.com*)
Gebbie Press All-In-One Directory (*www.gebbieinc.com*)
Gale's Directory of Publications (*www.gale.cengage.com/title_lists/*)
Editor Publisher (*www.editorandpublisher.com*)

GRAPHIC DESIGN FIRMS

Graphic designers and graphic design firms are wonderful clients for photographers. Like ad agencies, they work with the projects a company wants overseen by an external creative source. Like editorial clients, they work very collaboratively with their photographers and often use the photographer's perspective for the project. Their photography projects often have extensive photo shoots, such as an annual report, catalog, or a Web site. Sometimes their photo needs are regular and seasonal. Though more difficult to

research and less visible than an ad agency, they are very good clients for repeat business—for both stock and assignment photography.

Examples of directories:
The Workbook (*www.workbook.com*)
DesignFirms (*www.designfirms.org*)
Core77/Business Week Design Directory (*www.designdirectory.com*)

PAPER PRODUCTS/BOOK PUBLISHERS/RECORD ALBUM PRODUCERS
Paper products are a subject-specific marketing message client but also great for stock or conceptual photography sales. This includes publishers of calendars, greeting cards, posters, and other novelty products. In this market category, photography projects or assignments are often purchased on a small advance plus royalty payment plan. Be sure to have your personal attorney or a reliable agent look over any contract before you agree to the use of your work.

Examples of directories:
Photographer's Market or Writer's Market (*www.fwbookstore.com*)
Association of American Publishers (*www.publishers.org*)
WritersNet (*www.writers.net/publishers.php*)

BUYING DATABASES AND LISTS INFORMATION FOR LEADS

The first consideration in any database research and list buying strategy is to define your audience. Precisely who are you selling to? The more precisely you can define your market, the better you'll be able to buy the best database or mailing list and the better your response will be.

Buying information based on researching the way clients behave (behavioral database) is always more expensive than the purchase of a simple address mailing list (demographic database), but the quality of the information is usually better targeted for your work. The firms listed below are just a few of the resources available for the purchase of information. The databases are compiled from telephone surveys, credit card purchases, magazine subscriptions, association memberships, job title, household income, and number of children in household—just to name a few. Two excellent resources for researching consumer lists are the SRDS Direct Marketing List Source™ (*www.srds.com*) and the Oxbridge Communications National Directory of Mailing Lists (*www.mediafinder.com*). A good source for commercial work is *www.adbase.com*.

Before you buy from a database firm, ask a lot of questions. Unlike using a directory in which the information has already been compiled, buying a database is based on a profile *you will create,* so the database companies will compile—with the greatest possible accuracy—the list of potential client names. Here is a good checklist of questions to ask before you buy.

1. What is the origin of the list?

2. What is the minimum purchase?

3. Does the list include actual photo buyers or merely inquirers (who are of less value)?

4. How old are the names on the list?

5. How often is it updated?

6. How often (and how recently) has it been cleaned of non-deliverable addresses?

PARTIAL LIST OF RESOURCES FOR BUYING COMMERCIAL PHOTOGRAPHY LEADS

- ADBASE Creatives (*www.adbase.com*)

- Agency ComPile Web site (*www.agencycompile.com*)

- The Workbook (*www.workbook.com*)

- Constant Contact *(www.ConstantContact.com)*

- ArtNetwork (*www.artmarketing.com*)

- The List (*www.thelistinc.com*)

PARTIAL LIST OF RESOURCES FOR BUYING CONSUMER PHOTOGRAPHY LEADS

- Target Marketing magazine (*www.targetmarketingmag.com/*)

- InfoUSA *(www.infousa.com/)*

- USADATA *(www.usadata.com/lists.html)*

SECONDARY MARKET RESEARCH

Once you have finished your primary research, here are some additional resources and new areas of research for developing leads for your photography business.

Every day in the newspaper (print or online) business section, you will find news released by companies that includes: new products, expanded services, changes in personnel. Any of these are opportunities for you to get in the door with your photography services.

Check in the periodicals section of your library reference or online for trade publications. You'll find magazines for every possible industry and trade. These publications, much like newspapers, include news releases that are specific to the area of photography you're interested in. You may even want to get the information to subscribe in print or online so that you can use them for contacting clients for photography services on a more regular basis.

Trade associations often have a membership directory you receive upon joining, and it may be all you need as a source of new business. If you do not know the trade association your prospective clients belong to, check the resource book, *The Encyclopedia of Associations* (*library.dialog.com/bluesheets/html/bl0114.html*), that lists tens of thousands of industry groups. Whether it is travel, food, architectural healthcare, there is an association for companies that are more qualified for your leads. By joining you know they are aggressively pursuing new business. When companies aggressively pursue new business, you can safely suspect they need photography services and they are the better leads.

Trade show exhibitors need photography and every industry also has some kind of annual trade show. The value of this research is that they are pre-qualified for buying photography. Many companies in today's economy choose not to participate in their own industry trade show. You can make a good guess that the ones that do participate will need more photography for brochures, flyers, CDs, and displays than their competitors that have decided to stay home. Check out *www.tscentral.com* and *www.tradeshowweek. com* for tradeshow information. At this writing, many trade shows are shifting to the virtual world, but they still need photography for marketing materials!

Editorial calendars are essential when researching any kind of publication for editorial photography clients. The editorial calendar identifies the issue-by-issue articles for the year. Knowing the articles the magazine is writing means knowing the photos it will be buying. Keep in mind magazines work three to six months ahead of publication date (shorter timeline with online publications). With the information from the editorial calendar, when you approach the publication you will be able to reference your work to a specific need it will have for photography for an upcoming issue. You can get the editorial calendar by calling the advertising sales department and asking for a media kit but most commonly today you will go the magazine's Web site to look it up. Remember, you are still in the research stage (not selling anything yet) so you do not need to talk to a client or decision maker to research an editorial calendar.

Awards annuals are good for research when you have a very strong visual style; you'll find that these clients who buy style tend to win the creative awards in their industry. If a client used a strong photography style once, he or she is more likely to do it again! Research these clients by reviewing advertising and design industry award directories from trade associations and from publications such as: *Communication Arts* magazine (*www.commarts.com*), *Applied Arts* magazine (*www.appliedartsmag.com*), and *HOW* Magazine (*www.howdesign.com/designawardgalleries*).

NEW TECHNOLOGY RESEARCH

RSS Feeds can be a good source for keeping up-to-date on potential clients. Rick Thues, owner of iMentor (*www.theiMentor.com*) says, "Really Simple Syndication (RSS) has changed the way we communicate. RSS originally stood for Rich Site Summary and was designed to publish excerpts or headlines of frequently updated Web entries like blogs, news, video logs (vlogs), or Podcasts. Once you subscribe to an RSS feed, new entries are delivered to your computer automatically." RSS is a great way to take the pulse of an industry, subject, or topic. It's like skimming the headlines and drilling down into the article for more detail when something catches your interest. You are looking for new products, new services, and new people—opportunities where there will (eventually) be a need for new photography. Current sources for free feeds include *www.feedzilla.com/rss.asp, www.wikihow.com/Find-RSS-Feeds-on-the-Web*, and *www.newsgator.com*.

Computers for Your Business Management and Marketing

Not only will you be using a computer for creating images, photographers also need to use computer programs to run a business most efficiently and effectively. Many photographers use a separate computer for the business side. Software programs used for business rarely need the power or memory of the imaging programs.

If you are short on time and patience when it comes to learning what you need to know to make a smart computer purchase, hire a consultant. Not only can a consultant help you with the initial setup but also they will be able to hold your hand through the inevitable problems and glitches. Problems are inevitable. No matter the choice, Mac or PC, you are buying equipment that will make your life both heaven and hell. Don't expect anything different!

GET PROFESSIONAL HELP

When seeking a consultant, look for someone industry specific. It is helpful if your consultant is (or was) a photographer and understands the business. Most important is to find someone you have good chemistry with and someone willing to take panicked phone calls from you at two in the morning. Make sure he or she has lots of experience with your choice of hardware and software and plenty of background in small businesses that sell professional services like photography, design, or art.

Interview as many as possible; remember short-term pain (interviewing time) will always bring long-term gain (someone who will really work well with you). Look for someone who knows tech but speaks non-tech. Though you don't want to know what he or she knows, you want to know what they are doing to your computer and why. Try networking through your professional peer associations and social media networks for referrals. Take advantage of someone else's hiring-a-consultant learning curve.

BETTER MANAGEMENT OF YOUR BUSINESS

First, evaluate your type of photography business management needs. For example, a studio shooter with lots of production-heavy assignments is more likely to benefit from materials and equipment inventory control software programs than an editorial shooter who works on location. If you are planning extensive stock photography management, you will need filing, research, and captioning programs. When you work completely on your own, an integrated program that does multiple tasks would be a time-saver. For example, when you are invoicing clients you can access their addresses out of the client contact database. Individual software from different manufacturers for each of the above functions may not share information so you should be careful.

Second, there are the hardware and software decisions. Decide on your software needs first. The machine, the hardware, is just the equipment. The software—individual or integrated—is the real workhorse of your system. Beware of buying one manufacturer's hardware with another manufacturer's software already installed. This is a marketing trick on the part of the hardware company to get you to buy their machine. You may end up unlikely to get the technical support you can plan on needing from the software company—you didn't buy the program from them!

The biggest decision you'll make is whether to buy an integrated software program (from $2,000 to $3,500) that will perform functions in all the below areas. The main advantage is that the information (for example, for an invoice) is accessible from within other areas of the program (such as the client database). It's not a small thing to consider. Non-integrated software programs (from $75 to $750) are cheaper, but then you'll find yourself doing very time-consuming tasks such as retyping a client's name and address for each function or exiting one program just to find a client's e-mail address.

There are four major areas of software programs for your business: business planning, marketing and selling, bookkeeping, and accounting, and one that does it all.

BUSINESS PLANNING
One important function to look for when buying software is the development of a business plan. Later you'll be writing a marketing plan for your photography business. But marketing is only one aspect of a business plan. Look for a program that includes templates for spreadsheets, production planning, goal setting, and the financial statements that are all critical aspects of business planning. This will be especially valuable should you need to approach a bank or financial institution for a loan or credit line.

SOFTWARE CHOICES
Here's where your software choice is the most critical and gets the most daily use and workout. A database program is essential to organize and maintain client contact information. A word processing program that will *mail merge* with the database and print mailing labels will also allow you to send personal and custom letters for sales, quotes, and follow-up. These *contact management* programs assist with both client prospecting

and maintenance by keeping track of names, people, addressees, contact dates, types of contacts, and dates for the next contact.

The days of paper-only files are long gone for keeping track of information on clients and prospective clients. There are many different software programs, for both Mac and PC systems, available for contact management. Selecting the best one for you is not as easy as a word-of-mouth referral or what's on sale this week at the local software warehouse. You have to balance a purchase you can grow into with the need not to outgrow it too soon.

You should be able to easily search your client database for any field of information. For example, you want to talk to every food client you talked to in May who said to call back in September. You should be able to sort the information as well. In the above example, a zip code sort allows you to talk to people in a geographic order. Then, when you make appointments, you are not driving from one end of town to another or calling someone in a different time zone when they are at lunch.

USING DATABASES

There are two basic directions to go with the database part of the contact management program. The first direction is to buy a program that has a pre-existing client profile form and fields of information. Many word processing programs now come with their own database programs. This is great if it is your first database and you can simply input the client profile information from your index cards into the existing fields (a field of information is anything you want to retrieve later, such as addresses, phone numbers, or dates of client contacts). This takes less time at the front end in the set-up, but generally is less flexible.

The second direction is to buy a program that requires you to design the client profile form (sometimes called a record or a template) and specify both the fields and layout of the form. More time at the front end in the start-up, but it will be exactly what you want. Either way, with any typical database form, your client profile will look something like the following example. A colon following a word creates a *field* and allows that information to be searched sorted and retrieved.

ALPHA: (allows alphabetical retrieval for firm names like John Smith & Company, at this field you would type "smith")

FIRM:

ADDRESS:

CITY: STATE: ZIP:

FIRST NAME: LAST NAME:

All of the fields of information allow for printing mailing labels or merging with a word processing program for personal letters. Keep in mind: the postal service requires the last line of a mailing label be the zip code, not the name of your contact!

You can also add fields such as below.

ADDITIONAL: (usually additional contact name, such as a secretary)

PHONE: (always use area codes for search and sort functions)

DIRECT LINE:

MOBILE:

FAX:

E-MAIL:

WEB SITE:

DATE LAST: (date of last contact)

TYPE: (type of contact—phone call? appointment?)

DATE NEXT: (date for next contact)

The below are optional fields, but very useful for managing the information in your photography client database.

JOB TITLE:

TYPE OF CLIENT: (manufacturer? ad agency? magazine?)

SOURCE: (research? referral?)

PRODUCT: (usually a code, such as "f" for food clients)

PROJECT NAME: (for follow-up and estimating purposes)

REMARKS: (where lead came from, or any other comments)

STATUS: (usually a code to distinguish current versus prospective clients)

Designing the form or record for the above *client profile* is critically important for future follow-up. Selling your photography services is not easy but it can be as simple as managing the information on *what* clients and prospective clients need and *when* they need it. For example, you can call prospective clients, sorted by zip code, so when you're on the west coast, you are talking to the earlier time zones before lunchtime. You can call all clients you talked to in January that said to call back when you had a new product promo piece. You can mail new promo pieces to just the prospective clients that saw your food photography portfolio. You can mail a different promo piece to magazines and corporations. All from one form!

PUBLISHING PROMO PIECES

In addition to the contact management function (which is essential) you can look at the option of using desktop publishing software for the production of marketing materials. You can create newsletters, project announcements, and copy for printed and electronic promotions, even brochures. Multimedia software programs can be used to create portfolio presentations that include video, graphics, and text with your images. Even if you do your own production, continue your relationship with a graphic designer for your marketing materials concept and design. Let him or her help you make the most of your investment in computers and software with his or her expertise in these areas. Poorly produced materials will actually cost you more in lost business than the cost of working with a professional designer.

BOOKKEEPING AND ACCOUNTING

A financial software program is a necessity and no longer an option. The functional and laborsaving benefits far outweigh the costs. Some of these functions are incorporated into integrated programs specifically designed for photography businesses or they can be purchased as an "à la carte" program. Either way, using this software will be as simple as using your business and personal checkbooks. It is done on your computer. When you make a deposit or write a check, your screen looks exactly like your regular checkbook and checkbook register. Whether you choose an al la carte or integrated program, look for these features:

- Writing and printing all checks
- Categorizing expenses for these checks

- Recording deposits and any other transactions typical of a check register

- Reconciling checkbook in about $\frac{1}{5}$ of the time—to the penny!

- Memorized transactions for repeating the same payments

- Splitting one check into different expense categories

- Finding a transaction by keyword, check number, or date

- Net worth statements

- Profit and loss statements

- Transaction statements by category, payee, or date

- Creating budgets to track money in and money out

- Ordering these bookkeeping supplies

- Preparing for tax time

- Online banking and transfers

WHEN TO START

If you start at anytime but the beginning of your tax year, you may need to enter all the transactions, checks, and deposits up to that point in order to be able to use the reporting and searching functions effectively. But check with your accountant first to see if it will be worth the effort. Reports generated from this software help you make good business decisions and you will also save hours of time every week and month spent on managing your finances.

ONE THAT DOES IT ALL

You can look at fully integrated software programs combining all of the above needed functions. These programs can help you in the management of the production of photography assignments as well as your business. They are more expensive than any "à la carte" programs, but remember, the data entered once can be then used in any application. Look for these specific features if you consider buying an integrated photography management software package:

- Appointment scheduling with daily, weekly, monthly, and yearly at a glance views

- Photo equipment inventory database

- Suppliers and vendors database

- Supplies and props inventory database

- Automatic data backup

- Stock photography management

- Client records with sales history and response tracking

- Mail merge with a word processor and print letters

- Mailing list management and labels

- Correspondence, thank you letters, and cover letters

- Add your company logo and URL to all forms

- Project management by job and organized by due date

- Photography delivery memos

- Industry standard photography estimate and invoice forms

- Accounts receivables and payables management

- Cost analysis for jobs that tracks costs, supplies, and rep's commissions

- Sales reports sorted by any field selected

- Profit and loss reporting function

BACKUP AND ANTI-VIRUS

It probably does not need saying but I have heard enough horror stories to bring it up, you must add good anti-virus and good backup software to your final package of programs for business computing. Why anti-virus software? Because the bad guys really are out to get you. Why backup software? Because every hard drive will die eventually, and it will always do so at the least opportune time.

Steps to Selling

No matter how great you are as a photographer, at some point you have to talk to people. To get appointments, close a sale, follow-up, all involve personal contact with your clients you might not feel comfortable doing. After all, if you were good at talking with people, you would probably have been a salesman, not a photographer! You may have the greatest Web site or direct mail campaign, but you still have to communicate with clients. Unfortunately, this is not a skill most photographers learn in school. Communicating with clients shouldn't be done without some preparation because you want to make the best use of your time, get more information about what clients want, and have the best chance to be effective. If you are happy with the amount of business and the type of photo jobs you are getting, stop reading here. After all, if it is not broken, don't fix it! This chapter is for those of you who want to get *more* out of each contact you have with a client.

In this chapter, we will look at the usual obstacles to making the sale and tools to overcome them. Some of these stumbling blocks include: finding the will to be persistent, making better submissions, motivation to make the call, handling objections before they come up, getting the name of the person in charge, and presenting your portfolio to reduce rejection.

Some of the tools you will find useful and ready to put to immediate use include: the rule of 3, phone etiquette, asking better questions, how to close the sale, and dealing with voicemail. Do any of these sound familiar or desirable? Then you are ready for this chapter!

FINDING THE WILL TO BE PERSISTENT

Persistence comes from conviction, and conviction comes from knowing your message. Start with your strong marketing message when you are preparing to sell yourself and your work. Photographers sometimes use the terms *direction* and *marketing message*

interchangeably. In order to sell your photography you need to be as certain as possible that the person you are selling to is interested in your work. To do this your marketing message identifies *what* you are selling and *who* buys it. Whether you are looking at a portrait client, an ad agency, a publisher, or a corporate client you will always approach them making a match between what you are selling and what photography the client is buying. This will give you two important benefits: better qualified potential clients and less rejection during selling presentations.

THE RULE OF 3

Selling is not marketing, and lots of photographers confuse the two. Selling is *personal promotion,* all the one-on-one contact it takes to make a sale. Marketing is what you think of when you combine selling with such *non-personal* promotions as advertising, publicity, e-mail, direct mail, and Web sites. So selling does not stand alone. A marketing plan that includes selling will give you the Rule of 3: repetition, recognition, response.

Repetition requires you to repeat your message and to be persistent, but you cannot imagine calling a client over and over—so don't! The different marketing tools at hand give you a variety of ways to repeat your message.

Recognition requires you to keep a consistent marketing message throughout all your promotions as you repeat them to build this recognition. You want people to be able to see your promos, your e-mail, your Web site, and say, "This is the photographer I want to work with someday."

Response only comes with repetition and recognition of your marketing message when you are seeking work from potential clients, galleries, reps, and others.

MAKING BETTER SUBMISSIONS

First, follow any published submission guidelines. I realize this is obvious but as a photo rep I always get a handful of queries every month that clearly do not follow my published submission guidelines. Also, be sure to check if the submission guidelines indicate their buying is seasonal, so you are in the right place at the right time. Always find out exactly what submission format is required. The traditional submission is a cover letter explaining (briefly) your work, your desire to be considered for representation or portfolio review (depending on whether it is a rep or client you are addressing), and what will happen next (the follow-up). Also, be sure to keep your client database up to date even if it means hiring someone to make the calls. Not having a current and correct contact will slow down your progress and increase your rejections.

SCRIPTING FOR CONVERSATION ETIQUETTE

Poor conversation manners and etiquette have kept more photographers out of the photography business than any lack of talent. There is no lack of talent out there, but

one-on-one contact with people that can make or break a sale for you is a big gap in photography teaching. Nor is it a natural trait: no one is born with good conversation etiquette.

Whether this is an online or phone contact, *scripting is a selling technique based on good conversation etiquette.* I teach this to close the gap between you and your goal of selling your work. It is not a new sales tool. What is new is applying the technique to photography. You may feel you should know what to say—after all, you are the photographer—but writing everything down (scripting it) will guarantee you good conversation etiquette. It will seem odd at first but once you try scripting you will wonder how you got along without it before!

Basically, scripting is the back and forth conversation with clients prepared with care because you want to make the best use of your time and their attention and because you want to get more information about what clients need and have the best chance to get your work in front of them. It is simply writing down the expected interaction between you and your client (wedding client, corporate photography buyer, magazine, or ad agency). Adaptation is the key. Once you write the basic scripts, you can adapt to any phone or online situation from print sales to licensing queries.

You need to do a careful, thorough preparation, just as you would prepare before going out on any photo shoot. Start by writing down the conversation from "Hello" and write it just as you would like it to go. Be sure to plan for all variations. In other words, no matter what the response, you have anticipated an appropriate reply. Sometimes it helps to write your scripts as you see below or you could write them as flow charts. Use any technique as long as it gets you to put words together in a way that works best for you and your client.

Scripts do not have to be elaborate but they do have to be planned ahead and written down with all possible responses (yours and the photo buyers') indicated. It is simply a matter of thinking through what you want to communicate and what you want to learn from the other person. You will find your communications and presentations not only easier, but also more effective. If you have ever completed any phone call or meeting and thought afterwards, "Why didn't I think of that? Or, "Why didn't I mention my new portfolio?" then scripting is your answer to better conversation etiquette.

THE MOTIVATION TO MAKE THE CALL

Without a goal, there is no motivation. What is your goal for each personal contact? What do you want when you approach potential clients or reps? Is it for them to visit your Web site? Give you an appointment to view your work? Meet you in person? Look at your CD? Discuss representation? Get a referral? Before you write any scripts, send any e-mail, or call anyone, educate yourself and know everything about their photography needs. For example you can go to their Web sites, subscribe to trade magazines, browse stores where your potential clients shop, and watch social media sites and blogs for trends. Information creates motivation.

HANDLING OBJECTIONS

Always use open-ended questions in your scripts to keep objections and rejections to an absolute minimum. These are questions that begin with *how, who, what, when, where,* and *why* instead of closed questions that begin with *can you, could you, would you, do you.* Handling objections means you are encouraging your client to consider what you are saying—to take a moment to think—instead of automatically replying with a "No." It helps you to gather information, saves time, and reduces the rejection that comes with the "No" you often get when you ask a closed question.

GET THE NAME OF THE PERSON IN CHARGE

Your objective is simple. You will make the phone call to get the name of the true client, the person in charge of buying photography. You can also look this up online in any of the research from chapter 9. Since this step is still research and not selling, it is very easy to delegate to your marketing coordinator or studio manager.

You can start by using the below role-play scripts to get the most information with the least amount of effort. It is very important to prepare ahead for even the simplest verbal interaction. You do not want to waste time or to frustrate a client because you don't know what question to ask. Be sure to be specific as to the type of photography work you are looking for (this is your marketing message) so that you will get the correct contact name. You can use the variations depending on whether you are calling a company or agency of some kind. You can even use job titles if you have the correct title information in advance.

Here are examples of a phone call script for finding and qualifying new client leads.

You: "Hello, my name is (your name) from (your company) and I'm just updating our files. Who is in charge of hiring for (fill in with a specific type of work) photography?"

Answer: "Mary is in charge."

You: "Hello, my name is (your name) from (your company) and I just need information on your company. Who is responsible for hiring the (fill in with a specific type) photography services?"

Answer: "Mary is responsible."

You: "Hello, my name is (your name) from (your company) and I'm just updating our files. Who is the art director for the (fill in with a specific client name) photography?"

Answer: "Mary is the art director on that account."

After you get the name, say "thank you" and hang up! The next step is to get that person to look at your portfolio. If you have been successful getting the name and the portfolio review all in one phone call, keep doing that, but usually you will find a higher level of success by simply separating the two steps.

With the name of the contact person in hand, you can now decide how to proceed, based on your marketing plan. You can approach the person to get a presentation of your

portfolio or you can get some important piece of information. The name of the prospective client and decision maker, the buyer of photography services is the key. Get that first!

GET AN APPOINTMENT

Open this script by asking for the contact by name. When asked why you are calling, answer with a brief and specific description of your photography and request to show your work. You: "I am a nature and landscape photographer and my name is (your name). We are interested in presenting our portfolio for your corporate art photo collection; when would be a good time to make a presentation?"

Break this down. The first key phrase is *"nature and landscape,"* because this helps the person you are calling to visualize your work and more accurately identify his or her interest in seeing your work, much more accurately than if you had simply said "I am a photographer." The second key in this script that opens doors is to use the phrase *"when would be a good time."* Too often photographers say "can I come by" or "is this a good time" and these closed questions lead to pretty immediate rejection. Asking a more open-ended question gives you more options in terms of reducing rejection and having a conversation.

GET INFORMATION

No matter how the client contact person responds, there are only two real paths to take: "Yes, now" or "No, not now." In other words, you will either get to present your portfolio (in person, online, or sending it—any way you can) or the contact is not interested *at this time*. I trust clients to clearly respond with interest because it is a positive feeling and they need you. It will sound something like, "Yes, let's take a look" or any variation on, "Now is a good time."

It is the other response that can be confusing for both clients and photographers because it is a negative feeling. Many people you approach have trouble giving a response that is rejecting or discouraging and will often make deferring comments such as "in a meeting" or "can't come to the phone." *This really comes down to the same thing* and you can safely interpret as, "No, not now."

In any case, when you don't get a positive response to getting your work seen right now, I suggest treating the situation as a, "No, not now," because it gives you a place to go from here. After all, what would be the value of responding to, "No, not now," with "Thank you, goodbye"? The answer is no value at all and a dead end.

When you hear (or interpret), "No, not now," you can turn to a list of specific items of information you want to acquire. You can have more than one goal when approaching your photography clients and prospects but never hang up the phone or leave a meeting or client contact without achieving some specific objective. Yes, it would be great to get an appointment or commission or presentation *on the spot* but that is not always likely. Having a second goal *is* necessary to avoid rejection and keep you moving forward.

For example, at this point you can ask any one of a number of open-ended questions:

- When would be a good time to check back for an appointment?
- How do you feel about a follow-up call in three weeks?
- Who else is reviewing portfolios of photography?
- What are your current submission requirements for portfolios?
- How often does your company work with photographers?
- How about for now I just send my mini-portfolio for you to keep?

Because getting any piece of information qualifies as a success. When you are successful, you will stay motivated to do this for yourself and for your photography business.

"BUT WE ALREADY HAVE PHOTOGRAPHERS WE WORK WITH!"

This objection comes into play when you are dealing with anyone who gives you the standard line, "But we are happy with the photographers we are already working with." Usual sales technique tells you to ignore the objection and proceed, but I have not found too many photographers willing to be that hard-sell. Remember, the most important thing in scripting is to be prepared for any personal interaction (phone or e-mail) so try this technique. You can't meet your primary goal to get a presentation and avoid rejection so you need to follow through with a secondary goal. Make this script about the relationship and not the client's photography needs at this time. Not every client/photographer relationship is an entirely happy one so at this point try one of these questions when stopped with this objection.

- How often do you evaluate the services you are receiving?
- When is the next review of the photography services you are using?

PRESENT YOURSELF TO BUILD FOLLOW-UP

This step does not have any specific scripts because there are no canned portfolio presentations. Every time you present your work you are customizing the presentation to the situation. But it is a good idea to prepare an introduction, some benefits of working with you, better questions to ask, and a conclusion to end the presentation with a strong follow-up.

INTRODUCE YOURSELF

Have an introduction that helps clients focus on who you are and what you do and why you are there. The best introduction is to simply recap how you came to them and why

you are asking them to look at your work. Keep it simple and short; think of this as re-introducing yourself even though you already did so to get the client to see your work in the first place. A strong, clear instruction helps the client focus on you, your work, and why you are there.

BENEFITS OF WORKING WITH YOU

Present your images from clients' perspectives of the value to them, not the image itself. Don't talk about what the image is; they can see *what* it is. Talk about the *why, who, how*. You don't need to talk a lot or about every image but be prepared to have something to say to help the client decide to work with you. The image will sell itself but it doesn't say enough about you. Clients tend to hire you for how you think, how you solve problems, and how you put the image together. These are called the *benefits* of working with you. Come up with something interesting for at least half of the images in your presentations. This will also be good information to use when writing copy for your promos, Web site, and e-mails. After all, you are often competing with photographers the client already knows and feels familiar with so why should they want to work with you? Give them good reason—be irresistible.

Also be prepared for tough questions. In fact, you should hope they ask these questions because your answers allow you to bring out the benefits of working with you! If clients aren't asking you about price, experience, other clients you have worked with—all the hard questions—then they are not very interested in working with you at this time.

BETTER QUESTIONS TO ASK

Remember your open-ended questions. For example, when showing your portfolio, ask some of these open questions to get information, to confirm their interest, and to take it to the next level. This is a consultation, not just a presentation. Please note, these questions totally depend on the type of client you are presenting to, so be sure to adapt as needed.

- What work are you featuring in upcoming advertising?
- How often do you review for different photographers?
- What upcoming photography needs do you have for your marketing?
- When will you be looking at costs on that Web site project?
- Who else do you know works with this type of photography?

As you are packing to leave, ask for a referral with an open question, "Who else do you know who may need food photography?" Again, use your marketing message (food photography) and be specific.

CONCLUDE THE PRESENTATION WITH A STRONG FOLLOW-UP

This is your chance to conclude this client contact or presentation with a follow-up you and the client agree on. Your presentation goal is to develop follow-up because it is the follow-up where you will get the work. This is not your traditional sales close but more of a conclusion. Once you begin the process of selling, then follow-up is the answer to the question, *what happens next?* This step requires a careful and tightly constructed script. Choose any one of the below questions to conclude your presentation, meeting, e-mail, or phone call. Always be the one in charge of the follow-up. It is not the client's job. Here are some good questions to create follow-up:

- When should we get together again?

- What work would you like to see more of?

- When should I call you back about that project?

- How about I give you a call next month?

- How do you want to keep in touch?

- When should I send more information?

- How do you feel about an e-mail follow-up?

Be sure to leave behind some type of promotion material for clients to keep on file and to help them remember what you can do for them. Find out first what clients prefer—CD? Postcard? Inkjet print? Probably something they can keep on file. If you leave any contact with a client without a follow-up agreement or decision you have made with them as to what happens next, then you *do not have any follow-up.* It is always the photographer's job to create the follow-up that continues the relationships that lead to the work.

DEALING WITH VOICEMAIL

Often you will deal with a voicemail in between some of the above selling steps. Voicemail allows you to leave a clear, specific message and allows clients to work without interruption and deal with all the phone calls they get at a later time.

Because your voicemail message is heard as one of many incoming calls, it is important to have a single and simple goal: get the client to listen to the end of your voicemail message. To do this, start your voicemail message with the *"what"* and not the *"who."*

For example, this is not a good voicemail message: "My name is Maria, I am a photographer, and please return my call." Not only do clients not know who you are, they don't know what you do or why they should bother calling you back. Also, they don't have any verbal way to visualize if they are interested or not.

Try this, "I'm calling regarding your nature and landscape photography needs, and when you are ready to see this type of portfolio, please call back. My name is Maria from Creative Services and I can be reached at (then repeat your area code and phone number twice)." Yes, you can replace the phone number with your Web site address or e-mail but *only if* it is impossible to have it misunderstood (watch letters "s" and "f," for example, because they sound alike over the phone).

When you must make phone calls, this useful technique is easy on clients and less stressful for them because they only need to call back *when they need your type of photography.* If they don't return your call, you can safely interpret their lack of response as "No, not now."

Packaging Your Cost Proposals

All photographers run into the same wall at some point—pricing photography services. It is not about what to charge, it is asking for the money that causes the problem. There is something about that much-anticipated yet dreaded question, "What do you charge?" that causes many photographers to flinch in dismay. There are probably a dozen psychological reasons for this feeling of vulnerability. Rather than take on the feelings behind pricing your work successfully, let's look at specific actions and steps you can take to improve your behavior towards pricing.

THE BIG QUESTION

The first step to getting paid what you are worth is to quote a price both you and the client can live with and profit by. This process begins when prospective clients or customers ask the big question, "What do you charge?" To start with, they are asking the wrong question and must be stopped and corrected.

There are two meanings to this question, and you may not know yet which clients are asking. The first meaning is that they really do want to know, "What does it cost to shoot my job?" What you need to do here is turn the client away from the use of the pronoun *you charge* to talk about what *it costs*. This will increase your objectivity and professionalism. In this case, you go on to get a complete project description to give them a cost for *it*—the photos or the use of the photos.

The second meaning is that they *don't* have a job at the moment, but would like to know what it would cost to work with you when they have one. With the increase of price consciousness among clients, this is a great concern. It is also very difficult to answer. How do you quote a job when you do not know what the client wants yet? The best solution is to understand that clients are really asking for a way to *measure you* against other photographers. Day rate cannot answer their question for several reasons. Day rate is not

an accurate measure of photography cost, as it does not include expenses. Day rate does not transfer usage rights, the real sale in selling photography. Day rate implies employment and you know the client does not want to employ you.

Your best bet is to prepare some simple measuring devices to use when clients want a price, *but don't have a job to quote.* Try using a price range or asking them to describe a typical job or even pricing something they like out of your portfolio—anything to give them your measure.

For the best reference guide on copyright, usage, and pricing guidelines for both assignment and stock photography, see *Pricing Photography, 3rd edition* by Michel Heron and David MacTavish (Allworth Press). For wedding and portrait pricing guidelines, check with your national photography associations (another advantage of membership!).

PLUS SIZE RESOURCES

Last year, the PLUS (Picture Licensing Universal System Coalition) published the Universal Picture Licensing Glossary, a free resource providing industry standard definitions for more than 1,300 terms used in transactions involving photography and illustrations. The new PLUS Glossary is available free for use online at *www.useplus. com.* The glossary is the first component of the Picture Licensing Universal System created and approved by a worldwide coalition of art buyers, photographers, illustrators, publishers, graphic designers, advertisers, artist representatives, stock picture agents, and their trade associations. "We are well on our way to developing other PLUS standards, including the PLUS License Format and Media Matrix," President and CEO Jeff Sedlik confirmed. The PLUS License Format will allow standardized license information to travel as metadata within digital images, easily accessible to any viewer. With the PLUS Media Matrix, media selection will be quick and easy, with internationally uniform media categories, organized by type and identified by universal billing codes. Collectively, the PLUS Glossary and other PLUS System components will exist as the most comprehensive standards in the world of image licensing, creating a new, universal licensing language that is easy to understand, and easy to use. Watch their Web site for more updates and information!

THE PROJECT DESCRIPTION

When clients have a specific job request, the most important start to getting paid what you are worth is to get a complete description of the photography project. Ask what they specifically need. Ask for the number of setups, the number of views, and then the number of variations.

For example of a setup, you are looking at the background, camera, lighting, props, and surfaces. Then you look at the number of views: how many people or products (or both) are going to move in and then out of each setup. Finally, you look at possible varia-

tions: once the setup is fixed and the view is in place, how will the client want to vary the pose or the product placement? You can't get too much information! Be sure to find out how it will be used electronically or printed (for commercial jobs), as that will dictate your expenses on film vs. digital capture, scanning, and delivery media.

Ask about delivery due date but in a way that gets you usable information. This allows you to include any possible rush charges for a faster than normal delivery. Your best bet is to ask information-gathering questions designed to help the client give you objective information rather than just an opinion on the delivery due date. Don't simply ask, "When do you want this job done?" It is much too subjective a question. Instead ask for more objective and measurable information such as, "When will the Web site be launched? When is the ad artwork due? How many people need to approve it beforehand, and how long will that take?" By breaking the deadline into a series of benchmarks on a timeline, both you and your client will feel more control and more likely to meet the true deadline. Always be able to help clients motivate others in the approval process by giving them this timeline. Be a partner with your client. It is the two of you against all the other forces that can delay a job.

Ask about the usage. For commercial jobs you are selling rights to use the image and some clients can tell you exactly the rights they want to buy. But when your client isn't familiar with copyright and usage pricing, try this question, "Who will see it and what will they do with it?" This question will determine whether your photography will be a simple catalog use or a national advertising campaign use.

Ask about the budget. What were they planning to spend on the photography? Though clients won't always tell you, at least they will know that you are concerned. You'll get the information in a later step so don't worry if they won't give you the answer.

Ask how many people are bidding. Who else is giving them a cost proposal? This question will often tell you the answer to the budget question. Again, your client may not want to give you the information, but at least you'll know whether the job is being put out for bids or you are the only one.

Ask about payment. How will this be paid? Always work out all the details of deposits and payments at the beginning of a job. In consumer photography, wedding and portrait clients usually pay a substantial amount upfront to secure the photographer. Payment for commercial photographers is often related to the type and to the size of the client. The larger the company, the further away your client is from the person writing checks. When a commercial client does not know how you should proceed on the issue, ask if you can talk with the accounts payable department. Clients will probably appreciate one less thing they have to do, and the accounting department will be happy to tell you what to do to get paid in a timely manner!

At this point, you may want to get some professional help with putting together your estimate before calling the client back. You can buy different computer software programs that will assist you with the big question, "What do you charge?" For example, for more than twenty years fotoQuote has been an industry standard pricing guide for stock and assignment photography, (*www.cradocfotosoftware.com/*). With over 300

categories covering both traditional and electronic media, fotoQuote gives you the photo pricing information and negotiation help you need to get paid fairly for the work that you do. Once you have entered your information, the program will teach you how to build license agreements and negotiate more effectively from the comprehensive business information in the "Coach" section of the program.

TAKE SOME TIME

Once you have the project description the next step is to take the time to calculate your costs. Don't quote prices off the top of your head! Photography is not a product pulled down off a shelf with a price tag slapped on. Schedule calls with your clients to discuss price, especially when you don't know them well enough or don't know if you have the job for certain. Always ask when would be the best time to call them back. Often, clients have much more time than you feel they do and you do need the extra time. This will give you the chance to do an accurate cost estimate and show your clients respect for their requests of your photography services. When you call them back, you will use the script below to get some feedback on that mysterious budget figure they probably didn't tell you about before. This feedback will help determine exactly how much work you have to put into the written cost proposal they will receive from you.

CONSIDERATIONS TO NEGOTIATE

Why not just drop your price, why bother to negotiate? Because it is incredibly unprofessional to magically make money disappear, money from your profit. Because when you act unprofessionally it hurts the rest of us in the business. Finally, once you do this the client will never agree to your regular price; you will always be asked to drop your price for no reason.

You should be prepared to negotiate before you talk price. So what can you do when the client wants to pay less? Answer: you walk away or you negotiate. A great old saying is, "In business, you don't get what you deserve, you get what you negotiate." I will support you if you walk away but I do not accept the notion of dropping your price without negotiating some consideration to the project description. On any project, less money might be okay, but fairness and good business sense demand that some consideration be made before paying less.

It is a simple concept to use and explain. If the client wants to pay less, the client will get less of some aspect of the project description or you will get more of something valuable to your business. The considerations are items you and the client both agree on. Simply scripted, when the client names a price lower than what is acceptable to you, your answer is any variation of, "Let's take a look at how it can be done for that price." This has the potential to become a win-win negotiation if you can find common ground. You can always walk away if you are not willing to negotiate or the client simply can't come close enough to what you really need to charge for the work.

To create the considerations put *two lists together* in advance of any pricing discussion. One is a list of the considerations clients can make to lower the price. For example, they can get less work, different variations, fewer views, less usage (if the project is a licensing one) fewer approval stages (if the project has a long timeline). Anything you can think of that will help the client pay less without damaging the images.

If you need to, go to your second list. These are the considerations that can give you more of something from clients to lower the price. For example, you can get more time, more printed samples, a link on their Web site to yours, barter for goods and services, better photo credits, or better payment terms. Please check with your accountant for the income tax consequences to barter payment for your services.

Work on these lists before you need them and never wait until the client is asking, "What do you charge?" and the nervousness begins. Be ready. Your negotiations are simpler and easier when you have lots of considerations to choose from on both lists. The bottom line is *you do not accept less money for the same amount of work without some consideration.* You will damage your chance at a profitable relationship with clients. You will give your work away. Don't do it. Instead, look for the win-win. Learn successful negotiating techniques to get the best return on your photography and your business.

WHEN THINGS GO WRONG

You can tell clients that your price for their photography is the average, normal, and industry standard price, but if any negotiation is not going well for you, you may need to find out what is really going on with the client. One of the most common things to go wrong is when the client tells you, "I can get it for half price from someone else." To keep the conversation going, you can ask a one-word question, "How?" What you are really asking is, "How can it be done for less money?" The client will stop and think, primarily because he has not considered the question *in this way.* Because what you are really asking is, "What will the client get less of at that lower price and does he want to know now or be surprised later? "

TALKING ABOUT PRICE

Write a script to get some feedback on that mysterious budget figure clients probably didn't tell you about up front (even though you did ask). If the client does present you with a budget for a specific project description—for consumer or commercial photography—then you can work from there. But often they will not, and you should prepare a script in advance so that you can handle any direction their "how much do you charge" question takes you.

For example, ask, "From what you described, it will cost $15,000 for that amount of photography, how does that fit your budget?" The client will respond to the open-ended question with information.

Note the use of the word *it* making the photography less personal to you and then take note of the test-question part of the script: *how does that fit.* The less personal the

negotiation is the better you can handle the situation. The test-question asks clients to think instead of the more common use of the closed question you would never ask, "Does that fit your budget?"

If they respond positively, then you go forward to the written proposal. If they are negative about your price, then you go back to considerations to negotiate. Before you put anything in writing, negotiate all the considerations until you and your client agree the price is now *in the ballpark*.

NO FAIL QUESTIONS

Sometimes you will need to work harder to move the client around to your point of view. When you have a difficult situation in which you need the client to be on your side, try *no fail* scripting. It is subtle but very effective. Always start your sentence with the statement, "Since I am sure you want," name something you know the client wants, then finish with "here is what we can do." For example: "Since I am sure you want an accurate cost on this photography project, here is the information I need first," or "Since I am sure you want all those family portraits to be displayed properly, here is the estimated framing cost."

Sometimes you feel pushed by a client to do something you do not want to do. It may be some compromise of your work, the delivery time, production details, or even your price. Most photographers fold at the first sign of resistance to cost and will never get the price they want, but you do not have to do so with a good script for this situation. To agree to any request a client makes, no matter how irrational or irresponsible, is not only unprofessional but potentially unprofitable. This scripting does count on your being prepared, so this is a good place to stop, take some notes, and do some homework. To set the scene, the situation usually starts with your client making some outrageous request. For example, too fast a delivery time, too cheap a frame, too little money for production expenses. From this point you have what I call *two choices with conditions*.

One choice is to say, "No, but" then present your client with a more acceptable option. The other choice is to say "Yes, and" then present a cost to the client should he or she choose to stay the course. They can both work for you. For example: "No, that delivery time will not work *but* here is when you could take delivery without rush charges," or "Yes, that frame is available *and* it won't physically stand up to the exterior hanging you are planning for this piece."

THE WRITTEN PROPOSAL—PACKAGE YOUR PRICE

Now that you and your client have agreed on a price and a project description, the final step is to create an effective and irresistible proposal. This can be the difference between getting the photography job or not. Whether you are doing commercial, industrial, portrait, or wedding photography, this meticulous and highly visual presentation of your price demonstrates your professionalism, expertise, and abilities. It will help the client or customer decide to hire you instead of a competitor. It will help you get the work because

it explains to clients the value they will get for the price they will pay. More importantly, the person you call *client* probably has to get this approved and needs something to show and help get you the job

Today, many estimates are delivered electronically, so creating a pdf file of all the parts will make sure the client sees the entire package and can't lose any of the pieces. To show you the best way to package your price, we will walk through the four parts of an effective photography cost proposal: the contract (fees and expenses), the cover letter, samples of your work, and your third-party proof.

THE CONTRACT

The contract is more commonly called the "estimate confirmation"; it is most effective to print the contract information on your own letterhead to look as professional as possible. Use the industry standard forms with customary contract law for photographers to protect you and your client. You can find these forms in the book, *Business and Legal Forms for Photographers, Fourth Edition*, by Tad Crawford (*www.allworth.com*). This book comes with a CD-ROM to provide electronic versions of these forms.

Your professional associations are also the best place to look for the support you need to make sure you are profitable with your pricing. Check out the *ASMP Professional Business Practices in Photography, Seventh Edition*, published by Allworth Press. Successful contracts start with good business practices, and organizations such as PPA, APA, and ASMP have been established to inform and educate photographers on business issues. If you are not participating in your professional peer association, start today. If you are not a member, join now for information and relationships you will need later!

It is very important to get the correct name of the person with the authority to hire you and pay you. Does your client have the responsibility to find you, but needs further approval to hire you? When you are dealing with an advertising agency or third party of any kind, be sure to get their client and project names. Ad agencies get lots of photography estimate confirmation forms and you want yours properly considered by the right people.

Since any alteration in the project could cause an increase in expenses, getting a detailed job description can avoid the problem of going back to clients for more money to produce what they wanted in the first place. You really should get any fee or expense increase approved by clients during the job.

Photography fees should include a complete statement of the use of the photos. Will these photos be used just for display and exhibition or for reproduction in an ad, brochure, or Web site? Just because your wedding, portrait, or fine art clients usually buy only the prints (real property use) does not mean they are not planning some reproduction use (intellectual property use). Ask clients what their plans are for the image use and re-use. Plan ahead!

Also, to maximize profitability, find out which budgets can be dedicated to your part of the job. Often, a fee is set aside and named as photography *but that is just one line item* on a project budget. Whether it is a wedding or a catalog shoot, technology today

allows you to do more of the imaging work. These are often other line items named in that project budget that really should be rededicated to the photography fee. Check on pre-production, research, any and all retouching, post-production, and pre-press to name a few. The money is there to pay you for the extra work; it just may not be called photography fee.

Photography expenses can only be estimated and your form should state that the client agrees to pay actual expenses. State clearly what your price includes (such as the size and number of prints) so that clients know exactly what they are getting. Don't let any expenses come out of your fee. Calculate the delivery charges, special research needed, proofs, and any possible expenses for the photography assignment. Check the industry standard forms for a complete list of billable expenses. Client approval must be obtained if final costs will exceed original estimate by more than ten percent but I think it is still a good idea to get a signature on any cost overage you may be expecting. Standard contracts state that the client will pay for any changes or revisions they make to the original job description. So, the more detailed the description, the less you risk absorbing any of these extra expenses.

The deposits or advances should be discussed. A deposit is a percentage of the total cost (from 30 percent to 50 percent) that the client pays to confirm the assignment and is common business practice in wedding and portrait photography. Commercial photographers should try to get deposits, especially on new clients and large projects. An advance is the pre-payment for the expenses of costly pre-production or travel.

For payment terms, your invoice should be paid when the images are delivered or sent to your client's accounts payable department for payment "net receipt." This should get you paid within thirty days. A late payment charge (usually around two to three percent) should be quoted on all jobs. It is customary for clients to pay any legal fees if needed to collect money from them.

Now comes the fun part, the packaging! Remember, unless you know you already have the job, you may need to give clients more than this estimate confirmation (contract) to help them decide to hire you. After all, the estimate confirmation just tells them what it would cost to hire you, but not why it is a good idea!

THE COVER LETTER
A good cover letter warms up an otherwise cold-looking contract. It will help your client (and even the client's client) decide to hire you. Here is an example of a cost proposal cover letter.

Dear Robert,

It was a pleasure talking to you yesterday! As we discussed, enclosed is the estimate confirmation on the portrait photography you need for your annual report.

In addition, we have enclosed the special black and white samples you requested based on the work you saw on our Web site. You'll find our style of portrait photography is exactly what you need. Because we have been established portrait photographers for over 12 years, you will receive the experience and expertise this project requires.

Also, when you are ready to proceed with the photography for your upcoming trade show, we will work with you to develop the "new look" you need for your company brand. Our solutions are rock solid, creative solutions that will make your job easier. We are here to relieve your corporate communications photography headaches with expert images—on time and within your budget.

I'll call next week to find out when you will be making a final decision on this job. We are looking forward to working with you.

Sincerely,

Maria Piscopo

P.S. Before you make a decision on your photography, please let me know if you have any questions or need any additional samples of our work.

SAMPLES OF YOUR WORK

Unless it is a regular client or you know the job is yours, include samples of the work estimated in the cost proposal. In this case, the client is interested in a subject expertise, portrait photography, and in a particular style, black and white.

Never assume clients will remember the work they saw in your portfolio or go back to your Web site when they are deciding who to hire. *Never assume* they will pull your promotion materials from their files to make their decision. Count on having to visually re-establish your photography credentials. Also, samples will help your client *get you* the job when they have to present your cost proposal for decision by a committee that has never met you or seen your portfolio.

THIRD-PARTY PROOF

In addition to your contract and samples, you can add credibility by submitting proof of your capabilities. This third-party proof is someone else (not you) offering testimonial to your value. It may be the deciding factor to help the client decide to hire you. More likely, your clients may need these items to certify your reliability so they can sell you to their own committee of decision makers. Examples of third-party proof include: testimonial letters from satisfied clients, awards you have won, exhibits of your photography, a list

of clients, client references, and professional organizations you belong to. Anything you can do will give you additional trustworthiness and help the client make the right decision—to hire you!

CASE STUDY: MEETING YOUR NEEDS AND THE CLIENT'S NEEDS, ANDY BATT AND THERESE GIETLER OF ANDYBATTSTUDIO, LLC (*WWW.ANDYBATT.COM, WWW.LINKEDIN.COM/IN/ANDYBATTSTUDIO, WWW.IGROUPNYC.COM*)

Q: When do you assert yourself and when do you say, "Whatever the client wants"?

Andy Batt: We run a flexible business—bend but don't break. I think you have to have this attitude to make any headway in this business. We know our overhead. We know our pricing/fee history. Often times we have a good sense of what our competitors charge. We also listen to our clients. We try to understand their position. I think the line is often drawn between helping the client out and being taken advantage of. It's always a *quid pro quo* situation—we have to get something in compensation. Whether that's a reduced shot list, a PR boost, or in-kind payment, there has to be equality to the request.

Therese Gietler: There is a very fine balance in doing this; it is practically an art form. The best way to be assertive is to put suggestions out there and let it be the project manager's idea."

Q: How do you balance project management deadlines and client budgets with doing the best possible creative work?

Gietler: No matter what, regardless of the situation, we always try to produce the best possible work, because at the end of the day, that is the only thing that speaks for us. That being said, there have been many occasions where we had no choice but to produce what we would consider 'sub-par' work because of the time we had to produce it.

One such situation is when clients decide that they want to add a day to the production to shoot their entire product line, which was completely unreasonable but we were beaten down already and said, "Fine, we'll do it, whatever." It was a product shoot with one model, and we did an endless amount of shots—the art director and I drove Andy so hard, didn't allow him but ten to twenty frames before we switched out the wardrobe. Andy and I were exhausted by the end of the day and miserable and broke. It was horrible. Andy felt like a guy hired to push the button, not hired to be his creative self.

I've actually got more stories than not in this regard. Some days, we tell ourselves that "this job is just paying the bills," knowing it will never make the portfolio. At times, when we've been hired to shoot something mundane because the end client killed all the creative layouts and watered down what was left, we'll save five minutes at the end and shoot a version for us. Typically, the clients love it because it is hilarious, the talent really

enjoys getting to play a little, and several times we've ended up with a portfolio piece because of it. Depending on how warped Andy gets, these images are sometimes included on the Web editing site, and many times, it is these creative fun shots that end up getting used. I can name several clients who went with the "fun shots" at the end. Of course, we only do this if time allows, and if the client is willing.

Batt: Part of the solution is to believe in what you are doing, and what you are charging. It's a lot of time management, the more time allowed in the budget for the work, the better the results will be. The time might be spent in pre-production and planning, or on shoot days or on retouching. It always comes down to the triangle of cheap, fast, or good: pick two. We will always deliver work that we have done to the best of our ability but that ability is guided and constrained by time and money. Many times, the creative aspect seems to be thrown to the wolves in exchange for fast and cheap.

Q: *What is involved in packaging your photography bids/estimates to make the best presentation and sell the client on hiring you?*

Batt: We have always presented clear, understandable, and transparent bids. We understand and know our paperwork, and feel comfortable and justified when we need to explain it. We steer clear of the "hidden" bid style. We've found that most of our clients appreciate not finding any mysterious line items.

We also always try to put ourselves in the position of our immediate contact at the agency/client and understand what information he or she will need to sell us to their superior or to the end client. Sometimes it's a detailed explanation of the technical aspects, or a creative summary of how the job will be artistically interpreted. It may be including three images in the bid that reference a style, or subject matter.

Our bids always include our letterhead on each page, a detailed assignment description, a detailed usage license, and our terms and conditions.

Gietler: Our proposals have been getting bigger over time, and not just because the jobs are bigger. We always write a cover letter that explains why we're the best choice, there is a conditions of transaction page, and then the estimate, then the small print, and the final page is contact info. This is a pdf, so it can't be separated out.

Over the past year or so, if I have an image of Andy's that was either used by the client for comping or related very directly, I'll add that to the cover letter. If I have enough info, I'll add a rough calendar of pre-production, shoot, post production, and final delivery dates. If layouts or specific RFP is sent, I paste that into the doc as well. I've had many compliments regarding the thorough quality of my proposals.

Keep Clients Coming Back

When you get a call for that first job with a client, there is a tendency to rush through the standard photo industry business practices and procedures. This is usually caused by the catastrophic fear that clients will change their mind and give the work to someone else. Don't let your fears overrule good business sense. The way you handle the first job and the first time you have a project or price conflict set the tone and the code of behavior for the relationship.

In today's marketplace, many photographers complain of the decrease in repeat business and the decline of client loyalty. Many clients jump from photographer to photographer looking for the best price or the latest trend.

To keep your clients coming back and paying your price, you need to become more aware of the courtship and bond in the photographer/client relationship. You need to have a plan to keep clients coming back and not just wait for it. Here are some ideas for that plan.

DEMONSTRATE TECHNICAL ABILITY

Your portfolio and promotional material will do some of this but never assume clients will understand the benefits of working with you just by looking at your work. Lots of photographers they meet have good technical skills.

One way to demonstrate your technical ability is to distinguish between knowledge and skill. Knowledge means you have learned a photo technique, and skill or experience means you have practiced it time and time again. Technical ability is a combination of both. Don't lie and say you can do something when you cannot, any deception will come back to haunt you in the future. For example, perhaps you know how to photograph a building for an annual report, but have never actually done so. Be honest, the difference is often important to clients. They will have different expecta-

tions of you depending on your accurate reporting of your knowledge and skills. Depending on the project, many clients will be willing to come back and work with you if you have the knowledge but not the skill or experience. Understand that lack of experience has never kept anyone out of photography or the business would have come to a standstill years ago.

IF YOU DO NOT HAVE EXPERIENCE

If you want to keep a client but don't have the skills and experience as the client's needs grow, you can get as close as possible. For example, you can show financial services photography to healthcare photography clients, as they are both consumer-oriented services. Even if the experience and skills you have are only similar to photography needs of the client, this will help give the client crossover to thinking you can meet his or her needs as well.

Take the time to build your portfolio in the marketing message areas where you want to keep your clients. Often the best portfolios come from images you shoot for your own self-promotion. When you don't have exactly the right product or industry experience, you can build a portfolio with self-assignments and pro-bono work. You will learn more about this in chapter 17.

Also, learn as much as possible about the client you are working with so you always have new and interesting images to show. Ultimately, being able to demonstrate your interest in the company's product or service will make it easier for the client to keep working with you.

SHOW YOUR CREATIVITY

Beyond technical ability, your knowledge and skill, and experience, the photography client will look at your level of creativity or personal style to decide to go or stay.

Your personal style is not important to every prospective client. Some clients want to know *what you bring to the party*. Some just want the job done accurately, on time, and within budget. This is a cultural difference so be sure you find out the culture or personality of the client you want to keep. This cultural perspective could vary from very conservative to very uninhibited and will dictate the level of personal creativity the client will look for in your work. You can actually be too creative for some clients. For example, corporate communications clients may love your personal work, but can't figure out how to use your unique or unusual style for their more conservative and straightforward annual report. An opposite example, you may have a wedding or portrait client that only wants to see your non-traditional personal work for their needs.

One answer is to show your straight work to those clients who want more conservative images and find different clients for your highly creative work. These could be two different marketing messages.

OFFER MORE SERVICES

Many of today's successful photographers are growing their businesses by offering additional services not before considered in the photographer's realm. Why? Because today's commercial client has more diversified and technically advanced needs. One example, many commercial clients today want video shot along with stills during an assignment. Digital advertising is replacing some traditional print ad campaigns. Also, many consumer clients will ask about video services.

BE A PROFESSIONAL

Most clients must answer to a higher power and when they hire someone who is a professional it means they will be less likely to be sorry they made the decision. Remember that assignment photography is not a product pulled down off a store shelf. The photography client has to weigh all of the factors to feel confident you are the right person to hire and keep coming back to.

The best evidence readily available to any prospective client is your membership in a professional photography association. It may seem simple but the phrase in your marketing materials that begins "member of" can give a client an extra ounce or two of assurance.

There are many other ways clients can judge if you are a professional—for example, your Web site design and how you handle e-mail, answer the phone, handle yourself during a shoot, follow-up after you've worked together, and, overall, how you continue to market your work to them. Take every opportunity to give strong evidence of professionalism to keep clients coming back. In the working relationship, consumer and commercial clients may measure your professionalism differently but all will agree a professional delivers greater value.

MEET THE CLIENT'S REAL NEEDS

Be sure to find out what specific problem this photography project is supposed to solve for the commercial client or what the real need is for the consumer client. The more accurate a statement from the client of the assignment objective, the better chance you have to meet it, and the more accurate the cost estimate, the better chance he or she will come back for more. Don't take *anything* for granted and never assume you know what the client wants—even repeat clients.

For example, a communications department tells you they want the photography for a brochure but the marketing department also wants to use the images on the company Web site (departments in large corporations don't always communicate well with each other). Another example, the bride tells you she wants all photojournalism-style photos of the wedding but her parents (who are paying!) want more traditional ceremony and portraits-at-the-altar style photos. Help *your client be a hero* by shooting the project

to meet specific goals so that everyone is happy with the end results. Be sure to listen to what the client really needs, not just what they say they want.

MAKE THEM FEEL SAFE

As a general rule photography clients will look for, and continue to work with, photographers with whom they feel safe working. What does *safe* mean? Safety is much more than the technical execution of the client's photography. For some clients it is a sense of familiarity in a studio or with you as a person. For others it is the belief you will get the work done on time and within budget. Clients will have many different definitions so your challenge to help them feel safe beyond your creative and technical ability is to find out what is important to them.

The one exception may come up when you are selling a personal style as your marketing message. When a particularly innovative client is looking for a unique style to use on a specific project, safety becomes less of an issue and style is a greater concern.

In the end, most clients are looking for relationships they can count on and depend on, and they want to know that they are making the right decision to continue working with you.

HANDLE CONFLICT BETTER

What happens when things do not go according to plan? How do you preserve the relationship, get through a conflict, and keep your clients coming back for more?

First, you must stay calm! You may feel overwhelmed, underappreciated, and in the right but when you have a conflict with a client it is best to control your emotions so you can better manage his or hers.

Second, check your timeline. For both consumer and commercial photography clients there is a nasty tendency to procrastinate on approvals and then wonder why you can't meet deadlines. Watch for yellow flags such as projects dragging on, clients not meeting their deadlines, someone going on vacation and becoming unavailable to give an approval. Go through the timeline with clients and make sure you know where everyone will be when you need them.

Third, find an ally for your cause before you need someone to support your point of view. Depending on the type of photography, it could be an administrative assistant, a bride's sister, or someone in accounting—anyone who has the project's best interests as his or her own.

Fourth, check your photography objectives and plan. What was the goal? How were you planning to achieve it? Did you meet those standards on an objective level? Is the conflict based on a more subjective issue? The more information and agreement you have on objective and measurable factors such as color, backgrounds, props, or usage the better. Conflict resolution based on re-examination of the objectives can be a nightmare through which you lose the client or a series of small steps towards resolution through which you keep the client.

Five, be firm in your resolve but flexible in your solutions. Forcing a conflict resolution without all in agreement or when resistance is high only creates more grief. You don't want to blow up a bridge you may need to cross again.

Six, ask open-ended questions to get information and avoid rejection. One of my favorite things to say to an upset client is, "I am so glad you brought this to our attention and how do you want to handle this issue the next time we work together?" Your goal is to plant ideas and act professionally, making clients expect the best of you and of themselves.

Today's competitive marketplaces justify a closer look at how clients and photographers look at their relationships and make the decisions they do. The more you learn and study the relationship between photographers and clients, the better chance you have of turning jobs into repeat clients.

WHAT TO DO NEXT?

Write your plan for keeping clients as an update to your marketing plan (upcoming in chapters 21 and 22). Look to specific goals for keeping different kinds of clients. Use the above suggestions to increase your awareness of what clients really want and give yourself a competitive edge. Add them as copy or text ideas for Web pages and promo pieces. Use them to add editorial content to your marketing materials and Web site. These suggestions are designed to help your marketing stand out in the flood of promotional materials clients receive every day. To keep clients coming back, use these ideas to be irresistible to your clients, add value to your photography services, and support the client's decision that you are the one to come back to!

CASE STUDY: KEEP CLIENTS COMING BACK, TRACEY CLARK (WWW.SHUTTERSISTERS.COM, WWW.MAYPAPERS.BLOGSPOT.COM, WWW.MAYPAPERS.COM, WWW.WARMTONE.COM) AND PATRICK ECCLESINE (WWW.FACESOFSUNSET.COM, WWW.ECCLESINE.COM)

Q: What steps do you take to handle each job efficiently (for client) and profitably (for you)?

Tracey Clark: More than anything I am sure to make myself invaluable to my clients. Going above and beyond the call of duty, being a hard worker, and being easy to work with really goes a long way with clients. No matter what types of clients I'm working with (big companies or busy moms) they always have a lot on their plates and are often juggling a lot of things at once, even on shoots. Photography sessions of any kind can bring a lot of pressure and stress for clients depending on the project.

Everyone has an objective to meet. I try to maintain a level of calm professionalism and steady confidence when I work, but at the same time I throw in some good humor and fun so that my clients enjoy working with me. Between giving my clients a good experience and great photos in the end, they usually hire me back.

As far as being profitable, I obviously try not to underbid my jobs. Even if a client only claims to need "a few photos," I still know that I put 110 percent into what I do. That's really worth a lot! I am sure to share my work ethic with my clients so that they understand that when they hire me for a big or small job, I treat them all like big jobs. It's just how I work.

Patrick Ecclesine: Efficiency with a client is very important. Time is money and money is time. If clients sense that you aren't being responsible to their time or their money, you'll find yourself hung out to dry. The flip side is the client expects quality and quality takes time. Therefore, as a photographer it's your responsibility to be very clear with the clients, to guide them through the process, to estimate how long it will take to accomplish the amount of set ups in a certain amount of time, and to deliver upon it. Your word is your bond and if they see that you're taking what you do seriously they'll know they're in good hands.

As far as being profitable goes—well that is the goal. You have to know what a shoot is going to cost at the end of the day and you have to know what you have to clear to make it worth your time and bill accordingly. Of course, the end usage determines a lot. A celebrity portrait for a national advertising campaign is going to be worth a lot more to you than a portrait of a cook for a local magazine. So you really have to understand the market and know the going rate.

Q: *How do you make sure you are meeting your client's real needs?*

Clark: I try to communicate with my clients to be sure of what it is they want. It's always good to follow up and discuss the project after the fact as well. And if clients need something that doesn't seem to fit my style or strength, I will even refer them to someone who might be a better fit. I want to be sure my clients are happy with what I provide so I'd rather stick to what I know and what I know I can deliver, not to mention enjoy doing.

Ecclesine: To be sure you are meeting your client's needs you must understand this is a business built upon communication. You have to know exactly what clients want or expect from the shoot. You have to dig it out from them and have fun doing it. Play detective: What do they want the images to communicate? What do they want it to feel like? Is the tone light or dark? Is the color palette cool or warm? Do your homework. Then on the day of the shoot, stay in close contact with your client. This is a collaboration and don't forget to check your ego at the door. Involve the client in the process and if they're good at what they do they can only help you. Make them a part of it. This will help ensure that everyone goes home happy.

Q: *What is the best way to handle conflict with a client?*

Clark: Conflict isn't easy for anyone. When I have to deal with a client conflict I just try not to get defensive. It's best to stay level-headed. I really try to listen to them and to their issue and then ask if there is anything I can do to help the situation. Sometimes they can't

really think of anything. Sometimes they really just want to be heard and understood. It really doesn't do much good to engage in a fight. It's better to take the high road. Chances are if you kill them with kindness and try to make it up to them, it will all blow over soon enough.

Ecclesine: If there is a disagreement; remember to keep your emotions in check.

Find out what went wrong, what the concerns are, and address them professionally. Remember: you're there to make your clients look good, and if you've truly got their back, then they will love you for it.

SECTION
4

14

Advertising as a Marketing Tool

Advertising is defined as planning and buying display ad space and filling it with your marketing message and a call to action. It could be a business-card-size ad or a two-page ad spread. There are two distinct advertising tools you can use in photography marketing: free listings and display advertising, and we will study each of them in this chapter. While we are talking about planning, be sure to plan a budget for your overall marketing effort, including any advertising campaigns. Good marketing budgeting standards call for an average of 10 percent of projected gross sales to be set aside each year for all the different photography marketing tools and techniques. Use projected sales (how much you want to sell) rather than last year's sales. This way you will be marketing for the future, not the past! Projected sales amount calculates as a percentage; if you plan to make $100,000 gross sales, you'll spend an average of $10,000 (10 percent) for your marketing budget.

Now that you have a marketing message and a target market for your work (from chapter 2) all your potential advertising materials need to be directed towards this message. This marketing message is the work you want to do more of (not necessarily the work you are doing now). Because it is probably the biggest expense in your marketing plan, the advertising you do must be highly targeted to your target audience.

SUBMITTING FREE LISTINGS

The quickest way to start your ad campaign is to submit for all the sourcebook free listings available to you as a professional photographer. Some of these sourcebooks are print directories with Web sites, some are stand-alone Web sites. Your photography professional association membership is the most obvious free listing. Even though it may just be on the Web site and not in print, this listing says you are a professional. Many of the professional association Web sites use pull-down menus for clients to search for different

types of photographers. Also, every client industry trade association you may join has reference books and many offer free or low cost directory listings. Many of the creative sourcebooks that also sell display ad space offer free or low-cost listings in both their online and print directories.

True, it is just a listing (no images) but many include a *specialty line* where you get to very briefly describe your marketing message, and many now link to your company Web site. Remember, advertising should be about the work you want to do, so be specific in your description of your marketing message. For a listing of creative sourcebooks, check The Workbook Directory (*www.workbook.com*) and on the home page click on *database* then *look up contacts*. From there you will use the pull-down menu and select *directories*. There are at least thirty selections and many offer print and online listings as well as sell display advertising space.

BUYING DISPLAY ADVERTISING SPACE

Marketing is made of many different tools and buying advertising space may or may not be the right tool for you. Your portfolio, promo pieces, Web site, social media marketing, and even your direct mail and e-mail marketing will probably be your primary marketing materials. Since buying ad space is one of the most expensive and least measured marketing tools, you want to be sure to match your marketing message to your media purchase.

To decide where and when to buy, look forward and do not look backward. Look at both print and online advertising of the photography work *you want to do* (your marketing message) and not just a shotgun blast of favorite images. As an example, let's say you have decided on a style suitable for wedding photography clients. Then your advertising will center on this style and subject in your display ad purchase, in design, in text, and in image selection. You will focus on your personal style of wedding photography and the way you work with couples. This alignment is crucial. Your marketing message comes first; it lends focus and direction to your marketing plan and then will help you decide where and when to advertise. In this example, an ad purchase on a wedding Web site such as *www.weddingcompass.com* or *www.weddingphotographysites.com* might be a good match.

Each marketing message—use, subject, style, and industry—has its own distinct relationship with your need to buy display advertising.

USE OR SUBJECT MARKETING MESSAGE
As a photographer you may be less likely to invest in display advertising if your marketing message is based on the use of your work (editorial, for example) or the subject of the work (product photography, for example). The use of your photos or the subject of your images have very targeted client bases that you can simply research or buy a list and then use sales strategy, direct mail, social media, and e-mail marketing campaigns. In this example, you can research the client and contact them.

STYLE-BASED MARKETING MESSAGE

If your marketing message is based on your style, you will be more likely to consider buying display ad space. Style is not the type of market easily researched and you cannot always second-guess a client's need for style. When a photographer has a style based marketing message it would make more sense to use display advertising because it has the ability to reach more prospective clients. When you have a strong style, you can use a display ad to broadcast your marketing message to the tens of thousands of potential clients reached with the larger circulation publications and sourcebooks. Upon seeing your ad, clients decide you are perfect for their project and they will contact you.

INDUSTRY-BASED MARKETING MESSAGE

If your marketing message is based on a specific industry or type of client, you will be able to buy display ad space in industry trade publications and even in industry association print and online newsletters. Though these are smaller circulation (and less expensive ads) they are highly targeted to the audience you are trying to reach for your photography services. For example, a business-card-size ad for architectural photography in a newsletter read by architects may get more response than a full-page ad in a general consumer publication.

PLANNING DISPLAY ADVERTISING

There are two approaches to planning your ad campaign. One, you want to keep your name recognition at the very high level you have established (image advertising). Two, you want the ad to sift through the clients it will reach and identify the ones interested in working with you (response advertising). Image advertising is most often used for larger, more established photographers. Response advertising is much more common for everyone else. The goal of the ad for your photography services is not to sell, but to stimulate a response to bring a prospective client to you. In responding, the prospective client then becomes qualified for the selling steps discussed in chapter 11. Be sure you use the correct approach for your display advertising planning.

Since most of us need to do response advertising, you will then plan your display ad with two specific objectives: to communicate your marketing message *and* to ask for a response (the call to action).

Different marketing messages will also need different ad campaigns. It is very important that you start with a client profile from your photography marketing plan. Find out who your clients are and where they look when searching for a photographer. Where will they see your ad? How big a circulation do you need? Don't forget online advertising, social media sites, or smaller circulation publications such as industry trade association newsletters. Once you have a list of all the print and online publications your targeted clients read, get the advertising media kits (or just check the Web sites) to compare rates. You don't always have to buy full-page color ads. Be creative, be flexible; for response advertising, a quarter-page ad in a trade association newsletter may be more effective than a two-page ad in a crowded and busy creative directory.

ADVERTISING DESIGN CRITERIA

Once you have decided that a response ad campaign is appropriate, sit down with an art director and copywriter and form a creative team to add the objectivity you lack designing the advertising by yourself. With your team, review these factors that will increase the response to your ad campaign.

Decide on the response goal, aligned with your marketing message. Unless you have a well-established name and marketing message to maintain with an image ad, be sure to design your ad for soliciting a response in addition to supporting and reinforcing your marketing message. If you don't include a call to action, you are just showing pretty pictures. Clients will do what they are told, not much more and not much less. As a marketing technique, advertising is a non-personal tool. You are not there when they see your ad, so it has to work ten times harder than a portfolio presentation, e-mail, or phone call. Make the response mechanisms (how the client can reach you) attractive and easy to use. In John Connell's ad for architectural photography services, he opens with two intriguing questions for his target audience and then gives two strong choices for response.

When you create an ad that compels clients to inquire, decide on your risk/response ratio. A high-risk ad will get lower response. A low-risk ad will get more response. High-risk ads effectively discourage responses from people who are not in your target market. They act as screening devices. In an example of a high-risk ad, your ad copy might say, "Call us for your next photography project." This is a big risk for the client, they do not know you yet and it is hard to make the leap from your ad to working with you on that first job. In an example of a low-risk ad, your ad copy might say, "E-mail us to receive more information about our services." There is less risk here for the client and the probability of a higher response. Neither high-risk or low-risk is good or bad, you are simply deciding if you want to filter a large pool of potential clients down to the few interested ones (high-risk/lower response), or get every client even remotely interested in your work (lower-risk/higher response).

Determine what makes you or your work special, and include that in the ad campaign design. It could be a style, philosophy, personal background, cultural awareness, the location of your studio, services you offer, or even the ad concept itself. Clients hire photographers for how you think and solve problems so you will need to show them in your advertising. Lon Atkinson's ad campaign uses clever copy to tell his audience what makes his studio special.

Plan a campaign with enough frequency. Your marketing, including your advertising, will need anywhere from six to sixteen repetitions or exposures to your prospective clients before they will recognize or resonate with your message. Repetition builds recognition, and recognition builds response.

Add credibility to the advertising design with client testimonials, client quotes, client company references, or professional association memberships. Credibility is not naturally part of any ad design; you have to add it. Consumers and commercial clients have become fairly jaded about claims made in ads. Unless you convey a more credible message about your proven capabilities, all any client knows for sure about you is that you found some money to buy a display advertisement.

Something New

at our studio.....................

■ NEW WEBSITE

www.AtkinsonStudios.com

NEW LOOK

Atkinson!
STUDIOS

■ New Gear

The Best in Digital Cameras:
➤ **THE LEAF APTUS** ❮

Some Things Never Change

High Quality Photography

Impressive Service

GREAT PEOPLE!

So You Should...

Check Out Our Website

★ Visit Our Studio

Drop Us an E-Mail ✉

©Atkinson Studios
Lon Atkinson

Include a sense of yourself and what you might be like to work with. Ads are a non-personal medium of self-promotion and need to be warmed up with a personal identity clients can relate to. The most obvious for photographers is to use a self-portrait that visually repeats the marketing message and would be perfect to include in an advertising campaign design. You can also use a personal philosophy for your photography services to set yourself apart. Ask yourself what personal information can you include to help the client make the decision to respond to your ad. Tie this ad in with your social media presence as well!

Always think in terms of a coordinated, consistent campaign, not just an ad here or there. Advertising is a long-term commitment towards building an image in the minds of your potential clients, even when the most immediate objective is evoking a response.

ADVERTISING IMAGE CRITERIA

The crucial part of any ad campaign is the creation of visuals and selection of images used to communicate your marketing message. Here are some tips to review with your creative team.

What marketing message does your ad campaign communicate? Always tailor your visuals to your marketing message. Again there are four: a personal style of work, a specific industry, the use of the work, or the subject.

For example, a subject-specific marketing message would state, "Call on us for your family portrait photography needs," and this statement will define the visuals clearly to the viewer of the advertisement. Remember, you are advertising for the work you want to do more of (i.e., family portraits) not the work you are willing to do (just about anything). Julie Diebolt Price runs two separate ad campaigns—one for business portraits and another for her photo workshops. Each is specific to a subject and asks for a response.

©2010 Julie Diebolt Price
JDP Photography

PLEASE JOIN US AS WE EXPLORE THE BOUNTY OF OREGON -
RIGHT IN OUR OWN BACKYARD!

ACCLAIMED PHOTOGRAPHER AND AUTHOR JULIE DIEBOLT PRICE LEADS NOVICE, AMATEUR,
AND PROFESSIONAL PHOTOGRAPHERS ON AN EXPLORATION OF THE MT. HOOD AREA.

AS WE CAPTURE THE MOUNTAINS, LANDSCAPES, FLORA AND FAUNA,
YOU WILL COME AWAY WITH CONFIDENCE IN YOUR PICTURE-TAKING ABILITY,
KNOWLEDGE OF YOUR DIGITAL CAMERA AND MEMORABLE PHOTOS THAT WILL
LAST A LIFETIME.

ATTENDANCE IS LIMITED TO MAXIMIZE INDIVIDUAL ATTENTION.

WORKSHOP FEE - $469
INCLUDES WELCOME RECEPTION/WINE TASTING, 2 LUNCHES, 2 DINNERS AND
2 FULL DAYS OF PERSONALIZED INSTRUCTION

IF YOU CAN'T ATTEND THE ENTIRE WEEKEND,
PLEASE JOIN US FOR A
HALF-DAY SESSION-$69 OR A FULL DAY SESSION-$135

TO FIND OUT MORE, PLEASE CALL JULIE AT 714.669.4537 OR
VISIT WWW.JDPPHOTOGRAPHY.COM

©2010 Julie Diebolt Price
JDP Photography

Always show the everyday subject in an extraordinary way in order to stimulate the client to call and inquire. This is an important tactic in general, but it is absolutely crucial for a subject marketing message. For example, take any given subject of photography—people, places, products—and you need to use the most creative and technically challenging images for your advertisement and then ask the client to respond. Lon Atkinson's *Red Shoes* ad is an excellent example.

Your objective (whether print or online ad) is to get your client to stop and study your images, read your ad copy, and decide on a response. You want to create visuals and copy for your ads that prompt clients to ask themselves, "How did they do that? I need to know!" Andy Batt of andyBATTstudio does this nicely by giving a lot of information with the image in the ad on page 132 from his series of *Photo Cards* ads in *Communication Arts* magazine.

Finally, work with the most incredible creative team you can put together and don't forget the advertising copywriter. Be sure to adapt, but not adopt, when looking at other creative professionals' ad concepts. Don't copy! Be creative about how you and your team design and carry out your ad campaign.

SOMETIMES THERE IS A GAP

Because you cannot control how clients will respond and exactly what work they will bring, be aware that you do not need to change your marketing message and ad campaign when you get work you are not showing in your advertising. This gap is nothing to worry about. Stick to your ad campaign. For example, your best portrait photography advertising brings in a client with a product photography project. Another example: you are promoting your strong, visual style as a photographer and then get a call for a job that doesn't quite tap into your highest level of technical ability and creativity. No problem—take the work and maybe you will place that sample in your file of promotional materials just in case this type of project ever does come up again.

There is no controlling how clients will respond to your advertising. Some clients cause this gap between what you show and what you get because they like your style or personality and just want to work with you. Other clients cause this gap because they are trying you out on a less risky project before they turn over a big job to you. This does not mean you need to change all your advertising. Simply do a great job, take the money, and say thank you.

Direct Mail Marketing

Contrary to some reports, direct mail is not dead. Web site, e-mail marketing, and social media networks all offer opportunities to communicate with prospective clients, but direct mail is still vital and alive. Most often it can be integrated with online and social media marketing. Direct marketing by mail is one of the most *personal* of all the non-personal marketing tools you can use for self-promotion. Today clients need to be able to set you apart when they receive your direct mail so you will want to design to your highest level of technical and creative ability. Direct mail is not the same as a promo piece (see chapter 18). Direct mail pieces are an *invitation* to respond and promo pieces are an *announcement* of your services.

You also may want to use different direct mail design concepts for your current clients and your prospective clients when planning your direct marketing. If all of your current clients are in the entertainment industry and your new marketing message is for food industry clients, the mailings won't make a lot of sense to your prospective clients. Your current clients should get more personal contact in your direct marketing than the prospective clients. Exposing current clients to your new marketing message could lead them to think that you don't want their kind of jobs anymore and that's probably not true! With your new or updated marketing messages you are trying to expand your business, not scare your current clients away. If the current clients are so different from the clients you want to get work from, don't send current clients the new mailing; simply design a piece just for them. Andy Marcus of Fred Marcus Photography gives a good example with a *thank you* direct mailer to current clients.

This also brings up the possibility of designing different mailings for different marketing messages. For example, prospective clients in a particular industry need direct marketing text and images that they can relate to. Prospective clients who buy style are not specific to subject or industry images—style applies to many things. That

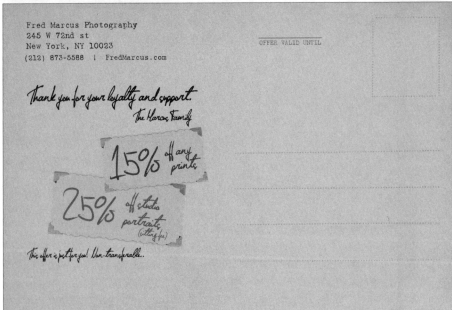

©Andy Marcus/Fred Marcus Photography

could mean two different direct marketing campaigns. When you know a client hires photographers based on their style, philosophy, or personal creativity, you can send them images regardless of the industry or subject. As long as the style message is consistent, they can relate and respond.

You do not need to be concerned about the low response rate of direct mail compared to the higher response from personal selling. The two are not competing with each other. Direct mail is non-personal marketing, and selling is a form of personal marketing. The two should work together to bring you new business. Direct mail has a lower rate of response but you are not selling a fixed-price product so even a ½ percent response could mean thousands of billings in photography fees.

THE GAP IS BACK

Sometimes there is a difference between the work you show in your direct marketing and in the work that comes from the client's response. The job the client wants you to do might not be as glamorous or exciting as the work you are showing. You can't control how clients respond to non-personal marketing.

It could just be that clients don't have that exact type or level of work at this time, yet want to begin a relationship with you. Clients can get to know you and begin a relationship by starting you off with whatever job they have on their desk at the moment. Don't underestimate the power of relationship-building in marketing photography services. Direct mail is perfect for this goal.

FREQUENCY AND RE-USE

Repetition leads to recognition, which leads to response. This is the mantra of all marketing so plan spaced repetition of your mailings. The best rule to use is to gear the pace of your direct mail to the client's volume or turnover of jobs. For example, when you are mailing to an advertising agency or editorial clients, they have a very fast turnover of jobs and you can mail more frequently—say four to six weeks. If you are marketing to corporations, you'll probably only need mailing every six to eight weeks because they work at a different pace. If your mailings are too close together, you'll lose effectiveness and annoy prospective clients. If they're too far apart, you will lose the recognition equity you gained from the previous mailings.

When you take the time and expense to print pieces for your direct mail, plan ahead for re-use of the pieces you are mailing. Because the presentation of a promotional piece changes the perception of it, you can use a direct marketing promo piece again in a different way—as a leave behind, mini-portfolio, or in a cost proposal. This ability to re-purpose the investment of your time and money is an important aspect to take advantage of when planning your direct mail.

SET SPECIFIC GOALS

Before you design your direct marketing, decide what it is that you want your clients (or prospective clients) to do when they get the mailing. Set a specific goal—do you want them to call for more information? Contact you for a job? Visit your Web site? Anticipate

the next mailing? Ask for a special premium promo piece like a mini-portfolio? Join your social media network? Refer you to their associates? You must be very clear about your expectations for your direct marketing campaign. Then, be sure to let the person reading it know what their choices are in order to maximize response. John Connell's fine art photo invitation offers four options: view his work, sale price on art prints, visit his exhibit, or make an appointment.

PLAN AND TEST

Plan the work and work the plan. Once you have designed your direct marketing campaign, schedule the production, printing (for ground mail), and mailing. You could have

the greatest concept and design, but if the pieces don't get mailed on schedule, you cannot achieve a successful direct marketing campaign. Add everything part of the campaign— design, approvals, image selection, production, and printing—to your calendar as you would any of your daily tasks.

Direct marketing allows more flexibility in testing than advertising different approaches due to the lower production costs. Testing is always a good plan so you can determine what combination of text and images bring the most response.

Always tie everything together in your marketing plan. Direct mailing can refer to your Web site and social media; Direct mail can refer to your advertising—round and round to build repetition, recognition, and response.

DESIGN CRITERIA FOR DIRECT MAIL

You can get more replies from your direct mail by asking the designer to add text requesting that recipients respond. The most important factor is to decide what kind of response you want from your client. What is it exactly that you want people to do when they receive your mail? How many response choices can you give them? There is no limit to the possibilities for this *call to action*. Here is my current list:

- Visit Web site (or page)

- Call for consultation

- E-mail request for mini-portfolio

- "Find us on Facebook"

- Reply for capabilities brochure

- Update contact information

- Forward to a friend

- Ask us how

RISK AND RESPONSE

Because actions can range from a very passive or low-risk response, such as, "Wait for our next mailing," to a very aggressive or high-risk response, "Call when you have a job," there is no right or wrong. But you must be sure to match your response and risk factors. The lower the risk to your clients (or the more passive they get to be) the more people will respond. The higher the risk (or more proactive they have to be) the lower the response. Again, both will work, but which one is right for your direct mail campaign must be determined by your overall marketing plan objectives. One factor to help you decide is the size of the mailing. On a very large volume of mail, you may want to use a high-risk response so you just get your serious photography clients to respond—that is, people

who are ready to talk to you about an assignment. If your mailing list is very small, you may want as many people as possible to inquire, so lower the risk!

INCREASING RESPONSE

In traditional direct marketing, you can increase the number of responses from clients by making an offer of some kind. The offer must have a greater value than the worn-out "Call for portfolio" request. Make an offer the client will find more valuable than just looking at pretty pictures! Make the offer about something they need or want. For example, you can offer a poster-size version of the image in your mailing, a mini-portfolio book, or a calendar. This could also be a specialty advertising promo piece (screensaver or notepad) and is something of value to the client that promotes your work at the same time.

Make it easy to respond by including the maximum number of response mechanisms on the printed pieces. It is important they be on the mailer itself so they are still there when the envelope gets thrown away. These are: firm name, your name (so they know who to ask for when they call or e-mail), full address with nine-digit zip code, area code with phone number, area code with fax number, e-mail address, social media address, and Web site.

Traditionally, giving a deadline to respond and receive your offer works to move the client to respond. Without one, there is more of a chance your mailing will go into a pile of things to do and never be seen again!

Maybe you want your mailer displayed in the clients' office or home. For this objective, you must design a *keeper* of some kind that has both form and function. Typical examples are mouse pads, door hangers or photo frames. These are more expensive and may be used for premium promotions given to clients after a certain stage of personal contact. Think of this as a mini-billboard your client will pass by in their daily activities.

Ask for clients' physical participation in your mailing with design elements such as perforations, die cuts, a riddle, or direction to your Web site to solve a puzzle—anything that allows the client to be more proactive other than simply opening your mailing. Get them interested, intrigued, and involved. Not only will this increase response, but also they are more likely to show your direct mail to all their friends in the office.

Personalization of your mailings can be quite costly so get a very clever graphic designer to work with you. For example, a self-mailer with the client's name and address highlighted and his or her name on the back with a window for the address—when folded out the back side of the image becomes the BRM (Business Reply Mailer) form. This technique works especially well with consumer direct marketing.

USE YOUR WORDS

When you are including text in your direct marketing, be sure it mirrors the client's wants and needs (the benefits) instead of how great you are (the features). For example, it is more effective to write, "You need a wedding photographer to make your day special," than to write, "I am a great wedding photographer." Clients should see themselves reflected in the copy you use in your mailings and be able to easily relate to your message. If the message is about you, not them, it is an obstacle to the viewer, so write from the point

of view of the client or prospective client. Fine art photographer David Davis and executive portrait photographer Julie Dielbolt Price accomplish this goal with their designs.

Make it irresistible. When clients look over your mailer, they should feel they have something they must respond to or should keep and remember. This impression is reinforced when you cross reference to your other marketing tools, such as social media or Web site. Hire a designer or designer/copywriter. Great copy can be as compelling as great images. When your direct mail client feels your promotion is useful and relevant, the likelihood of a response is greater.

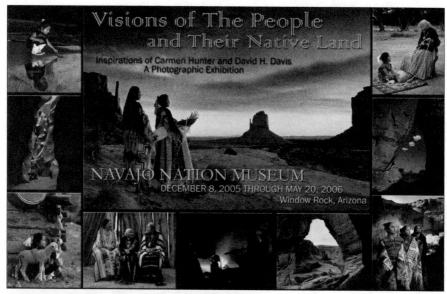

NAVAJO NATION MUSEUM
Highway 264 & Post Office Loop Road • Window Rock, Arizona • (928) 871-7941

Visions of The People and Their Native Land

Inspirations of Carmen Hunter and David H. Davis
A Photographic Exhibition

Opening Reception December 8, 2005, 5:00 P.M.—8:00 P.M.
Viewing of "Native Faces—Desert Light" film production at 7:00 P.M.

Navajo (Diné) photographer Carmen Hunter preserves pictorial and oral traditions of her family in her fine art photographs. Her sensitive understanding of her people derives from her life in and around Canyon de Chelly. Carmen's work as a Tseyi Guide and her knowledge of the best locations for photography give her the opportunity to work with many master photographers and learn new skills to develop her unique style.

This inspirational exhibit also includes work by master photographer, David H. Davis. You will see the results of his sharing with Carmen in their treatment of similar subjects. The two photographers' recent collaboration on the *"Native Faces—Desert Light"* film production allows the world to see and hear the beauty of the people and their land. David's work encompasses other people from around the reservation as part of his *Native American in the Landscape Collection.*

Carmen and David both believe in the importance of preserving traditional ways through creative imaging. They are committed to teaching aspiring Native photographers new interpretive skills so that pictorial memories can live on along side the oral traditions. Always showing the beauty of people's relationships, Carmen and David welcome new Native families who wish to be photographed. A special private studio area will be **available throughout the opening reception to photograph Elders and Grandchildren wanting to be a part of Carmen and David's future projects.**

Traditional attire encouraged.
Exhibition Open Through May 20, 2006

Request your **Media Kit** or schedule an **interview—**
please call David at 970.243.1507
Facerock Productions, LLC
1226 North 7th Street, Grand Junction, CO 81501
Email:davis@facerockproductions.com

Photography by Carmen Hunter and David H. Davis ©2005 Designed by Casey Dinner www.facerockproductions.com

©2006 David H. Davis Photographs by David H. Davis and Carmen Hunter

WHO ARE YOU?

Include yourself in your direct mail marketing and make it the most personal form of a usually non-personal marketing tool. Direct marketing response increases when your personality and philosophy as a photographer are strongly reflected. You are a total stranger to prospective clients receiving your mail. These clients need to get to know you to take the next step, to respond. You can add information from your social media such as a self-portrait, biographical information, hobbies, or your philosophy as a creative professional. The *what you do* is clear to clients in your images. Think of this personal information as the *why* they should hire you. Help them hire you by telling them *how* you got there and what you would be like to work with.

Be sure to add credibility or *third-party proof* as often as possible to your direct marketing campaigns. By definition, direct marketing is your saying you are a great photographer. You often need more objective evidence in your marketing to convince prospective clients to respond. Third-party proof could be in the form of clients' testimonials, case studies of actual jobs, or client company references. One of the best to use is your membership in a professional association. When clients want to hire a professional, they can look to these associations with some measure of assurance that they will find one. A possible exception to this is when your marketing message is style, and then credentials are less critical to response. Because of the way they buy, photography clients that buy style tend to be risk-takers; therefore, the issue of credibility is less critical.

IMAGE SELECTION FOR DIRECT MAIL

Again, like advertising, image selection is an important issue. Unlike adverting, there is a lot less pressure on the photographic image to carry the entire burden of the marketing message. Direct mail is helped with text-heavy marketing, combining a series of images you and your designer select with clever copy and headlines.

Your marketing message dictates your image selection and is targeted to the work you want to do more of to select images carefully. This is very narrow compared to the range of images you are actually capable of making. But you are *not* marketing what you *can do*; you are marketing what *you want* to do.

The main concern you have with mailings and image selection is to be careful of the exposure of too broad a message to your prospective clients. Again, because this means a narrow selection of images, you may want to consider a separate campaign for current clients who are used to seeing a broader selection of work.

Also, many photographers have more than one marketing message so it is important to watch for crossover images for your direct mail campaigns. Crossover images allow you to use the same image for more than one target market. For example, a great portrait of a corporate executive may work in a direct mail campaign for people photography and annual report photography for *commercial clients* as well as portrait photography for *consumer clients*.

If your marketing message is a visual style, then show it. Push it to the edge and show your style in as many situations as possible. Remember, style is not specific to any subject so your image selection will be a broad range of subjects all showing your personal style. For example, Trishann Couvillion of Fire Eyes Photography covers a broad range of subjects in her direct mailer under the image selection style of *Documenting Life Events*. Andy Batt of andyBATT studio shows his style with an unexpected sports image as well as adding great copy (*Need a photo? Take a picture. Need a story? Call Andy*).

Photojournalistic Style Weddings ~ Family Portraits ~ Maternity
Senior Portraits ~ Headshots ~ Corporate
Small & Large Events ~ Studio & Outdoor Photography

~ *Documenting All Life Events is my Specialty*~
www.fire-eyes.com
Contact Trishann Couvillion
206.367.1864 415.425.2733

©2010 Fire Eyes Photography Trishann Couvillion, www.fire-eyes.com

front, 6x8 postcard back, 6x8 postcard

CASE STUDY: DIRECT MAIL MARKETING, FRED HERNANDEZ AT MODERN POSTCARD (*WWW.MODERNPOSTCARD.COM*)

Q: Before even looking at all that a firm such as yours has to offer in new technology, please review the basics of direct mail marketing for our readers.

A: A good photo is a good starting place but the first thing you want to do is have an objective—what are you trying to achieve? There are two major goals: one, generate awareness, exposure, branding; and two, generate sales. The objective of your campaign will determine where you get your list. If you're trying to reach your existing clients, make sure you keep your house list clean and up to date. To reach new customers, you will probably want to look into purchasing a prospect list. What makes a good list? Always have the data provider work from a customer profile. Here's a tip. Assuming you want to secure more of the same type of photography business, any good direct mail company can provide a customer profile made from your house list and then you buy from that profile. The great thing about working with a full-service data provider is that you can pretty much find just about any type of list that meets your specific needs.

Q: And after you have your objective and a good list, what's next?

A: Plan your campaign. Once you determine your objective, it's time to build content and write copy for your piece. You have your objective but what do you want customers to do when they receive your direct mail? Direct mail by nature is direct response marketing. Any good direct promo piece is going to have a call to action—even brand building promos include this copy. Always ask for the sale. Tell your customers what you want them to do next: call, e-mail, or visit your Web site.

Q: Do you have any recommendations on how to find a good designer?

A: To get the best service from a graphic designer, look for a designer that has experience with direct mail. No question. There are not only postal service rules and regulations but there is an art to direct mail that you need to stand out and get maximum response. You want simple and effective design, not design that gets in the way of the message.

Q: Do postcards still work?

A: Postcards are more likely to be read compared to other types of direct mail (Source: Direct Marketing Association's 2009 *Statistical Fact Book*) and photographers are realizing the value of the instant visibility of postcards to make an impression and to sell their work. Postcards offer a higher level of engagement and interaction with the customer but the print quality must be excellent and you must be consistent and frequent. The power of the postcard is in its instant recognition. There is no need for recipients to open anything, and it is right in their faces. With the new postal regulations and postage increases, postcards remain not only an effective promotional tool, but the most economical choice for direct mail.

Q: Moving into future trends, how do you feel about the trend for e-mail marketing?

A: E-mail marketing is a hot topic and we consider it a perfect complement to print direct mail marketing. This creates what is called multi-channel marketing, the new technology buzzword for self-promotion, and this means reaching the same customer base in a variety of ways. Why not do both? Together they are a powerful combination with research showing that overall you can improve the effectiveness of your promotion by twenty to twenty-five percent by using both.

Q: What is available in new technology for the printing?

A: Look for leading-edge printing technology such as 100 percent digital workflow, high line screen printing, paper stock specifically designed for the intended use (postcards for example), information on setting up color management files, and direct mail marketing information, not just printing needs. Also, if you care about the environment, look for papers specifically certified as green and coming from sustainable sources. Recycled paper stocks are also very popular these days.

Q: What are some emerging direct marketing technologies that photographers should explore?

A: The most important technology for tomorrow available today is variable-data printing (VDP). This is now a viable technology for our postcard printing customers. What this means is that a photographer can customize each postcard: the photos, the content, and the offer, all within the same print run. Say you are printing 1,000 cards. Everyone could be different or you could break that up into any number of batches based on pre-determined variables.

Depending on the market you are targeting, a photographer can utilize variable-data printing (VDP) to send out a postcard with a specific image to target a particular audience based on demographic, psychographic, or transactional data. For example, within a single print run a photographer utilizing VDP can target families, students, youth athletes, and weddings with imagery and content specific and appropriate to each prospect.

Q: What do you think has stopped photographers from embracing this new technology?

A: It took a while for digital printing to approach the quality of offset printing and VDP requires digital printing. We are there now. Then, the photographer needed affordable control over the software for creating digital files with the VDP component included. Photographers are there now. The true value is not really the new technology; it is being able to target your print promotions in a one-to-one effective, affordable communication.

16

E-mail Marketing

E-mail marketing is essential to a growing business in today's world. It is accessible, affordable, and simple to implement, thus making it a strong vehicle in a photography business marketing plan. It offers long-term relationships and a communications channel that supplies ongoing and direct connection with prospective clients. You can also use e-mail marketing to leverage your most important asset, your current clients. Before we look at design issues, here are some basics for everyone.

Always use permission-based e-mail campaigns. Your marketing e-mail must be from an *opt-in* list that is used with permission from people with whom you (or your mailing list service) has a relationship. When permission is granted, then sending a targeted, timely, and relevant message is extremely effective. The personal nature of each message helps clients feel a one-on-one connection with you but only if you know and understand your client's needs.

Use a Signature Block in your e-mail program to appear at the end of each message you send or reply to. Limit it to six to eight lines with any of these items of information: company name, address, phone number, Web site, social media, e-mail address, and a one-phrase description of your unique business offering. Change this every few weeks to create more interest in reading your e-mail.

You only get one chance to make a first impression, and in an e-mail, that first impression comes in the subject line, so be sure to write a subject line to your client's interests. Different client lists mean different e-mails and subject lines, so customize as needed. One of the best metrics of the strength of a subject line is to send sample e-mails with different subject lines to a test group of friends first. What kind of response do they get when they arrive? Do they arrive safely or are they blocked as spam or filtered to a junk folder?

DO AND DON'T E-MAIL DESIGN ISSUES

Do test how your e-mail will display to clients. Broken links or raw HTML code in e-mail marketing could be a problem for you. Try setting up test accounts with the major online services to see how they handle your e-mail. Again, always put yourself in prospective clients' shoes; how will this look to them?

Don't use a subject line of more than thirty-five characters and make sure the first fifteen are relevant to the client (think of a client reading this on a smartphone). The subject line should contain at least one keyword that is a benefit to the client—for example, *photography for communications* or *photography that sells products*.

Do have the *From* address accurately identify your company name. An example would be Maria@stansholik.com instead of something obscure like princess2012@aol.com. Obvious perhaps, but you would be shocked at some of the addresses I receive as a rep! This practice reinforces the *From* line and name recognition, ensuring recipients that the message is coming from a trusted source.

Do have a good e-mail list. Your best e-mail address list comes first from current clients and good prospects who have consented to e-mail contact with you. This list also will come from people visiting your Web site, replying to your direct mail, your social media sites, and viewing your portfolio. You will also need to research how to buy an *opt in* e-mail list. Check with your mailing list companies such as Adbase or Workbook and see what they have to offer. Carefully review the selection criteria they use to compile their lists.

Do have a specific goal for your e-mail campaign. Regular contact with current versus prospective clients may be two different e-mail messages. For current clients, you can be more familiar as they already know your work. For prospective clients, you will need a reason that the client cares about. It could be new services available or current client success stories. Try to be irresistible! Ed McDonald's e-mail campaign is a good example—clean and simple—the e-mails are consistent in design and use copy to the marketing message (*photographic storyteller*) and for an irresistible client benefit (*get more*).

Do think about an e-mail newsletter. While it's a big commitment in time, publishing a monthly e-mail newsletter is one of the very best ways to keep in touch with your prospects, generate trust, develop brand awareness, and build future business. Ask for an e-mail address and first name so you can personalize the newsletter. It also helps you collect e-mail addresses from those who visit your site but aren't yet ready to make a purchase. Gray Photography and Davis Freeman Photography offer the examples on pages 152 and 153. Lots of work but interesting for their clients!

Don't ignore bounced e-mail. Bounced e-mail is when you send an e-mail to an address that does not exist. It is a good way for you to keep your own personal database clean. Also, today's ISPs have rules and if you exceed their standards for undeliverable (bounced) messages, they could flag you as a spammer and block all your e-mail!

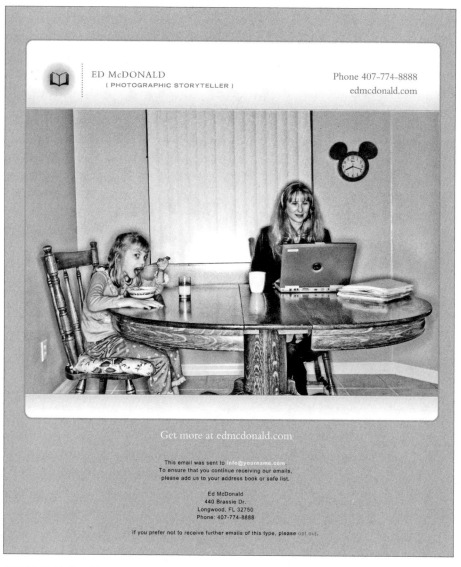

©2010 Ed McDonald
Ed McDonald Photography

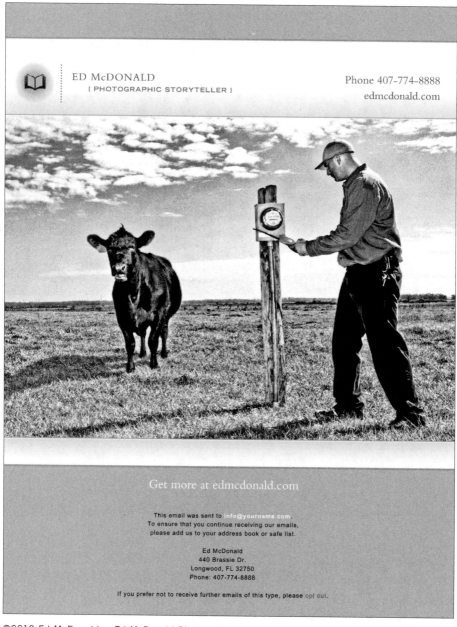

Do balance text between selling images and interesting content. Yes, include your selling message with your images but try adding a brief *behind the scenes* or client case-study information. This adds value to your e-mail marketing campaign and keeps clients interested in hearing from you. Meg Baisden offers a great example (see page 154) with

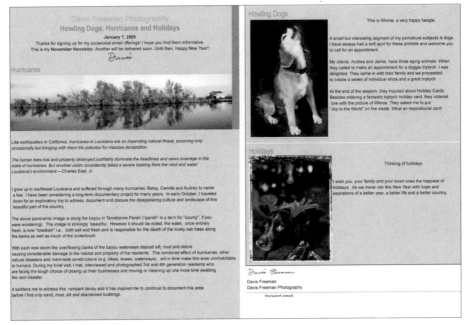

©Davis Freeman

this template design for her e-mail campaign that balances images *(slideshows)* with content *(fit to print, new on the blog)*.

Don't think only of online response. Give clients the option to call you (toll free numbers work very well) or to visit your Web site. The "image is found" photography e-mail (see page 155) uses five different response choices-call, e-mail, address, Web site, and blog.

Do monitor the results across all metrics such as open rates, click through rates, spam complaints, bounce rates, and un-subscribes to make sure that a bump in your open rate didn't lead to an increase in un-subscribes, bounces, and spam complaints

Don't go on and on. Your very brief e-mail body message should open with the first couple of sentences designed to capture clients' interest and active hyperlinks to selected Web pages on your site (you do not need to send them to your home page).

AVOID SENDING SPAM

As of this writing, there are still some words that you need to avoid using in your e-mails due to the use of software designed specifically to find junk e-mail and trash it. Keep in mind this subject defines the term *moving target* and the entire discipline of e-mail marketing may change with legislation in the future. One of the ways that these programs currently identify junk e-mail is the words and phrases contained in the copy and subject line. If one of the filters catches these spam words or phrases, your message may never be seen by anyone who has turned on their junk e-mail filter. Avoid using them in your e-mail marketing or online newsletters.

Content and images
©Gray Photography
Zach and Jody Gray,
GrayPhotograph.com

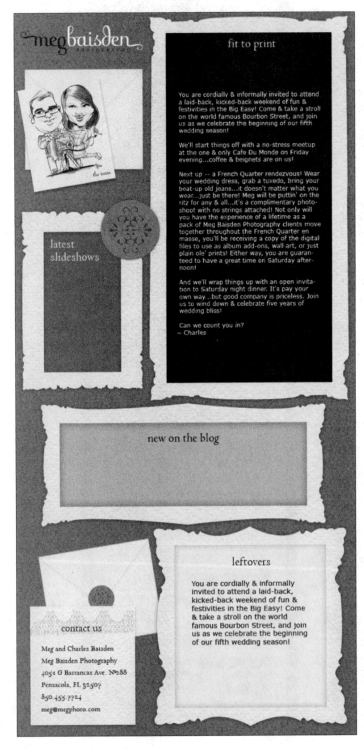

fit to print

You are cordially & informally invited to attend a laid-back, kicked-back weekend of fun & festivities in the Big Easy! Come & take a stroll on the world famous Bourbon Street, and join us as we celebrate the beginning of our fifth wedding season!

We'll start things off with a no-stress meetup at the one & only Cafe Du Monde on Friday evening...coffee & beignets are on us!

Next up -- a French Quarter rendezvous! Wear your wedding dress, grab a tuxedo, bring your beat-up old jeans...it doesn't matter what you wear...just be there! Meg will be puttin' on the ritz for any & all...it's a complimentary photo-shoot with no strings attached! Not only will you have the experience of a lifetime as a pack of Meg Baisden Photography clients move together throughout the French Quarter en masse, you'll be receiving a copy of the digital files to use as album add-ons, wall art, or just plain ole' prints! Either way, you are guaran-teed to have a great time on Saturday after-noon!

And we'll wrap things up with an open invita-tion to Saturday night dinner. It's pay your own way...but good company is priceless. Join us to wind down & celebrate five years of wedding bliss!

Can we count you in?
~ Charles

latest slideshows

new on the blog

leftovers

You are cordially & informally invited to attend a laid-back, kicked-back weekend of fun & festivities in the Big Easy! Come & take a stroll on the world famous Bourbon Street, and join us as we celebrate the beginning of our fifth wedding season!

contact us

Meg and Charles Baisden

Meg Baisden Photography

4051 G Barrancas Ave. N°288

Pensacola, FL 32507

850-455-7724

meg@megphoto.com

©the image is found
the image is found.photography

Watch for words or phrases like *free offer, no obligation, on sale now* as these are often spam-filtered out and your e-mail will never be opened. Use online content checkers to test your e-mail for words in the *To, From, Subject,* and even in the body text that might trigger a spam filter. Keep in mind that it is not any particular word as much as the combination of these words that triggers the spam filters. Do some research on SpamAssassin (a widely used filter) or search for sites that will run a diagnostic check on your e-mail before you send it.

E-MAIL SERVICE PROVIDERS

Should you use an e-mail service provider? In addition to Internet Service Providers (ISPs), there also are E-mail Service providers (ESP). If you choose this route, you can expect the latest in privacy approaches and good relationships with ISPs. In addition, though, you also can benefit from e-mail filtering expertise and other elements that can help your business grow.

If you plan to rely on your e-mail as the center of your marketing communication strategy, you should stay as close as possible to it. Understanding its definitions and meanings can enable the successful marketing communications that create business success. If you or your rep plans to outsource e-mail marketing, look for a close relationship with the service provider. If you use an outside service, here is a partial list of resources:

- ADBASE E-mailer (*www.adbase.com/create*)

- Constant Contact (*www.constantcontact.com/index.jsp*)

- Emma (*www.myemma.com/*)

- ExactTarget (*www.exacttarget.com*)

- Got Marketing Campaigner (*www.wilsonweb.com/afd/gotmarketing.htm*)

- Listrak (*www.listrak.com/*)

- Mail Your Market (*www.mailyourmarket.com*)

- Responsys (*www.responsys.com*)

- Silverpop (*www.silverpop.com*)

- Vertical Response (*www.verticalresponse.com*)

CASE STUDY: E-MAIL MARKETING WITH MEG BAISDEN, MEG BAISDEN PHOTOGRAPHY (*WWW.MEGPHOTO.COM, BLOG.MEGPHOTO.COM*) AND SUZANNE NORMAN, DIRECTOR OF COMMUNITY RELATIONS AT EMMA® (*WWW.MYEMMA.COM*)

Q: How are you using e-mail for marketing and branding?

Meg Baisden: We use the graphic designers on staff at Emma to discuss the individual style we seek, and help us to establish a consistent e-mail presentation for mailings. Our e-mail marketing goal is to offer new product offerings and create a drive-to-blog marketing strategy where viewers can extend their customers interaction.

Suzanne Norman: When you send an e-mail, you're sharing more than just news, work, and content. You're showing off your unique style. That's good news for folks who make a living in the creative arts field. After all, e-mail lets your would-be customers see your creativity, style, and brand in action.

Q: Where did you get your e-mail database and how is it working for you?

Norman: We strongly suggest (and for Emma clients, require) that you use e-mail as a permission-based means of marketing. Instead of buying, purchasing, or renting a list, e-mail folks who are asking and expecting to hear from you. To build a list around your existing relationships, look for all the places you're interacting with people who know and love you (in a completely non-creepy way), and start asking them to sign up for your e-mail updates.

Baisden: We built our e-mail list the old fashioned way: through requesting our customer's permission! Each time clients order prints through our studio, we ask them to join our e-mail newsletter. We also display "join" links on our Web site and a studio blog so visitors can join as well. Then, using the ESP software allows us to separate visitors from customers so we can deliver targeted content to specific groups of users.

Q: As you receive and track e-mail responses, how do you analyze the results to send more targeted messages to these clients in the future?

Norman: One of the best things about e-mail is that it talks back to you. Most e-mail service providers offer tracking and reporting that show you who opened, clicked, forwarded, and more. A dedicated review of those numbers will help you spot eye-catching work, stand-out content, or subscribers who'd likely respond well to follow-up, all valuable information to apply to future campaigns.

Baisden: Having the ability to divide your audience group into sub-groups is extremely valuable. Combining tracking technology with grouping technology that an ESP like Emma can offer makes the system unbelievable. Once I introduce an e-mail campaign, I can drill down into specific results and identify the individuals who clicked on a link inside

the document. I can isolate these users into separate groups, and market specifically to them. This allows me to send special offers solely to my active responders, increasing the odds of action from my customers.

Q: How does the assistance of an E-mail Service Provider help to keep your mailings from being filtered into a junk folder?

Baisden: Trying to get our e-mail newsletters delivered before we started working with an ESP caused constant frustration. What we have learned through experience is that the content of an e-mail is secondary to the delivery platform that is used. Certain e-mail newsletter services have serious issues with delivering e-mails to common consumer e-mail servers like Yahoo or Hotmail. Using an ESP like Emma for all of our e-mail marketing needs was the key in this area. Their compliance with e-mail delivery standards, and refusal to allow spammers to use their platform, ensures consistent delivery for the rest of us.

Norman: Partnering with an ESP gives you the benefit of a professional e-mail delivery system. They'll navigate the rather complex world of e-mail delivery for you, bringing both new-fangled tech expertise and old-fashioned relationships with spam watchdogs and Internet service providers. They may also offer tools that double-check your e-mail for any words, links, or content that could increase your spam score or cause delivery issues, letting you focus on your e-mail's content, design, and strategy (the fun part).

Q: What kind of frequency do you find works best for your clients?

Baisden: We use our e-mail marketing system an average of once per quarter. We have based this decision on the seasons that affect our business, and our need to make offers at certain times of the year. Our company has found that by limiting our frequency, we increase our open rates, and minimize our unsubscribe rates.

Portfolios That Sell
Your Work

For most photographers, portfolio presentations are not as effective as they could be because they are not packaged or planned. Many just hope clients find their Web site. Many show a collection of random images and hope consumers or commercial clients will find something they want. Portfolios for clients should not be a multiple-choice quiz.

Your portfolio must shout out your marketing message so that prospective clients can retain the information and remember when to hire you. Remember, this is someone you have not worked with and, unless you are showing a portfolio for a specific photo job, clients rarely have jobs to hand out on the spot. They will need to remember when to call you back. As much as you may hate to be pigeonholed this way, there is simply too much visual information presented everyday to clients to avoid it. They need your marketing message as the visual hook to hang you on so they can come back and find you when they need your type of work.

Your portfolio provides the focus and direction for your photography business but at the same time it is so personal it is hard to be objective. Just because you are tired of looking at an image does not mean it will not do the job and stimulate the people that see it to give you work.

So let's start by re-defining the term portfolio. A mixed assortment of images is not a portfolio. All the images you have ever created are not a portfolio. Your image files make up a *body of work*. Whether you are a consumer or commercial photographer, this body of work is used to create various portfolios that are customized by your marketing message for viewing by a specific client. Each portfolio you pull out of the body of work must also target the level at which you want to work (not necessarily the level you are now). To get great work, show great work!

You will also want this type of polished portfolio when you are looking for a rep. For reps, the state of your portfolio is an important consideration when they consider

taking on additional talent. Your portfolio (print or Web) needs to be ready to show a rep's client, it cannot require months of work or be "under construction." Portfolios are one of the most important tools for a rep. How will your portfolios show against the competition? What is special or different about them? Are they what art directors will respond to in a portfolio? Portfolios that are packaged to sell the photographer (and not just show his or her work) will have a greater attraction for any rep. A polished portfolio also shows your sense of pride, your ability to be consistent, and a strong sense of direction that tells the rep this will be a successful and lucrative business relationship.

PORTFOLIO PLANNING

There are two major areas to concentrate on when planning your portfolio presentations. First, *what* you show in your portfolios (image selection) and second, *how* you show them (image format).

Before you do anything else, however, go to your planner or calendar and schedule the time for this portfolio workout. Like an exercise workout, you need to plan the time. Overhauling your portfolios is not the kind of project you can just wait for the time to get around to. You will always be rushing around at the last minute every time you need a portfolio. That does not work! It should be treated like a real assignment and be given the proper budget, time, energy, and attention.

WHAT YOU SHOW—IMAGE SELECTION

You have certainly heard that "you get what you show" in your portfolio. So, first you must look at the work you want to get. What kind of work do you want to do more of? Be specific as to the marketing message from chapter 2 (style, subject, industry, use of the images) and to the type of client from chapter 5 (consumer or commercial). Then you can select images for your various portfolios considering both of these factors.

Perhaps, the work you want to do is not the kind of work you have been getting from word-of-mouth or referrals. Paid jobs may not even show your desired or best work. Photographers often work with budget or creative restrictions that keep them from doing the images they would be most proud to show. The most basic rule is to not show this work. Never include a piece in your portfolio just because you got paid for it. Never include an image you feel you need to give an apology for. Your portfolio must reflect your best work and your passion for photography.

What if you don't have the images *you want to get* to show in your portfolios? You could be making a transition and looking for different types of assignments or maybe you are just starting out. Then there is the client who says, "But I want someone who has experience!" Your problem is the classic dilemma: how do you get a job without experience when it takes experience to get the job? Two good solutions are self-assignments and pro-bono projects.

First, look at self-assignments. People hire you as a creative professional because of what you can do, not necessarily what you have done. So your portfolio workout at this

point is to pull all images from your portfolio that don't meet your marketing message and your highest level of creativity and technical ability. Retire them back into the *body of work* somewhere. Once that is done (be merciless), you can more clearly see where the holes are in your portfolios that need to be filled with self-assignments.

For example, if you want to do more corporate communications photography, you need to create self-assignments built around the problems and solutions you would find in a corporate assignment. If you want to do more fashion assignments, select a fashion product and produce a portfolio of images to promote it. Self-assignment work is not the same as personal work. It always has a pretend client and a problem/solution scenario. To come up with your self-assignments, either work with a client who can supply ideas or collect samples of the kind of work you want to do. Then create your self-assignments from this ideas file. Be careful of copyright violations! When looking at someone else's work, think in terms of adapting the idea with your own visual solution, not adopting their solution.

Review the upcoming chapter 20 for more information on another great technique for creating images for your portfolio. Pro-bono or community service work provides you with a real client, real problems to solve, and real testimonials from happy clients. Everyone donates their time to a charity to produce creative projects for fundraisers. It is a win-win for all parties. The charity gets great work and you get to add great images to your portfolio.

Finally, for further assistance, try checking with your local creative and photography associations. Many of them sponsor annual portfolio reviews where you can get your photography portfolio critiqued and evaluated by reps or photography clients. Since this is not an actual sales presentation, this review can be the most honest and open source of feedback you can find.

HOW YOU SHOW IT—IMAGE FORMAT

Consider target client: What format are they most familiar with? Don't format your portfolio, and then decide on your target client. Target your client first, and then format your portfolio. This is not just about what you want to show, it is about what the client wants to see. The target client will influence both the format and the presentation.

How many different portfolio formats will you need for your target markets? Depending on what you are selling and who you are selling your photography services to, you could create as many as five different portfolio formats. Keep in mind that any of these formats can be presented as traditional print, digitally produced, or the newer hard cover book bound format. No matter what you choose, format to your marketing message: what are you selling, who buys it, and what types of portfolios do they prefer to view?

First, the *show* portfolio is your personal portfolio that goes with you to all your client presentations. Many photographers have dropped this format in favor of using their traveling portfolios instead as many clients have cut back on in-person presentations. You can always show a portfolio lightweight enough to travel but the opposite is not true.

Second, when you send a portfolio to an out-of-town client, you will need a duplicate of all the work in the show portfolio but these *traveling* portfolios are usually smaller and lighter for easier and less expensive shipping. Usually called in *after* a client has seen your Web site, they will be highly targeted for the client's photo needs and projects. This format also works as your show portfolio.

Third, sometimes a local client will ask for a *drop-off* portfolio so they can easily check out different photographers and evaluate whether they want to see you and the full show portfolio. This drop-off book is a partial portfolio designed to give clients an idea of what you can do. It should only take a small number (perhaps five or six) of images to help them make this decision and the images should be bound into some kind of book so that nothing gets lost. Binders or albums would also work well though Web sites have worked extremely well for this function.

Fourth, many clients need more than one or two promo pieces to remember what you can do and why they should hire you. You may need a *mini-portfolio* that they can keep on file or keep in their office. Not a true portfolio, this format is actually a promo piece because the client keeps it, but it is more like a portfolio that fully represents your work more than a postcard promo piece. Many photographers today use this popular portfolio format and work very hard to produce a unique combination of concept, design, copy, and photography that becomes an interesting piece the client will want to keep on hand.

Fifth, your Web site is also a portfolio and discussed more thoroughly in chapter 8. With Web sites so prevalent in today's client search for a photographer, it is often the first contact with a prospective client. Coming from your Web site, many clients then will call you and your portfolio in for a one-on-one meeting or presentation. In other words, the Web site portfolio often leads you back to one of the other formats.

One final note: Just because you need a format familiar to your prospective clients does not mean you should not be creative. It should be a portfolio that clients want to call and ask for. It could be a logo folder that holds a number of samples and printed promotional material (good idea, they are easy to keep on file), an unforgettable CD, a DVD, or a mobile that hangs from the ceiling!

CREATING PORTFOLIO IMAGES

For the work itself, go for production quality and professionalism. It is possible a client will assume that if your portfolio images are poorly produced or presented then the work you do for them would be too.

Outdated Web sites, poorly produced CDs, worn mats on prints, and ragged client samples must be taken care of immediately. Resist the temptation to throw something into a portfolio just to show it. It's a poor excuse for an unprofessional presentation.

When your clients want to see a traditional print portfolio, many photographers have switched over to the new hard cover book. I would recommend you show images as either laminated or mounted, but they don't mix all that well, so choose one. It's really a

personal decision based on your budget and comfort levels. Also, consider using the one your prospective client is most comfortable and familiar with. If you don't know what he or she prefers, ask! It is also a good idea to have your name and logo on each book, lamination, or mat board.

What size should your portfolio be? Most print portfolios today are in the range of 8" × 10" to 11" × 14". This is the outside size of the mat board or lamination. All of your portfolio pieces should be the same size and then, inside this dimension, you can mount any size images! Check out the new hard cover bound *coffee table style* books you can get printed for your portfolios as new technology brings the cost to a more affordable level.

How many pieces should you show? Remember, a complete body of work is not a portfolio. The entire body of work could be dozens or even hundreds of images. Any given portfolio should be a selection of ten to fifteen pieces depending on the particular client. Because each board or lamination could show two or more images, this keeps the portfolio quantity manageable while not severely limiting the number of images you show. Show to the client's comfort level (find out what it is!). For example, an art director at an ad agency will enjoy strong single image pieces since that is usually what an ad calls for. An editorial client would prefer a series of images telling a photo story. Certainly consumer clients will want to see wedding and portrait work in either albums or frames much as they would buy from you. Once past the Web site, a hands-on portfolio should be something the client is familiar with and not an obstacle to viewing your images.

If you have to make even a glimmer of an apology for an image in order to show it, then don't show it. Yes, it will take some effort to make the time to have the proper materials on hand, to get images properly scanned and printed, to properly format and label those CDs, to update Web sites, and to find the money and time to do all of this. It is worth it. It is your career, your business on the line.

CASE STUDY: PORTFOLIOS THAT SELL, LOUISA J. CURTIS, CREATIVE CONSULTANT, CHATTERBOX ENTERPRISES (*WWW.CHATTERBOXENTERPRISES.COM*)

Louisa J. Curtis is a creative consultant based in New York City. After spending a number of years in the commercial photography industry, she formed Chatterbox Enterprises to offer photographers a variety of creative consulting services ranging from portfolio and image reviews to customized marketing packages designed to help refine your vision, target the appropriate audience, and create and implement an Internet-driven business plan. Her experience ranges from *Archive* magazine, to the Black Book, photo representatives Watson & Spierman Productions, PDN's PhotoServe, and IPNStock, as well as database services ADBASE and Agency Access. Besides her creative and marketing consulting, Louisa also works as an event coordinator, panel moderator, and seminar speaker. She has regularly presented programs for Adorama, APA, ASMP, Miami Ad School, and PhotoPlus Expo.

Q: When you are doing a photography portfolio review for a photographer, what is your starting point?

A: I usually start with the Web site, unless I am only looking at a hard copy book. When I meet or speak with new clients I am automatically going to look at their Web site. In today's world, that is your main portfolio and no matter what genre of photography you shoot, if you are looking to sell your work in some way, you must have a Web site.

If I am only looking at a hard copy portfolio then I might begin by asking photographers if they have anything they want to say or should I just go ahead and look? That can be quite revealing! And even if the work is not that strong, or the presentation is bad, I will always begin with something positive before I critique.

Q: How do you determine how many different portfolio formats the photographer should be using (print books, CD, Web sites)?

A: This will depend on the photographer and which markets he or she is interested in presenting work to. As I said before, photographers must have a Web site but nowadays having six to ten hard-copy portfolios is simply not as necessary as it used to be. Ultimately, you should have something tangible to show people but there are many more affordable options out there these days with self-publishing available online.

Q: How do you handle the topic of image selection, what goes, what stays, what holes are in any portfolio you are reviewing?

A: I like to look at the work first to get an overview of the photographer's style, strengths, and editing capabilities. I also like to ask what it is that he or she likes to shoot the best. And whatever that is, it is usually the best work. Your portfolio should show what you want to be shooting, not what you think people want to see. I will also look at the work in relation to the markets and people the photographer wishes to promote to, does the image selection and presentation make sense for those markets and those buyers?

Always open with a strong first page that makes me want to see more. You should also finish your portfolio with a strong closer. Don't try to fill your book or portfolio out. If there are some images left over, use them elsewhere such as in a promo. And if I reject a personal favorite during an edit then I tell the photographer to print it and stick it on their wall.

I look at what is strongest in the images. What stands out and grabs my attention? Does it tell a story and take me on a visual ride? Does it show a unique and consistent vision? Does it draw me in and if so, why? What, if anything, moves me? Unless your work evokes an emotional reaction of some sort in the viewer, then it will not stand out or be memorable.

Q: Anything else you would like to add on the topic of creating a portfolio that sells?

A: Three rules: generally less is more, always show your best work, and all roads lead to your Web site.

Promotion Pieces

Promotional materials are generated from many sources. It is unlikely you can have too many promo pieces, but you can easily have the problem of unrelated promotion pieces. Decide on your marketing message, write your marketing plan first, and then design your promotional material.

To start, let's look at where promotion pieces come from. Leftover direct mail or ad reprints may not be your first or best choice. You need promotion pieces designed for their intended use in *sales correspondence*. A co-op approach of combining the talents of a creative team to reduce the cost is a popular technique for producing promo pieces. Be careful using this approach for your primary promotion pieces as they are rarely produced on any kind of deadline or schedule you can count on.

PRIMARY PROMOTION

The most basic need next to your portfolio is your *primary* promotional material. They can be inexpensively and nicely done, the key is planning good design and production, not just spending money. These are *not* direct mail promotions. Go back and re-read chapter 15 since promotion pieces and direct mail are very often confused. The difference is their purpose. The purpose of a promo piece is correspondence and announcement. A promo piece is to remind the client to hire you. These are the primary visual pieces used most often for sending ahead to get an appointment or for leaving behind after showing a portfolio, or for mailing after a follow-up call. They are usually sized for giving someone at a portfolio presentation or to be filed (and kept!) by the client. They can be digital or print depending on what your targeted clients prefer to keep on file.

There are still many ways to produce primary promotion pieces including digital, photographic prints, laser color copies, inkjet prints, and black and white prints. Inkjet prints are the most popular and mounting any of these to card stock or printing on a heavier card stock improves the perceived value of the piece. These methods work best when you have a small number of pieces to print (or are just starting out and have very little money).

With a larger print run, you may want to invest in digital printing where you can get a better per unit price. Outsourcing the printing of your promotional material may cost more money, but will be less labor in the long run and a lower per unit ink cost than printing in-house. New technology including POD (print on demand) allows you the freedom to change the number of pages you print, page quantities, and even binding techniques if you are making booklets. You don't have to spend a lot of money for promotion pieces to do them well. Design and quality of production is the key no matter how you print your promotion pieces.

Keep it simple; your goal is just to present images and contact information. Look at how beautifully and simply Andy Marcus of Fred Marcus Photography presents their work. Jesse Diamond (see page 171) adds clever copy (*drive: a winding road of mood and mystery . . .*) to his images and contact information.

...*for all the moments*...

©Andy Marcus/Fred Marcus Photography

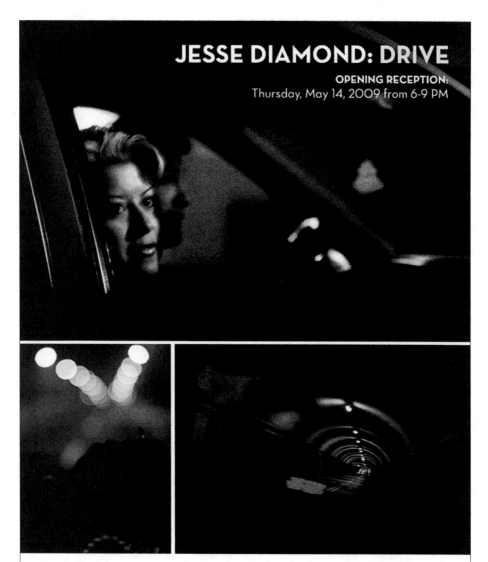

Photography by Jesse Diamond

SECONDARY PROMOTION

Secondary promotional materials are all about information. They are added to your inventory of promotional materials once you have the visual primary materials for your send ahead and leave behind sales correspondence. They are an addition to the visual materials and are very important for marketing of any field of photography. Consumer or commercial clients—no matter who you are promoting to—they all need more information than a pretty picture. Who are you and what makes you special? What will clients need to know to make the decision to hire you? What other information will help clients decide to hire you or come back again?

A secondary promotion piece is the best way to package your *images* with this valuable *information*. Some examples of this information: your specialties, facilities, location, contact information, biographical information, professional memberships, client list, client testimonials, marketing message, published work, social media contacts, and publicity reprints.

Your images and this information can be packaged into promo pieces such as capabilities brochures, text-only pieces, newsletters, client project materials, mini-portfolios, and specialty advertising items.

CAPABILITIES BROCHURES

A capabilities piece can be flexible to work for each of your studio's different marketing messages. Each version should include all the information basics (your background, client testimonials, client list, professional memberships, equipment available, facilities inventory, and a map to your studio). Then you can add different image inserts for different messages. By combining your primary and secondary promotional materials you can create a flexible capabilities brochure.

The most flexible format is a presentation folder (customized with your logo label on the front cover) and inserts printed in advance or printed as needed, depending on the client. This format is the most easily used and customized for individual client presentations. This is especially important in today's new marketplace where you need a number of marketing messages to build a successful business.

Folders are also a good design because they are adaptable to any situation, such as send ahead or leave behind. Note: this is *not* a direct mail piece but it works very well as an *offer* in a direct mail campaign. For example, in the direct mail, the text would read, "Call for our capabilities brochure." It is also a multiple purpose piece. Besides using it as a promo piece, it can be included in cost proposals to add power and impact to packaging your price (chapter 12).

TEXT ONLY

Information promotion materials are great supplements to the visual materials. These pieces can be used for both the consumer (wedding/portrait) client as well as

the commercial photography clients. For example, you can design and print a studio locator map that can stand alone or work in a capabilities brochure. Professional membership volunteer work and background information on you and your studio are important. Who you are as a person can help a client decide to hire you. Another example is a page of client success stories or testimonials. One design tip: when you quote a client, use only his or her name and job title. When that client changes jobs and goes to another company, your piece will not become obsolete. List the client company names separately from the people who work there so you get a longer shelf-life from the promo piece.

NEWSLETTERS

A newsletter is an intimidating prospect for photography promotion. You may decide to deal with this as an Internet marketing tool (see chapter 8). Now, with in-house desktop publishing software, RSS, and e-mail, newsletters are growing more popular. They are labor intensive and time sensitive and take a lot of commitment. You have to come up with some interesting and newsletter-worthy copy and images on a regular basis. Adding newsletter-style editorial content to your Web site is one way to help motivate clients to come back and visit.

CLIENT PROJECTS

Your clients' printed pieces (or even Web sites) displaying your photography will create an opportunity for secondary promotion pieces. Your design challenge will be how to turn their work into your promo piece. It is worth the effort since clients have spent all the money on the production and all you have to do is get their permission to use it for your self-promotion and figure out how to add your promotional information to the piece.

Corporate event photographer Marc Grauer of Specialty Imaging International uses the interactive green screen background digital prints his clients receive to demonstrate one of his firms many services (see page 174).

MINI-PORTFOLIOS

The mini-portfolio is not really a portfolio at all (see chapter 17). It is a sample portfolio given to a client as a promo piece to keep in file. The ultimate combination of concept, design, copy, and photography comes together to produce a real keeper. It is a promo piece you can use as an offer from your Web site, ads, or direct mail. Good design and planning does not mean spending a lot of money. The most flexible format for a mini-portfolio is a CD, DVD, or print presentation folder (add your logo label to personalize the cover) with inserts printed in advance and used as needed, depending on the client. This format is also the most easily used and customized for individual client cost proposal presentations. Flexibility and convenience is the key.

Photos courtesy of Specialty Imaging International

Remember that the central issue in creating promotion pieces is to understand the targeted clients' needs and help them see that you are the one to meet those needs. Great images, relevant copy, and a good design plan tying it all together will help convey that important point to prospective clients.

SPECIALTY ADVERTISING

When you have done everything else, you can get creative and design a specialty advertising promo piece. Again, being creative does not mean spending a lot of money. These promo pieces tend to be best used for name recognition and reminders, rather than traditional sales promos.

They are useful items (pens, notepads, coffee cups) that you give to your clients. You can order from any catalog supplier of specialty advertising. Some creative ideas for photographers are: blank greeting cards, calendars, and the mouse pad or screensaver. Whatever you choose, make sure it echoes the marketing message of your primary promo pieces and is nice enough for the clients to want to keep! The quality of the specialty item will reflect on the quality of your work.

CASE STUDY: PRODUCING PROMO PIECES, STEVEN E. GROSS (*WWW.REALLIFEWEDDINGS.COM* AND *WWW.STEVENEGROSS.COM*), TONY BLEI (*WWW.TONYBLEI.COM* AND *WWW.TONYBLEI.BLOGSPOT.COM*), JESSE DIAMOND (*WWW.JESSEDIAMOND.COM*), HENRY LEHN (*WWW.LEHNPHOTO.COM* AND *WWW.CAFESHOPS.COM/ANGELFOOD*), AND JULIE DIEBOLT PRICE, (*WWW.JDPPHOTOGRAPHY.COM* AND *WWW.BABYBOOMERSDIGITALPHOTO.COM*)

Q: What have been the main issues you have encountered with the design and production of your promo pieces?

Steven E. Gross: My present promo is a box of matches that I pass out to pretty much everyone I meet, and I leave some everywhere I go. I order them in lots of 10,000 so I try to use a different photo each time I order them since they last so long. It's a very simple promo that people love and use more than once.

The biggest problems or obstacles have been finding a good quality printer who can deliver a good quality product . . . matches that work and don't break. The lead time on a specialty product like this is usually three to four months once you order. I use the same graphic designer for everything I do. I have done simple post cards in the past and they, too, have been very good for business.

Tony Blei: A year ago I was doing it all myself: photography, design, and mailing. I would like to tell you that I was very successful, but that may not be the case. Sure, all of my friends got a kick from my funnier pieces, but it was pointed out to me that I wasn't effectively reaching my target audience. The hardest thing is creating something that

engages your viewers and causes them to react. You want them to become interested, go to your Web site, call in your book, and then hire you.

It's important to have a targeted audience to market to. Not knowing who you are marketing to will not only cost you money, but also ensure that you never get any business from that company. If you have ever received a postcard from a dating service but are married, you know what I mean. That postcard goes right into the trash. Clearly they don't know you.

Last year I hired an editor and a graphic designer to help me with my image and promotion materials. Based on what I submitted, the editor chose the images for my portfolio and created a year-long marketing campaign. She also polished my list of people to market to and tailored everything to fit.

Technology is a beautiful thing. My designer created a template for e-mail that matches the template for postcards. Since a year's worth of images have been selected, all I have to do is drop in an image.

Two days ago I sent out 3,000 e-mails. I know exactly how many people opened those e-mails and how many clicked through to my Web site. By doing this I saved a ton of money. A postcard, with postage, costs about $1.50 each. Mailing 3,000 postcards would cost $4,500, and mailing those cards every other month comes to $27,000 a year. I can buy a block of e-mails from Agency Access that cost about $.04 each e-mail. From there I can see who might be interested and then send a postcard. My postcard costs drop from $4,500 to about $100.

Because I have a plan, I know what to do and when to do it. According to the experts (and my wallet), we're in a recession. Yet I know that every six to eight weeks I'm going to send an e-promo. I will then follow up the e-promo with a postcard and lots of phone calls. My goal is to direct my audience to my Web site and have them eventually call in my book and hire me.

Jesse Diamond: You have to start with a strong marketing message when you are preparing to sell yourself and your work. My photographs are made from an initial response to real life moments. I use my camera as much as it uses me to find those rare instances or singular images that can extend beyond a verbal description. These moments of connection create a seemingly endless drive to look closer at the world, essentially, to find an understanding of my place within it.

I use inkjet prints and have them bound together by a professional bookbinder. I also worked with a designer to create a general presentation theme around the selected photographs. About once a year I'll invest in a new promotional booklet. These I like to use as mini-portfolios so the same designer and I will create the look based on the larger portfolios.

Henry Lehn: The design portion of my promotional materials was no problem, since I have been a graphic designer and art director most of my professional life. I had a full color 5 × 7 postcard printed of an award-winning photo to promote my photography

further when I won the grand prize for *Popular Photography* magazine's *Assignment Puerto Rico.*

In terms of production and printing of four-color jobs, color issues seem to be the most prevalent problem. If you produce a piece on your home computer that is not calibrated to the profiles of the printer's system, you usually get surprises when seeing the printed piece. A press check is advised to make sure all is running smoothly.

For very small print runs of a card of brochure, I will print them on my home printer. It's more work, but I get what I see on the screen.

Julie Diebolt Price: Absolute top priority is getting a written testimonial from happy clients as each job is completed. There is no better time to get it in writing! Then, I use it in all promo materials.

My biggest problem is cost for design. I have trouble justifying the cost because I can design my own promo pieces (just because I can doesn't mean I should). DIY (Do It Yourself) equals not the best design and often not very creative.

Other problems to overcome include making time for writing and producing the promo materials or delegating and follow-up of same. I do postcards and e-mail. My business cards are updated every eight months to one year. I will be updating my media kit as I send out press releases as often as my company news can be created. Social media is important (Blog, Facebook, LinkedIn, Twitter), and I have video on my Web site and a DVD for eBook. I also use my radio interview posted on the Web site.

My success has been when people recognize my business and/or name, getting referral business, and being found on a Google search or in a social media venue. The more promotion that's in print *and* online, the more my name will come up to the top of a search.

Public Relations

Getting publicity from a plan for public relations is still one of the best but least utilized forms of self-promotion for photographers. It is under-utilized simply because most photographers feel it is inappropriate to promote how great they are. Quite the opposite is true. This may *feel* strange but if you are not shouting your name from the rooftops, then who will? Besides, where do you think the media get the news? After natural disasters and tragic accidents, news comes from the press releases businesses like yours are submitting. By putting your feelings aside and with a little planning and research, you can easily add public relations to your marketing and self-promotion plan.

To most simply define it, a public relations campaign is the process of getting all types of people to discover you (through publication by the print and online media) and remember you. In today's competitive marketplace, being recognized can give your marketing plan a cost-effective and valuable helping hand.

A public relations campaign also gives you the one thing you can't buy with any Web site, advertising, or direct mail campaign. Because it is third-party proof, it gives you credibility. You must submit your story and be accepted to be published, and this gives you the credibility and an aura of being *chosen*. You don't get publicity just because you are a great photographer. You get publicity because you submit newsworthy information that gets accepted and then gets published. It works to strengthen and support your other marketing efforts. Another major benefit is the creation of additional promotion material from reprints of any public relations. You can use these reprints for secondary promo pieces or cost proposals to supplement the promotional materials you design and produce on your own.

Start today to incorporate public relations in your marketing and self-promotion plan. Review the ideas in this chapter and add to your marketing plan. Get a folder and start an ideas file for your public relations. You can build this file from articles you find about photographers in the media—both printed and online. This will give you an idea of how stories are written from submitted press releases.

Schedule a quarterly review of your public relations. You'll be more likely to come up with something newsworthy if it is on your calendar than if you just wait around until something happens.

Technology is changing this field as I write this. Look at blogs and social media networks as public relations forums as well as the traditional techniques. With blogs and social media, we can explore the four most popular possibilities for public relations for your photography business: planning and writing press releases, entering and winning awards, events and programs, and presenting photo workshops

PLANNING AND WRITING PRESS RELEASES

The most common tool of public relations is the press release. The press release is a standardized form of submitting some newsworthy item to the editors of publications. Upon evaluating your press release, the editor then decides whether or not to accept your news for publication. There are no guarantees you will be published and the protocol of publicity does not allow you to call and ask to be published! The value of publicity is the acceptance of your submission and is a form of a third-party endorsement that provides the credibility.

It is simple to write and submit press releases. You start with a media list (names of both print and online publications) that is up-to-date with the name of the editor that reviews press releases. It is a good idea to check the publication's Web site and find the name of a specific editor that deals with business press releases like yours. Another option is to study the publication's Web site for *press release submission guidelines*. Many releases today are submitted either online or by e-mail.

Be sure your media list includes print and online magazines, newspapers, and newsletters read by your clients, your community, and your peers. For example, client media would be a trade publication, community media would be your local newspaper, and your peer media would be photography publications.

Client publications are an obvious choice for submitting your press releases. You want to publicize yourself to people who buy your photography. But that is not the only publicity you seek. Everyone reads the local paper and, because the goal of public relations is repeated exposure of your name and firm, some of this exposure will influence clients. This exposure will also help you build towards your 3-R's (*repetition, recognition, response*). If you are not sending your press releases to print and online publications, you're missing out on the chance for great promotion, referrals, and some great reprints. The only cost to you is the time to write the release and submit it.

PRESS RELEASES

You may want to use a Web news release service such as *www.prlog.org/*. Be sure to include your Web site URL in your press releases. Every link to it increases your popularity to search engines. Here are some examples of newsworthy items for you to submit a press release to all of the media: client, community, and peer.

- Have you recently opened or moved your business?

- Added a new business relationship—gallery or rep?

- Have you been selected for a juried show or exhibit?

- Are you involved in any public service projects?

- Have you been elected to an association board or committee?

- What is your most recent unique or new service?

- When will you complete your next interesting client project?

The news must truly be of interest and value to the readers of the publication. Blatant self-promotion that just advertises your photography will not be accepted and reduces your credibility with the editor. However, the more you submit newsworthy items, the more likely you will get published. So get busy and start planning ideas based on the above list.

When the editors get to know what you do as a photographer, they may call on you when they have their own story ideas and need an interview or a quote. Remember, you have no control over the media, which of course increases their value and credibility when they select your news to publish.

The press release format is specifically designed to be read quickly and give the editor an immediate sense of your news. Include all the facts (who, what, when, where, why) in the first few sentences without flowery descriptions or adjectives. Double spacing is required for releases printed and mailed to allow the editor to work right on the release, adding comments or editing notes. If submitting online, follow all instructions.

The date and the phone number at the top are required information and the ### at the end indicates there are no following pages (this is automatically added when you use an online submission service such as prlog).

Always write in the third person and don't forget to enclose a photograph that illustrates your news. Only send your press releases by e-mail when the publication solicits your news in this format (check the Web site first). Here are some sample press releases. Follow the below format and when you print your releases, be sure to double space and don't forget to include visuals or photos whenever possible!

FOR IMMEDIATE RELEASE

MEDIA CONTACTS:
 Three Girls Media & Marketing Inc., (408) 871-0377
 Erika Taylor Montgomery
 ErikaMontgomery@ThreeGirlsMedia.com
 www.ThreeGirlsMedia.com

After School Photography and Arts Program for Kids Launched by Foster System Success Story

Local Photographer Helps Neighborhood Children with Fostering Creativity Program

SUNNYVALE, CA. September 8, 2009 — Photographer Melanie Jones, one of the twenty percent of foster children to graduate high school, now works as a landscape photographer out of her Sunnyvale home, where she recently launched Fostering Creativity, a nonprofit after school program for foster children. In addition to homework help, Jones offers photography, art, and career classes, bringing in speakers who have been through the foster system and overcome challenges to succeed. Jones hopes to give these children a chance to rebuild their lives and choose a different path than their parents, many of whom are imprisoned.

Felicia Carrey, age thirteen, has been attending events at Fostering Creativity since its inception in January 2009. She says that she has already noticed an improvement in her grades. "It's different here, because they really want you to succeed," says Carrey, who is now reading at grade level. This can be said of only sixteen percent of foster children.

Jones is incredibly proud of the work that she and her dedicated volunteers are doing. So far, Fostering Creativity has served over fifty children from neighborhood schools. Jones says, "I lived in eight different homes in six cities, attending seven different schools during my ten years in the foster care system. No one knows like I do the importance of giving these children a strong sense of community and an education that will follow them even as they change homes and schools. This consistency is vital to their success."

ABOUT FOSTERING CREATIVITY
Fostering Creativity is a nonprofit organization founded in January 2009. This program gives kids ages six to seventeen the opportunity to speak one-on-one with foster care system success stories and offers photography, art, and career programs

in addition to personal tutoring. Fostering Creativity aims to assist children to graduate high school and transition into an independent and successful lifestyle once they outgrow foster care. Please visit *www.fosteringcreativityisfake.com* for more information.

ABOUT MELANIE JONES
Melanie Jones, 30, is a landscape photographer. She is most well known for her long exposure nighttime photos of city lights. Jones' *Meteor Shower Over the Bay* series was featured at the San Jose Museum of Art in May.

Jones' childhood was far from idyllic. Her father was out of the picture before she was born and her mother, Janette Woods, was unreliable at best. After her mother was sent to prison on drug charges, Jones was moved into the foster care system at age eight. At age sixteen, a troubled and rebellious Jones was placed with the Farmers, a couple in their forties. For the first time, Jones had parents who showed interest in her life, encouraged her to do well in school, and showed her that she could make a new life for herself. With the Farmers' encouragement, Jones was able to graduate high school. Jones went on to graduate from West Valley College with an associate's degree in photography. Since she left the foster system, Jones has reconnected with her mother, who was released from prison in 2001 and now works with Melanie at Fostering Creativity, calling her daughter "an inspiration." For more information, please visit *www.fakephotographer.com*.

* * *

FOR IMMEDIATE RELEASE

MEDIA CONTACTS:
Three Girls Media & Marketing Inc., (408) 871-0377
Erika Taylor Montgomery
ErikaMontgomery@ThreeGirlsMedia.com
www.ThreeGirlsMedia.com/

Local Photographer Receives Joan Todd Award

Caleb West Recognized for Outstanding Portrait

MONTEREY, CALIF. August 1, 2009—Caleb West, a Monterey native and photographer for sixteen years, is proud to announce that on July 30 he was honored

with the Joan Todd Award for Outstanding Portraits. His winning photo, taken in Bandera, Texas, on a cross-country road trip, features a young family relaxing on the front steps of their house while a For Sale sign looms in the foreground. The photo paints a brutally honest picture of today's housing market. The rate of homelessness in Texas alone has increased by 28 percent in the last two years, and the foreclosure rate has nearly doubled. To view the winning photograph, please visit *www.winningfakephoto.com*.

The Joan Todd Award is given annually to a professional photographer whose portrait photograph epitomizes the style pioneered by Joan Todd. Todd, a New Yorker, made her mark in the photography world in 1988 at age twenty-eight, when she took her black and white camera and her Volkswagen Rabbit and set out to photograph what she called "Unseen America." Todd is well known for her unexpectedly moving images of ordinary Americans.

When asked for his reaction to receiving the award, Caleb West said, "I feel so privileged to be in a class with such talented photographers. Joan's work inspired me to become a photographer, so this award has especially deep meaning for me." West has long cited Joan Todd as his greatest influence, and said that he could imagine no higher honor than to receive the award bearing his role model's name.

ABOUT THE JOAN TODD AWARD
In order to be eligible for the award, photographers must reside in the continental United States. All photographs must be in black and white. This year is the third year that digital photos have been allowed entrance into the contest, as Joan Todd has traditionally focused on the feeling of the pictures, rather than the technology used to capture them.

ABOUT CALEB WEST
Caleb West, age thirty-seven, discovered his passion for photography at a young age. He always had a camera in his hand, starting at age eleven. After high school, he worked for a number of small photography businesses, photographing weddings before striking out on his own as a traveling portrait photographer. West has been working as a professional photographer for 16 years, during which time he has lived in seven states. He has visited all fifty states, where he goes to small towns, photographing people in their real lives. He recently established his Monterey travel photography studio. For more information, please visit *www.fakeurl.com*.

* * *

MEDIA ADVISORY

A Media Advisory uses a very different format and is specifically intended to announce events like a gallery opening. This format will be used instead of the press release format.

FOR IMMEDIATE RELEASE

MEDIA CONTACT:
> Three Girls Media & Marketing Inc., (408) 871-0377
> Erika Taylor Montgomery
> *ErikaMontgomery@ThreeGirlsMedia.com*
> *www.ThreeGirlsMedia.com/*

MEDIA ADVISORY
> WHAT: *"Grand Opening: Chris2x Studios"*

> All are welcome to join published travel writer and experienced photographer Chris Christensen to celebrate of the grand opening of his new Carmel studio. This open house extravaganza will be a night of food, fun, and photos, with refreshments provided by Peppers Restaurant.

> The Grand Opening Special will be available to all attendees, entitling them to 10 percent discounts on all prints.

> Admission is free, no RSVP required.

> WHEN: Friday, August 21, 5 pm–8 pm

> WHERE: Chris2x Studios
> Carmel Plaza, 1664 Ocean Ave
> Carmel-By-The-Sea, CA

> RESERVATIONS: (555) 408-9648

ABOUT CHRIS CHRISTENSEN
Chris Christensen, a former software engineer turned travel writer and photographer, discovered his passion for photography during family vacations around the globe. Chris gave up his day job after 25 years to follow his passion for travel. He now travels the globe giving travel writing and photography workshops and experiencing the wonders of the world. For more information, please visit *www.notarealurl.com.*

* * *

FOR IMMEDIATE RELEASE

MEDIA CONTACT:
 Three Girls Media & Marketing Inc., (408) 871-0377
 Erika Taylor Montgomery
 ErikaMontgomery@ThreeGirlsMedia.com
 www.ThreeGirlsMedia.com/

MEDIA ADVISORY
 WHAT: *"Workshop: Travel Photography"*

Join published writer and experienced photographer Chris Christensen in beautiful Carmel to learn about:

• Finding the best equipment for a light packer

• Manual exposure for landscape photography

• How to photograph people

• Taking advantage of natural light

This workshop will focus on capturing the best photos with a moment's notice, and is suitable for beginners and advanced amateurs. Registration required.

WHEN: Saturday, September 12, 9 a.m.–3 p.m.

WHERE: Chris2x Studios, Carmel Plaza, 1664 Ocean Ave
 Carmel-By-The-Sea, CA

COST: $65 per person

RESERVATIONS: (555) 408-9648

ABOUT CHRIS CHRISTENSEN
Chris Christensen, a former software engineer turned travel writer and photographer, discovered his passion for photography during family vacations around the globe. Chris gave up his day job after twenty-five years to follow his passion for travel. He now travels the globe giving travel writing and photography workshops and experiencing the wonders of the world. For more information, please visit *www.notarealurl.com.*

* * *

ENTERING AND WINNING AWARDS

When you are just starting or changing your direction, award competitions can give you a great head-start on promotion, and winning will give you important public relations experience and credentials.

Research all the industry publications with *call to entry* juried programs. In addition to the usual photography industry magazines, look at the visual arts and graphic arts magazine award programs. Many of them have photography categories of submission. For the consumer photographer there are community associations with award competitions as well.

When you win, you get credibility and exposure with print and online publication of your winning entry. Then, you get to write your own press release for the news, further expanding on the equity you are earning from the investment of your entry fee.

Before you get started, read the entire call for entry submission carefully noting any areas needing special time, attention, and preparation. Review past publications to see the winning entries. The information you should be looking at before you enter any competition will include:

- Competition name

- Contact and shipping information

- Deadline

- Any eligibility issues

- Fees

- How winners are notified

- How and when (and if) entries are returned

- Usage of images and retention of copyright by you

- Exactly what you are submitting and the format (prints, CD) required

EVENTS AND PROGRAMS

You can also publicize, build name recognition, and help clients get to know you by non-selling event promotions. Here are some event ideas you can use to promote your business.

Working on a pro-bono community service program brings you in contact with influential community leaders that do a lot of public service. The work itself is a great way to get printed pieces for your portfolio and promotion.

Speaking at association events is a great way to meet potential clients and gives you the chance to write a press release. Here's an important tip: if you're new to this

kind of promotion, start out with participation on a panel of speakers; there is less pressure on you!

Sponsoring an event or program at your studio is a nice option. It is less pressure on you to be on the spot as you are just the host. It may even be a more attractive invitation for your clients to come and visit your studio space when there is something fun or interesting going on there. For example, a commercial photographer brings a public relations firm to the studio to host an event called, "Boosting Sales with Public Relations." A wedding photographer creates an invitation-only "Bridal Fair" at his or her studio. A family portrait photographer brings in a specially qualified instructor for a "Mommy and Me" exercise event. All are very newsworthy! The marketing theory is that if clients found their way to your studio once to have fun, they can do it to again to give you a job.

PHOTO WORKSHOPS

The business of photography workshops is a wonderful source for press releases and promotion. It has other benefits as well. Teaching photography workshops gives you *backstage* access to people and places so you can create unique images for your portfolio, it provides an additional income source from selling stock and prints, and it helps generate press releases. Most of all, it lets you follow your photography passion.

CASE STUDY: BENEFITS OF PUBLIC RELATIONS, ERIKA TAYLOR MONTGOMERY, CEO OF THREE GIRLS MEDIA, EXECUTIVE PRODUCER OF BUZZLE TALK TV & RADIO, AND CO-HOST OF GIRL TALK TV (*WWW.THREEGIRLSMEDIA.COM* AND *WWW.BUZZLEDOM.COM*)

Q: What is the true value of publicity to a photo business?

A: Credibility, visibility, and brand exposure. Publicity, not advertising, gives clients the confidence in your skills and expertise as a photographer. How often do you pay attention to the advertisements in the magazines, newspapers, and Web sites you read? If you're like 98 percent of Americans, the answer is never. Being mentioned in an editorial feature is excellent publicity because it's the features and articles that consumers pay attention to.

Some people may argue that ads give them complete creative control allowing the company to toot its own horn, choosing the exact words it feels best represent itself. Even if a photographer claims expertise in his or her ads, people are likely to be skeptical simply because of the fact it is an advertisement.

A strategic publicity campaign can also help photographers become well-known for certain skills or styles. If they are a technically innovative, have extremely unique artistic viewpoints, or other noteworthy talents, a good public relations plan can help create, brand, and solidify their place in the photography industry and with potential clients.

Editorial space in all media outlets is highly coveted. Everyone wants to be featured on the pages of magazines, newspapers, TV, and Web sites, and heard on the radio because it puts them in the limelight. It makes sense that whether it is a brief mention or a full-length article, photographers chosen by a media outlet to grace their pages—or airwaves—gain valuable exposure from the experience.

If your images or services are featured in any media outlet, you've instantly become exposed to thousands, tens of thousands, or even millions of viewers or readers that likely didn't know about you before. This may not translate into instant sales, but it will have planted a seed of awareness about you that wasn't there before.

Q: What other public relations tactics do you recommend besides sending out press releases?

A: Press releases as a tactic have a time, a place, and a purpose. If your goal is to increase Web site traffic, a formal press release with the right key words may be a good choice. But if your aim is to secure editorial coverage in a media outlet, individualized story ideas or news sent to specific reporters and editors often result in much greater success and a higher level of media coverage.

Blogging is one of the hottest and cost-effective publicity tools available to photographers. Blogs, if managed properly, can dramatically increase search engine rankings and Web traffic while simultaneously building credibility. Some successful blogging sites offer pre- and post-photography tips, trends, and, of course, plenty of their best images.

There are a few rules for blogging that should be observed. It's important to keep a blog updated regularly, at least three to four times per week. The content of the blog should be related to photography and be interesting, helpful, or educational posts. Don't forget to show off the best-of-your-best images on your blog. Remember that it is okay to post content from other sites, just as long as you attribute your sources.

The popularity of social media sites such as Facebook has exploded in the last few years. Starting a free fan page is a great way to do a variety of things including showing off your photos. Facebook friends can post testimonials on your wall; other Facebook users can contact your Facebook friends as references and much more.

E-newsletters are also a fantastic publicity tool. They offer a great way to communicate regularly with your past and present customer base. Showcase your latest accomplishments or projects, remind people of what services are available, announce media coverage, and think outside of the box to develop more ideas that will communicate specific skills and talents. Spread the news about your latest clients or projects, share testimonials, and more.

An e-newsletter is equally as cost-conscious as a blog, but can also include additional features such as an advertising component with a coupon or special offer. There are several quite inexpensive sites that offer templates and distribution of e-news, one of the most popular being Constant Contact (*www.ConstantContact.com*). These sites also sync with your online database, making distribution exceptionally easy.

For maximum effectiveness, ensure your e-newsletter is distributed at least once per month, preferably twice. Each story should be short and sweet, three to four sentences at the most. A good rule of thumb is that consumers should be able to skim your e-newsletter in sixty seconds or less. Attention spans have become much shorter in the Internet age, so keep your e-newsletter brief to keep clients reading instead of deleting.

Another tried and true public relations tactic is to hold an event. You can keep it simple and base it around National Photography Month held each May, or create a special day of your own, such as "Smile Day," any time of year. An event is a great way to show off your work and meet plenty of potential clients. Besides a theme, some balloons or other simple decorations, food, and offers of discounts, complimentary invitations, or prints for those who attend is all you need to build a fun event. More elaborate events include music or other special activities like an amateur photography contest.

If gaining new business is a key part of your public relations plan, consistently attend networking events and seize each opportunity to meet potential new clients or other professionals in the industry. Begin promoting your services in-person, on a local level, and always attend with a portfolio. As the old cliché goes, a *picture is worth a thousand words!* If the event offers display tables or sponsorship opportunities, consider taking advantage of them for greater visibility.

Investing in good collateral such as note cards that you send out to current or potential clients is another desirable public relations tactic. This is a great way for you to stay top-of-mind, especially around holidays and special occasions such as birthdays, anniversaries, graduation season, and more. Sites such as Vista Print (*www.VistaPrint. com*) often offer free products and ask you to only pay for shipping. There are hundreds of templates to choose from, making designing your collateral exceptionally easy and affordable.

When it comes to successful public relations tactics, don't forget to do a little bit of reconnaissance to stay up-to-date with the field and what your competitors are doing. Visit the competition's Web sites regularly to see what public relations activities they may be engaging in.

Q: Is giving art prints to charities for fundraising auctions still a valuable public relations technique for photographers?

A: Many charitable events offer opportunities for photographers to give away art prints or special sittings. But don't expect too much; aside from the mention of your name and the building of goodwill through generosity in front of the crowd, participation is likely to gain nothing more than warm feelings for the donor. A more effective course of action might be to offer new art to display each month at a popular café, coffee shop, or bookstore instead. Even some donut shops are displaying art these days! Participating in Farmers Markets or local festivals is another way to keep visibility high and it gives you the opportunity to meet one-on-one with a large number of potential clients. Hand out promo pieces or coupons at the event and you could even do casual sittings at the event. You'll have a larger audience over time and could earn business in the long run.

Q: How do photographers generate publicity if they are not ready to hire a public relations firm?

A: They should start by making a list of goals that they wish to achieve through their publicity efforts. Is the number one priority to drive traffic to your Web site? Is booking more weddings on the top of the list? Setting clear, measurable goals for the next six to twelve months will help to develop the tactics needed to turn intentions into reality and help you see whether you've attained them.

Creating a strategic, targeted plan with a timeline is a must for photographers who want to promote themselves without the assistance of a public relations agency. Research the types of promotional activities that will help you attain your goals. Is it authoring an article for a regional wedding magazine? Starting a blog to drive online traffic? Then, put those activities into a realistic, step-by-step plan that is truly manageable considering your time, skills, and confidence level.

Once you have your goals written down, research the best ways to obtain the goals. If you want to book more weddings, think about brides, where they shop, how they research, then figure out how to gain visibility in these places. It could be as simple as asking a shop owner if you can leave promo pieces in the store. If one of your goals is driving traffic to your Web site, make sure your site is optimized for search engine rankings, and that you're taking advantage of all the social media opportunities available today such as Facebook, Twitter, and Digg.

Hiring a public relations agency for an hour or two of consulting, rather than to represent you full time, can also be incredibly valuable. As experts in the field, public relations practitioners can help you develop a strategic game plan that you can then implement, and they can help with ideas, questions, or problems that arise as you move towards completing your public relations goals.

CASE STUDY: WORKING WITH A PUBLIC RELATIONS FIRM, TRISHANN COUVILLION, OWNER FIRE EYES PHOTOGRAPHY (*WWW.TWITTER.COM/FIRE_EYES, WWW.FIRE-EYES.COM,* AND *WWW.FIREEYESPHOTOGRAPHY.COM*)

Q: What made you decide to work with a public relations firm?

A: Photography is such a great expression of talent, skill, focus, and hard work. To help me become a photographer who is consistently in demand, I have found that working with a publicist helps me get focused on how to best help my clients and serve them in a way that uses my talents to the fullest extent. Publicists are idea people and they are the area of strength I need so I can focus on what I do best, which is making captivating images.

In all of my work, be it wedding photography, corporate events, family portraits, or high school seniors, my goal is to capture the real moments. A publicist with the ability to formulate publicity ideas and create a game plan as to how to gain recognition

of my *real moments* work has been essential to my growth as a photographer with a unique style.

Q: What recommendations would you make to a photographer who is seeking an outside firm?

A: Consultations with a few publicists is a good idea, as you will be spending some good creative time with this person or firm and paying him or her to help grow your business. Get to know publicists' style, approach, personality, and see the way they formulate ideas. Some publicists will work with you for a period of time or one job at a time. Ask how much of the actual implementation of ideas they will be responsible for. Will they actually make phone calls or write letters and e-mails on your behalf to editors and TV producers for publicity exposure? Will they just give you a list of ideas to do your own calls? Talk about your options and ask what type of creative professionals they have worked with prior to you and ask to see examples, online or in print, of ideas that were put into motion from their past and present clients.

Q: How has publicity helped you build business? Is there any type of photo client who responds better to publicity than others?

A: Publicity, especially strengthening my online presence, has proved valuable in gaining new clients. This year I began a workshop-style promotion called *Free Friday Photo Assignments* on my Fire Eyes Photography Facebook page. Anyone who has become a fan of my page has access to the videos that I post each Friday with instructions on the simple assignments I create each week where the student can go out, shoot the assignment, and e-mail me the images for personal critique. I offer this as a free service for anyone who wants to learn more about photography. In turn it allows my Web presence to strengthen so more clients can find me and also offers more resources to gain publicity for my business.

Today, using social media as a public relations tool to grow your business is essential. Most companies are building a strong online presence and using all of these free tools to reach out to their audience. Talk with a publicist about which may work best for your type of work. There are many options and you must focus your time and attention only on the ones that will benefit you the most.

My clients who have responded best to publicity have been corporate clients, brides and grooms, families, individuals, and couples who see my work in magazine articles, blogs, and additional Web sites showing the work I did for them.

Marketing By Association

Another often overlooked marketing tool of the successful photography business owner is networking. It is a tool to help clients get to know you. In the end, people will hire people they know. Like public relations, using associations for networking is not hard-sales. It is the connections and relationships that develop on a personal level that fall outside traditional and more direct tactics like portfolio presentations, Web sites, direct mail, and advertising. It can also *include* these direct marketing tactics—for example buying ad space on an association's Web site that will be seen by clients in your target market. As discussed in the case studies and throughout the chapters of this book, social media networks such as Facebook, Twitter, LinkedIn, and blogs have made relationship building a more accessible and simpler photography marketing tool.

The best marketing plan is a layering of your direct marketing efforts with the indirect marketing of networking for *maximum effectiveness*. In addition to being more effective, you'll also increase your marketing equity; each single promotion effort will be worth more than what you invested when it has the support of the complimentary efforts of networking.

There are three types of associations to identify and interact with: client, community, and peer. For most of the benefits of networking, you must be a member of the association. In today's new economy of marketing, joining is just another marketing expense. Association dues are not only tax deductible, they should be considered as essential a business expense as any promotional material. Many memberships are online so it is simpler to go to Web sites and discussion forum groups and get to know people as well as have *them get to know* you—the ultimate networking.

As you read each section below, cross-reference the techniques to your current marketing plan and analyze what can be put to work immediately to market and promote your business, to find and keep new clients.

CLIENT ASSOCIATIONS

There are many ways to incorporate associations of your potential clients into your marketing strategy. Look for client associations that produce newsletters and Web sites. These can be excellent avenues for writing articles. They offer display ads (either online or print) you buy. These can be anything from banner to business card to full-page size. Because the circulation in an association printed newsletter is reasonably small compared to many of your other advertising opportunities, your ad rates will be low. Don't be misled by the small circulation! For example, it may have a total circulation of only 300 but if this is an architectural association and you are an architectural photographer then each is a targeted client for your photography. This avoids shotgun marketing. Maybe another more expensive publication offers a 30,000 circulation but only 300 are architects, then you are overpaying for your advertising. If you are concerned that the print production values of these smaller association publications are not high enough, ask for a *freestanding ad insertion* rate. This will allow you to print your own ad page and have the association insert it before mailing to members.

Look for client associations that produce directories of their members. This will provide you with a source of leads for making portfolio presentations and looking for sales calls. In addition, your own member listing in the directory is probably free or low cost and a great supplementary advertising tool to the perfect target audience. Being included as a listing in the photography section of your client's association membership resource directory gives you a boost in credentials and marketing equity. You will then be on a shorter list for clients than if they were looking at traditional sourcebooks that have bigger and more diverse photography listings.

Look for client associations that offer their membership list as a database to purchase for your direct mail campaign or sales calls. This will save time and energy researching new leads for your personal and non-personal marketing. You can make print labels for your next direct mail campaign, send out e-mails, or search/sort the names for your sales calls.

Another advantage of professional associations is the better quality of the clients you'll find. Any company or individual who takes the time and money to participate in an industry association tends to be more assertive about *their own* marketing and promotion. In other words, they are more likely to use photography than the companies that have cut their photo budgets or even started doing their own photography. They are more likely to respect the quality and value a professional photographer brings to a project. Also, since every association has recognized business practices and ethics, these clients are more likely to recognize your photography industry standards and ethics.

When you are just starting or changing direction, look for client associations that have awards programs and active committees you can join and get involved with. Nothing beats hands-on experience with potential clients to build name recognition and marketing equity. You are still not selling! This is a relationship building exercise. For example, the Hospitality Committee is an excellent choice. There's no simpler network-

ing than being the official greeter at a meeting. It is always easier to do this when you have an official responsibility. Or as program chairperson you get to call on clients as potential speakers for meetings. Publicity chairperson for an association allows you to meet and greet the local media.

Volunteer for committees and get involved with their events. Work with as many different committees as you can, especially programs, events, and awards programs. Online or in person, this is a great way to get potential clients to know you before you can get a job from them.

COMMUNITY ASSOCIATIONS

These groups include internationals and national associations as well as groups that only work within your community borders. Depending on your marketing message and targeted clients, your community could be your immediate locality or an international audience. Check with your local chamber of commerce to find the associations and charities active in your community. Check online for sources outside your local area (see the resources section at the end of this chapter)

Find something you are interested in and passionate about to guide your choice. What do you genuinely care about? It could be an environmental group, a humane society, programs for the homeless or hungry in your community, or any of the groups that work with children or seniors. Your choices will only benefit you if you have passion for the cause.

There are many benefits to your marketing strategy that come from networking with charities or community associations. Writing articles for them gives you the initial benefit of the exposure from publication, and reprints of the articles can be used as promo pieces. Also, centers of influence are people in these community associations who are the movers and shakers—people you are not likely to have lunch with for any other reason than you are both on the same association committee. Though they may not directly buy photography, *they influence people* who do buy your services. Their relationship with you is an endorsement that could be a valuable marketing asset.

Community service projects—local, national, or global—give every photographer an opportunity for personal and professional fulfillments. The desire to help others is also part of the human experience that every photographer brings to his or her work. You may feel that in today's economy helping others is somehow beyond your reach as you focus on the daily effort to grow your business. How can you use your talents to help others and pay the rent at the same time? How can you spread awareness and improve society with your photography? Answer: by donating your time and skills for important social projects that create change. This will benefit you personally and professionally.

Pro-bono or public service projects often bring together some of the community's best creative people. This is because everyone is contributing his or her time, attention, and energy to get a lot of creative freedom on the project. Often it is the only way you can

obtain access to the people and places you need to create images for your portfolio self-assignments.

These organizations usually have high-level production values from the contribution of a printer or paper company to the all-volunteer creative team. For your time and efforts you get all the benefits of a real job: client-driven projects for use in your marketing, the experience of working with clients, client references, testimonials, press releases, publicity, and client samples for your portfolio and Web site.

PEER ASSOCIATIONS

Marketing yourself through a group of your photography peers is another neglected and overlooked tool of marketing. Membership dues and participating in your peer association should be considered a necessity of business and not an option. Photographers afraid of relationships with their fellow professionals have nothing to gain and everything to lose. Join or renew your membership today.

You can't really call yourself a professional in today's marketplace without being able to prove it with those magic words, *member of.* Clients are much more educated and discerning today. Until your work is a household name, it is the quickest and easiest way for any consumer or commercial client to determine you are a professional. Maybe being judged by the company you keep and your professional associations or affiliations doesn't seem fair, but it is real. When clients want the value of a *professional* for their money they know where to look.

From your peers you get information and social media networking and both are powerful marketing tools. As a member, you will get business advice, examples of legal forms, business guidelines, supplier discounts, insurance information, and more assistance with your business from being connected than being the traditional non-joiner. You can call fellow members, ask questions, and get help.

You can get referrals; not to be underestimated as a benefit, referrals are an excellent marketing tool and most often will come from your fellow professionals. With the association online directories and the social media networks available today, other members can refer assignments to you *because they know you.*

Within your peer group, you get to practice people skills. Peer associations give you the opportunity to practice all the social and business skills you are learning—or learned and forgot how to use—that come with running a business. Many photographers do not have this opportunity in school and you certainly can't practice on your clients. When you want to learn publicity and familiarize yourself with the local and national media, join the publicity committee. When you need to overcome your reluctance to call total strangers and get them to give you work, join the membership committee. When you want to practice your management skills, join the events and programs committee. Your photography association gives you a safe place to practice. Plus, you can't get fired—you are a volunteer!

CASE STUDY: PHOTOGRAPHERS MAKING A DIFFERENCE, PAUL MOBLEY (*WWW.PAULMOBLEYSTUDIO.COM, WWW.WELCOMEBOOKS.COM/ AMERICANFARMER*) AND COLIN FINLAY (*WWW.COLINFINLAY.COM*)

Q: How do you see your photography of environmental, social, and cultural issues as separate from your commercial work?

Paul Mobley: It was not commercial work at all. *American Farmer* was born when I needed some time off from being a commercial photographer. I had this successful long run in New York and I got burned out. I took the summer off and went to my cabin in Michigan. While there I came across some of the local farmers, just sitting in a coffee shop in this little town. In that moment I rediscovered the joy of photography. I felt I had to capture the images so I started taking pictures—without any plan or direction—without any client over my shoulder. It started out as a personal/fine art project that got turned into a book and then became a beautiful and unexpected three-year journey.

As far as my business now, I am a portrait photographer first and foremost so I am looking for opportunities to photograph people in my own style. For example, at Christmas I went to the Capuchin Shelter in Detroit (*www.cskdetroit.org/*) to look for a way to photograph the homeless people coming to the shelter and bring out any sense of hope I could find. Sometimes I had to sit and talk with them for awhile, but this is what my portraits are all about—they have to celebrate an emotion, in this case, hope.

American Farmer continues to touch lives, I am constantly amazed at the level of awareness this book has brought to the family farmer. The director of the soup kitchen was astonished to receive a print of each person photographed for the project. There is so much mistrust in this world that he never expected me to follow through with the prints. The people at the soup kitchen were so stunned to receive their personal portrait, something they will treasure forever. For me, it was a small way to touch many lives at once in a profound way. It was so much more than just taking pictures of people.

Colin Finlay: The work itself is not separate because I blend the two together. The commercial work for me is just a different side of the same coin. For example, I had just come back from a photojournalism project in Pampas on the Gauchos in 2001 and the horrible events of September 11th began my entrée to the advertising world.

Fake "bright lights" and traditionally commercial images did not strike the right note for advertising clients. That particular client, Ocean Pacific, needed images of its whole clothing line for upcoming ad campaigns. The clients wanted to change direction and sought my ability to capture reality—not fake, artificial, posed images. They requested realism and a photojournalistic sensibility to highlight their products. I have my approach and style for both advertising and photojournalism projects. The ad campaigns I am shooting now still have that look and feel. It takes a special commercial client to use that type of style for an ad campaign and we find each other because that is my niche.

Q: How do you see your photography creating change and where in the world do you hope for this change? Local? Regional? National? Global?

Finlay: All of the above. My inclination to create social change through photography led to my work as a cofounder of the nonprofit organization, Proof: Media for Social Justice (*www.proofmsj.org*). Our most recent book project, *Darfur: Twenty Years of War and Genocide in Sudan*, covers three periods in the Sudan crisis of the starvation, civil war, and murder of the people of Darfur. I did both photos and writing for the book along with photographs by Lynsey Addario, Pep Bonet, Ron Haviv, Olivier Jobard, Kadir van Lohuizen, Chris Steele Perkins, and Sven Torfinn. It also includes essays by Jonathan Alter, Larry Cox, Mia Farrow, Ryan Gosling, Nicholas D. Kristof, Susan Myers, and John Prendergast.

It was published in 2007 and all proceeds from the book are donated to Amnesty International and The Genocide Intervention Network. This is an amazing project, produced in partnership by Proof: MSJ, Amnesty International, and the Holocaust Museum of Houston. The publisher, PowerHouse Books, was honored in the Fifth Annual Lucie Awards as the Photography Book Publisher of the Year. We are all connected, and there has to be a worldwide perspective to inspire an urgent and immediate increase in awareness of human suffering. Next, the exhibition for the book will premiere at the Holocaust Museum in Houston and will then go on tour.

Mobley: One of the changes I have seen with *American Farmer* is the response of the farmers themselves. I speak at Farm Bureau Conventions and have had so many people come up to me and thank me. My portraits are always about bringing out emotion, and doing that for the famers—locally, regionally, nationally—has changed the perception they have of themselves. Many farmers have commented on the affirmation and validation of what they do as a result of these images. Their comments have been amazing to me. Another change is in the people who read the book, the "normals" or non-farmers. For many people the book has changed the awareness of the most essential thing, how our food is grown and how we are fed. It has even changed the way people shop; maybe they will go to a local farmer's market instead of a big chain store for their produce. The book also has raised my awareness and credibility among "normals" and with the book as an introduction I can get into places and with people who would not speak with me previously.

Q: What recommendations would you make to photographers looking to make a difference with their photography and still pay their rent?

Mobley: I have such a love/hate relationship with this business, and in talking with young photographers (I speak at different colleges) I emphasize the importance of working hard at the business and marketing side. I think you have to start as an assistant to do this. It does not matter the area of photography, you have to experience the inner workings of the shoot and you can only get this firsthand. Being a genius-photographer in today's world is not enough. I work as hard or harder on self-promotion than making

my photographs. My book has opened lots of doors, doors that were never there before. It has been very strange to be an overnight success after working all these years.

It is hard to tell someone young to shoot what you love but that is where your style comes from. Pay your rent no matter what it takes, sleeping five people to an apartment, whatever it takes so that you can be in the environment that will build your understanding of what you can contribute as a photographer. I think the struggle will teach you to be persistent and will sustain your career.

I don't want to discourage people, I am doing so much more speaking and workshops, but it is more important now than ever to remind people you have to be a serious professional. There is no room for egos anymore, you have to be good at everything, be courteous beyond measure, and be responsible.

Finlay: To pay the rent, I worked very difficult and undesirable jobs in the beginning. You must determine how much you are willing to sacrifice. Success requires effort and you must give all or nothing.

RESOURCES

Your best reference for identifying different *client associations* is the *EA Directory* or *Encyclopedia of Associations* available in the Business Reference Section of your local library and online. Your local Chamber of Commerce, or the Web site for your city, readily identifies client associations by industry. Look to sourcebooks, such as *The Workbook* (*www.workbook.com*) to identify other client networks.

For *community or charitable associations*, find a cause you believe in. Here are some Web sites to help locate nonprofits in your area:

- GlobalGiving (*www.globalgiving.com/*)
- Charity Guide (*www.charityguide.org/*)
- Make the Difference Network (*www.mtdn.com/nonprofits.aspx*)
- Make a Difference Day (*www.usaweekend.com/diffday/*)
- Focus on AIDS (*www.focusonaids.com*)
- Be the Change, Inc. (*www.bethechangeinc.org/*)

Here is a partial list of some of your *peer photography associations*

- Advertising Photographers of America (*www.apanational.org*)
- American Society of Media Photographers (*www.asmp.org*)
- American Society of Picture Professionals (*www.aspp.com*)
- Canadian Association of Photographers & Illustrators in Communications (*www.capic.org*)
- Editorial Photographers (*www.editorialphoto.com*)
- National Press Photographers Association (*www.nppa.org*)
- PMA, previously Photo Marketing Association International (*www.pmai.org*)
- Professional Photographers of America (*www.ppa.com*)
- Stock Artists Alliance (*www.stockartistsalliance.org*)
- Wedding & Portrait Photographers International (*www.wppionline.com*)
- Women In Photography (*www.womeninphotography.org*)

Writing the Commercial Client Marketing Plan

Writing your marketing plan is the final step in the self-promotion process. In this chapter you will first see a sample marketing plan for commercial photography clients using all the tools discussed in this book. Following the sample plan are case study interviews with photographers from various areas of commercial photography. Note the differences in their marketing plans are based on their different targeted clients.

You may want to re-read the chapters that discuss the different marketing tools as you plan the work. Here is a recap of the marketing tools to be used in writing your plan. Note there is a lot of cross referencing between the tools, one referring to another. Final note: all the *actions* listed in your marketing plan outline must get transferred to your calendar. This will make sure that self-promotion becomes something you do every day and just not when you get 'round to it.

Advertising is a non-personal form of marketing designed to reach very large groups of people. It is best used when you want to broadcast your marketing message and have clients call you. With print ads, you will expose thousands of people to your marketing message. With a Web site, the reach is broader in geography and larger in potential visitors to your site. Your print ads must refer clients to your Web site and your Web site must refer clients to your print ads. Use this cross-referencing to build marketing equity; don't waste any chance to build frequency of repetition with a potential client. Remember that clients are looking at your ad or your site because they are looking for something they don't already have. Your design objective is to give clients a strong and distinct impression of your photography marketing message and to ask them to respond. Be sure to add people who respond to your mailing list.

Direct marketing by mail or e-mail is another form of promotion very popular with photographers. Direct mail is becoming more and more sophisticated with *call for action* copy added to your images as a necessary part of the design, not optional. Don't forget the visual impression you make must also match your marketing message. Always

include your Web site URL on your direct mailer or e-mail and always give clients a really good reason to visit your Web site after they receive your mailer. Invite clients to refer friends or find out more information about their photo needs with your e-mails or newsletters.

Public relations campaign is a powerful tool so you should include some form: press releases, awards, or events. Add your Web site URL as an additional method of contacting you. Mention it again in the body of the press release copy. Add a gallery of recently completed publicity projects to your Web site. Then, when writing project press releases, add quotes from clients that refer to the Web site where you show images from this project. All clients love to be included in any publicity and will check out your site to see their project. Decide how you will add social media networks to your marketing efforts.

For your *personal selling* efforts, you can successfully integrate your Web site by making sure prospective clients have the option to visit your site to view your portfolios. They can also visit the site while talking with you. Literally, it is a virtual portfolio presentation. You can also call them to suggest they see the print portfolio or perhaps a mini-portfolio they can keep. Don't forget your promo pieces!

SAMPLE MARKETING PLAN

I. WHAT YOU ARE SELLING (marketing message)

A. First, write your marketing message: *The Photography of Locations, to create images of locations, settings, surroundings, places, buildings, and environments to promote the location and to tell its story.*

II. WHO YOU ARE SELLING TO (identify targeted clients)

A. Design firms for high-end companies and ad agencies with clients in: aerospace, airline, agriculture, developers/architecture, environmental, healthcare facilities, telecommunications, travel/hotel/resort, leisure, and transportation

III. HOW TO GET THE WORK (marketing tools you will use)

A. DIRECT MAIL CAMPAIGN

 1. Need designer to create concept, photography, and plan production of response mailer that will work for both ad agency clients and design firm clients

 A. Mail every six weeks to all clients

 B. Design e-mail campaign for current clients

 C. Make a strong offer for response

D. Preferably series of single strong images

E. Objective is to get responses from purchased mailing list to create personal database and send traffic to Web site

F. Design print mailer to be re-used as a mini-portfolio

2. Need mailing lists that match prospective client profile

ACTIONS:

- Find designer/copywriter team to turn marketing message into a design for mailers

- Research mailing lists purchase

B. Advertising Campaign

1. Objective is to impress audience with marketing message and ask for response

2. Then send more information and add to personal database

3. Need sourcebook advertising campaign

4. Need domain name and Web site

ACTIONS:

- Call annual source books for current media kits

- Meet with design team for ad and Web site design

- Select host company for Web site

- Register domain name

- Announce Web site

- Schedule Web site updates

C. PUBLIC RELATIONS CAMPAIGN

1. Send to advertising and design clients media, photography peers, and local community media

2. Plan quarterly project press releases to all media

3. Start entering awards programs for both self-assignment and published work

4. Submit self-assignments to industry publications' Awards Annuals like *Communication Arts* magazine

5. Update Facebook and LinkedIn profiles

ACTIONS:

• Build database of all media/editors of publications, newsletters, and newspapers

• Research awards programs and annuals and add entry dates on calendar

• Schedule press releases and review existing projects for submission

• Check on online webinars for integrating social media with current marketing

D. PERSONAL SELLING

1. Concentrate quality time on the *A-list clients* for commercial assignments and plan monthly or bimonthly calls for follow-up

 A. Past commercial clients

 B. Past prospects for commercial work

 C. Responses to direct mail, Web site, ads, and e-mail

 D. Leads from editorial assignments

2. Portfolio

 A. Continue with inkjet prints, 8 × 10 on cover stock

 B. Need three duplicate books of each portfolio

 C. Plan subject-specific portfolios that can be pulled from, based on client of ad agency or design firm

 D. Design mini-portfolio for clients to keep on file

3. Agents

 A. Check on stock agency interest in this body of work

 B. Check on fine art rep interest in this body of work

4. Promotion Material

 A. Buy gray folders, use with logo labels for cover

 B. Add ad reprints and inkjet prints of images along with existing publicity reprints and bio information sheet

 c. Use as a capabilities brochure for send-ahead and for
 leave-behind until budget is developed for separate eight-page
 brochure

ACTIONS:

- Build personal database

- Reorganize portfolios

- Re-do inkjet prints as needed

- Research printing hardcover books for duplicate portfolios

- Design and produce print and CD-rom for mini-portfolios

- Research stock agencies and fine art reps

- Print promo materials

CASE STUDY: EVENT PHOTOGRAPHY FOR COMMERCIAL CLIENTS

Specialty Imaging LLC (*www.specialty-imaging.com*) was founded by Ben Crosby in 1999 after selling Sports Imaging, a photo business specializing in amateur sports youth leagues for team and individual photos. Ben started Specialty Imaging in Salt Lake City with a focus on the corporate event industry and the Olympic Games sponsors coming to Salt Lake for the 2002 Olympic Games. Specialty Imaging was one of the first companies to use digital imaging for the National Collegiate Athletic Association and the first company to offer totally digital imaging and photographic services to the Olympic Games sponsors for their individual corporate programs. During the 2002 Olympic Winter Games, Specialty Imaging provided a variety of services for AT&T, VISA, Coca-Cola, NBC, the U.S. Secret Service, and other companies hosting special guests in the Salt Lake area.

Marc Grauer joined Specialty Imaging after twenty-one years with the Coca-Cola Company in Atlanta where he was responsible for managing many of the company's global events. His background includes over thirty years of hospitality industry and corporate event management. Marc came into the business as an advanced amateur photographer where he always had his camera at corporate events. When he met Ben Crosby at the Winter Olympics at Salt Lake and saw how well onsite digital photography worked for Coca-Cola, Marc decided to pursue a new, exciting opportunity and partner with Ben to work in digital event photography.

The audience may be the end-consumer but their client is the corporation. Most often attendees are made up of guests who have an ultimate impact on a company's business. It may be the top sales producers, customers who buy their products or services, and consumers. Marc says, "We have operated retail consumer programs but find our

services are generally too expensive for the consumer market. We recognize the consumer event services offered within theme parks and attractions as different and as less demanding than the corporate events we manage for our clients. Theme parks and attractions offer photographs and products in a set environment. We are totally focused on the corporate event market and these include programs such as corporate events, trade shows, incentive travel programs, social events, and consumer marketing initiatives where companies and company brands are showcased.

"We continue to focus on providing products and services that extend the value and investment of events. Our unique advantage is that we are *not just photographers* and have an in-depth understanding of the strategy of event marketing. Our clients plan or sponsor programs with a business goal in mind and we provide a solution to extending the event experience and reinforcing the value of their brands."

Event photography for commercial clients needs to be a brand development tool for the client, not just pictures of the event. Marc continues, "We understand the event business and the corporate strategy for staging events, hosting customers, and focusing on positive brand awareness and connections. We can bring a brand to life in a positive way and provide a quality amenity to a guest that will be kept. Think of the money spent on hats, pens, and other trinkets. Where do you think these things end up? Our products end up on someone's desk, in their office or home and are a constant reminder of a positive event or happening. (Look around your own office, I'll bet you have at least one photo with you in it.)The majority of the images have the corporate logo or marketing message in or on the image into the digital prints delivered onsite. In addition, we incorporate text or copy and deliver other products: green screen backgrounds for prints, custom design magazine covers or magazine-format promos, event badges, bobble heads, lapel pins. You can see examples on our Web site. Our clients want their guests or attendees to have a positive and memorable experience during their events or hosted activities. They have seen the powerful impact that a branded photograph can have before, during, and after their events. What's a better asset than having a personal branded reminder on someone's desk or in the office?"

Often event photography for commercial clients includes design, creativity, and a variety of services to get and keep clients. Marc adds, "We work with clients from four months to two weeks ahead to create *custom imagery* for each corporate event—no stock borders, backgrounds, credentials, or badge formats. Everything on our Web site is an example of custom design for a particular corporate event. With this type of customization, a corporation can increase the value and equity of the money spent on event photography. Also, by using products that are a follow-up on the event, the corporation can increase its photography ROI (return on investment).

"Today, the on-site delivery of our photos is faster and more efficient. We can now use the images we capture and share these with guests in new ways that, once again, extend the value of digital imaging. We bring solutions to our clients. They want value in today's market as the excess is gone when it comes to corporate events. We have products and services that can help capitalize on emotions and memories and provide an enhance-

ment that impacts the event experience. We can bring a new dimension to an event that surpasses what has been done in the past relative to photography. The fact that we can do this in China or under a tent in the Moroccan desert is the *wow* factor our clients want to bring to their events."

Your marketing plan for commercial clients' event photography will be geared towards personal marketing more than non-personal marketing. Marc says, "We do not use traditional advertising. Our client base has grown over time as they see the value of having one photography firm manage their programs. The learning curve is short for corporate meeting planners managing multiple programs and suppliers. When they hire us we become an asset and not a liability. So we do have strong relationships with established companies that manage corporate events and much of our new business comes from referrals and networking. Specialty Imaging International is a member of Visitors and Convention Bureau of Atlanta and Salt Lake City. Ben and I both do the networking and selling for now but will look at adding sales staff as the company grows. We have developed partnerships with companies that see us a valuable member of their team and not another vendor. We work closely with organizations that are made of global event professionals that have responsibility for planning thousands of programs. Our goal is to grow our business through these channels."

Often this field of commercial photography is highly technology- and equipment-specific and requires substantial investments. Marc adds, "It's too easy to cut corners with the variety of digital cameras and printers on the market. We use high-end equipment so we can shoot and print all night long without stopping. This includes different models depending on print size and application such as the Mitsubishi CP-9550DW and CP-3020DU dye-sublimation thermal transfer printers. The CP-9550DW is a high-speed, large volume printer offering a variety of outputs from 3.5 × 5" to 6 × 9," while the CP-3020DU provides 8 × 10" and 8 × 12" prints. Also, have a backup. We can't afford to have a printer or camera to go out on us, and at every shoot we have a redundancy plan—two or three printers and always a backup camera and lighting system.

"We promote ourselves to our clients using technology as a key selling advantage. They want to bring something new to their guests and programs that has not been done before and we can deliver on this."

CASE STUDY: FINDING COMMERCIAL CLIENTS RIGHT FOR YOU

For over thirty years, Edward Gajdel (*www.edwardgajdel.com*) has captured the images of his subjects for editorial, advertising, fashion, and corporate clients. From poets to politicians, actors to corporate leaders, his portfolio includes impressive and accomplished individuals from leaders of nations to the premier celebrities of Hollywood. Djanka Gajdel has worked in the field since 1985, developed extensive experience in the area of consulting for the photographic industry, and is Edward's photography rep. She develops unique and innovative promotional strategies and has done extensive work in areas of contractually commissioned photography and publisher's contracts in the visual arts.

Assessing and re-thinking relationships with their photography clients came about slowly, not necessarily a lightning bolt of insight. Edward's work had developed to the point where it took a sophisticated and astute client to let him light his subjects in his own way. Though he does not limit himself to a singular style, the end result is always a focus on the subject that the client is usually looking for but does not always know how to articulate.

This requires a level of trust and a leap of faith that is hard for most clients to take. Djanka explains, "I think clarity comes in stating it as it is. Tiptoeing around the issue is not servicing your clients. You can interpret how the short sightedness is costing them the difference between an average image and an outstanding image that is powerful in communicating their message. Ironically it's the client who puts a lid on this possibility."

Recognizing this problem and dealing with it takes a plan and confidence in your convictions as a creative. Edward starts by helping his clients visualize where he is going. He says, "The situation being photographed will dictate the lighting style, but, more often than not, I will design a lighting approach that supports and enhances the emotional response we are trying to achieve. I try to verbalize that approach by making associations to naturally occurring conditions, e.g., a soft warm light much like an hour before sunset in a Caribbean location."

Hiring you and letting you do your best work as a photographer is every freelancer's dream. So how do we get our commercial clients to go there with you? Does it require a level of firmness—a backbone—that most photographers find too difficult? Perhaps it is not too difficult and not impossible, as this creative team has experienced.

It started with Djanka questioning the way clients dictate how to approach any given project. She explains, "What is foreign to me is the concept that has been given birth with the dawning of the new technology and that is 'fixing it in the computer later.' Photographer's fees have plummeted and a large portion of a photographic budget is going to post-production in a misguided notion that that's going to make clients' creative better when all they are doing is fixing mistakes and trying to improve on poor execution. If a photographer is skilled enough to capture all aspects of the assignment as well as envelop the image with a mindful and appropriate lighting environment, then there is very little post-work that has to be done. Clients then get massive savings and a phenomenal final image. Now, that is bang for your buck. Not to mention the copyright benefits of securing all the information on the final image. When did that stop being the job of a professional photographer? Could that also be why mediocrity has somehow surfaced to the top? The illusion is with the onset of technology, photography has become so available and people believe it calls so many. The truth is it chooses so few."

So to find the commercial photography client *that is right for you*, it may be time to educate your clients visually on how to hire you. The key factor seems to be offering your clients benefits to working with you, a reason to hire you, and an irresistible call to action. For Edward Gajdel, the client benefit was offering his personal style and technique. His lighting creates a deeper level to any image that will draw the viewer in.

That's exactly what you are looking for when you are creating any sort of marketing message for commercial clients. You want to draw your clients to you. After all, in seeking the competitive edge you need today, how many choices do you have? You can't just drop your price or buy new technology. Djanka adds, "The old way of approaching the taking of an image, in reference to composition and lighting, it truly puts a line in the sand as to who the professionals are and are not. No computer can imitate or create that, nor will it ever be able to."

Edward continues, "It takes more than great lighting to make a great photograph when working with people. In the context of commissioned advertising photography the prevailing sense is an image that strives for the notion of perfection, even though that notion is an illusion that is endlessly changing.

"Images, be they for advertising or gallery walls, are simply reflections of the mind that created them. We must at some point look at the source of this creation and try to understand its function. Are we perpetuating the ego and creating idols or are we bringing new insight and understanding of life? That may seems like a huge question to place upon an advertising image; however, we must ask these questions of everything we perceive. We are in a time of great change and even though we desire our world to change for the better it is really not change that we are wanting."

Once you have found your client benefits, you can then re-think what types of commercial photography clients you want to work with. Edward says he looks for projects and clients who provide the opportunity to honor the greatness of the human spirit: "The lines between advertising and editorial are often blurred. I've been in situations where a magazine has provided layouts for an editorial shoot and where campaigns were designed to enable me to work in a more personal style. It comes down to finding an authentic connection to whatever project I engage in."

Djanka adds, "Eddie pursues projects that nurture and feed his creativity and his soul. As altruistic as that may sound, it's true. It really doesn't matter as long as it stirs him creatively. That doesn't mean that he won't shoot something that might be mundane, because he will and he does; however, he will shoot it in a way that it's exceptional. He knows no other way. It's important to him to use his skill in communications that can heal. Consequently he does an array of fantastic work for a whole host of charities.

"I've known of many photographers who have burnt out and had to leave the business. They were just spent, and I believe it's important that you have a skill that you are constantly exploring and reinventing yourself, especially when you are established. You never arrive in my opinion. It's a journey. The day you believe you have arrived is the day you have stopped searching and your images will reflect that. I believe the old masters would agree. Even in their very senior years they maintained a whimsical and curious vision of the world. That's exciting because complacency and mediocrity have no place to live within that world. Dare to strive for excellence in absolutely every undertaking."

Edward concludes, "My relationship with clients is taking on a new focus. I am finding myself in a position of mentoring. When prospective clients come to me to discuss

new projects, we end up dissecting their needs at the core level. Often times they leave with greater clarity of what it is they need to achieve and how to do so effectively. Clients today have an overwhelming amount of choices in how to communicate their message. Depending on the depth of their understanding and willingness to learn they will either retreat into fear and an old way of being or embrace new ways being in the world and in so doing create a better life."

CASE STUDY: THE FUTURE OF MARKETING COMMERCIAL PHOTOGRAPHY

Ed McDonald (*www.edmcdonald.com*) is a member of and a strong supporter of professional photography associations in the field of commercial photography such as the ASMP. Ed says about the future of commercial photography, "We seem to be in a transitional phase of commercial clients, they seem to be changing or morphing into sort of a hybrid. We don't seem to be dealing with the old model of big agencies anymore or at least not as often. Bigger agencies have given way to smaller, leaner agencies or more design houses that oversee the work from contributors (i.e., photographers, illustrators, writers, and even art direction). Some of this is even being done by the clients directly, and as a result the work is much harder to locate or find.

"For marketing efforts, the print book has almost completely given way to the online portfolio and Web sites. In only one out of about my last fifty jobs that I have been in consideration for, have I even been asked if I had a print book to show. The Web site almost always has been enough to sell the job. E-mailers and direct mailers still play a huge role in our marketing, although that is continually being reevaluated and I think that might change soon too.

"Social media is changing the way in which we interact with each other, client/digital content providers, and new ways of communicating with each other are developing at breakneck speeds. I think today, at a minimum, photographers should plan (along with their conventional marketing) a Web site, a blog or photo blog, a LinkedIn profile, and a Facebook profile/fan page. You can throw in a Twitter account (as I have done) if you really want to keep a fresh stream out there driving traffic back to your other media.

"I once heard it referred that if Twitter were like the conversation at the mailbox, Facebook like a coffee shop talk, and LinkedIn like being at the office, your blog would be a housewarming party, and your Web site would be where you live. More casual conversations on Twitter drive traffic to your various other medias with intentions of directing them where you want them to go. This can make for a very effective marketing strategy. Sometimes it's not about finding your market as much as it is letting your market find you. Shoot what you love and show what you shoot (often) and your market will find you."

What does a photographer need to think about when considering a career move into commercial photography? Ed says, "I think everyone is looking at ways to open up new revenue streams, whether it's wedding/portrait guys trying to gain more commercial work or commercial guys trying stock, or commercial guys doing wedding/portraits.

The mindset and the lines that used to divide us don't seem to exist anymore (at least not with the new age of photographers starting out). Photographers today see themselves more as visual storytellers and style is the only defining separation between one and another. They don't necessarily think wedding/portrait/commercial/stock; they just create images and the rest takes care of itself.

"Some of the new photographers I find online that I admire most have all these different types of work right next to each other and it works because their style transcends all those lines. Commercial, portraits, weddings—these are mindsets that we had for many years, and the lines are being crossed so frequently today with greater and greater results so the lines don't really exist at all. I think if you asked a younger set of art buyers what they are looking for in a photographer or visual storyteller, it would *be more about the visual narrative* and less about what it was originally shot for. They don't care because the visuals are king and that's all that matters.

"If you can convey a style, a sense of place, or feeling, this is what will sell you and your work."

22

Writing the Consumer Client Marketing Plan

The marketing plan in this chapter is the same format as in chapter 21 so we will not repeat it here. However, you must customize the outline format to suit your consumer photography clients using the principles discussed in chapter 7.

For example, your marketing message might be, "portrait photography: families and children, creating images on location and in the studio to record the life stages and events for family memories."

This in turn will dictate your targeted client base, "based on demographics and behavioral metrics, my prospects will be families with the interest and income to have their life passages documented by a professional photographer."

The third section identifies the marketing tools you will use to get this work: direct mail, e-mail, advertising, Web sites, social media, public relations, and personal selling.

As with the marketing plan for commercial photography clients, you will *plan the work and then work the plan* by transferring all your marketing action tasks to your calendar.

CASE STUDY: CONSUMER EVENT PHOTOGRAPHY, JIM ROSHAN (WWW.THEROSHANGROUP.COM, WWW.SHUTTERBUGPHOTOMALL.COM, WWW.EVENTPHOTOMARKET.COM)

"I am formally trained as a commercial and editorial photographer, but when I was introduced to digital photography it gave me the idea of expanding my services by photographing youth sports action and offering delivery of the photos onsite following the games. This exploded into a very lucrative business, EventPhoto, and my success was noticed by the leading event photography workflow solution software manufacturer, Express Digital. The company later offered me the chance to start training and promoting their software and the event photography business in general. With the connections I had established in the industry, I was able to grow my new business.

"To generate traffic and to display pricing and the photography product list, we built our first Web site (*www.EventPhotoMarket.com*), and on that site we incorporated a forum dedicated solely to the discussion of event photography. This forum led to the first National Event Photographer's Conference. Everyone came to the consensus that a formal organization was needed for event photography and I proposed the International Association of Professional Event Photographer (*www.IAPEP.com*), currently known as the Society of Sport and Event Photographers. SEP is a sister organization to the Professional Photographers of America (PPA). SEP now holds its conference in conjunction with PPA at Imaging USA every year.

"We then acquired Shutterbug Digital Photo (a regional pro lab) and Downing's Picture Perfect (a local consumer lab) and merged them into one new international level lab named Shutterbug Photo Lab under the Shutterbug Photo Mall umbrella. Shutterbug Photo Mall is a pro level camera store with a portrait and commercial studio along with the area's only 30-minute photo consumer lab and full-service pro level photo finishing lab. Along with a locally based school, Shutterbug educates consumer and pro level clientele with EventPhotoMarket.com's professional clients that come in from all over the world.

"RoshanPRESS, a division of TRG (The Roshan Group, Inc.), was formed last year and is able to make full-color photo books, calendars, greeting cards, pamphlets, catalogs, school yearbooks, and other photo specialty products. Today TRG is able to provide a one-stop shopping experience for all printing products such as banners, signs, car/trailer wraps, as well as wide format prints along with low-volume digital printing and high-volume off-set satisfying the needs of our clients.

"Because of the rural area we are in we do almost every kind of event photography there is: sports action, team and individual, school, dance, theatre, fairs, reunions, and parties. We don't concentrate only on one market; we have to be able to handle any kind of event!

"Don't look at this field as a get-rich-quick idea; it's not! With a lot of hard work and good business sense there is a lot of money to be made (compared to the other fields in photography). Competition has become rough over the years since a lot more people are realizing that with the advent of digital technology they now can get into the event photography business with little to no previous experience. This has hurt the reputation of the industry a little because newcomers are trying to enter the business by price undercutting their seasoned competition by significant amounts. In an already low-priced industry this does not help at all; we just don't have the margins to work that way.

"But this is the only field in the photographic industry where you don't have to be a photographer first; you really need to be a good businessperson. The photography can be learned (or hired). Event photography is high-volume business and the complete opposite of all other fields of photography. Everyone at an event has a disposable $10 or $20 bill in his or her pocket. Two hundred and fifty $20 bills equal $5,000. At an event where there are several thousand attendees you will find this amount of sales very attainable.

"Try not to get in to the grind of paying a commission back to the organizations you shoot for. The best thing to do is come up with a fundraising program that you provide to surpass any kind of percentage you could have given them. For example, most leagues have to supply all of their kids with trophies. What you do is buy them wholesale and resell them back to the league at your cost. They usually would have to pay retail for them and now they get to pocket the difference. This is money that does not come out of your original profits and allows clients to make money simply by working with you.

"Get as much education as you can. There are a couple of great organizations out there that are designed to do nothing but educate the professional event photographer. SEP (Society of Sport and Event Photographers) and SPAA (Sports Photographers Association of America) each have a broad array of educational programs that can get you from zero to feeling very comfortable about how to make money in this industry really quickly. Plus, the most important resource they both have is networking with your peers. This is, by far, the most valuable asset you can find. The exchange of information and ideas with others that are doing what you want to do is priceless.

"Find a vendor/dealer who speaks your language. I can't stress how important this is! There are a lot of vendors who can't offer you any support but they sure can sell cheap. What is more important—price or support? You need to find vendors who actually knows the field of event photography, can support you on the equipment and software they sell, and offer real tech support (like 24/7 access) to bail you out of situations when you need it the most. When are you most likely to be working an event? Nights and weekends! Why would you look for a vendor who can only offer tech support Monday to Friday, 9 a.m. to 5 p.m.? A good vendor should be as worried about the success of your business as you are. The good vendors offer not only great pricing but educational, graphic design, business, after-hours tech and, if needed, even emotional support—in other words they should be your best friend and business partner (kind of like a franchise without the franchise fees).

"We use several *Guerrilla Marketing* tactics to sell ourselves. These techniques help keep our advertising budget to a minimum and our calendar full several years out.

"Here are a few of our marketing techniques we can suggest for you:

Get the local paper to do a business feature story on your 'new company.' This has great circulation and also gives you a published credibility to help out when you go to get new gigs. Make sure you make a pdf copy of the articles and put those on your Web site. Linking to the paper's site is fine as long as they don't take down the article (which you have no control).

"Hit up the sports or assignment desks of the local TV news (depending on what kinds of events you shoot) and let them know about your on-site printing process, green-screen technique, or custom sports photography at an upcoming event. Make sure you do this when it is a dead news period. You don't really want to go up against a major news event that will dominate the tube and knock you out of the viewing. Don't just tell them about it; make sure you explain how visually interesting the shoot will be for them!

"Most areas have some kind of local or regional sports newspaper or magazine that would love to exchange professional action photos with you in return for a photo credit listing your Web site address. You will be surprised as to how many hits, and sales, you will get after your photos run in one of these periodicals.

"Make sure you are offering low-res action photos to the local clubs for their Web sites. They usually don't have access to professional looking photos from their tournaments or games and by you supplying them you will be known as the 'official-go-to-photographer' of their organization and your work will be greatly appreciated and displayed. (Remember to get the link back to your Web site!)

"Use margin area of photos for your info. If you print onsite (which you should be doing in this business) you should be using one of the professional event photography workflow software to do so. These products will give you the option of printing a margin around your photos that can be used to insert any kind of advertising message you desire, so use it wisely.

"Check with your local Chamber of Commerce for events such as ribbon cuttings. They are very easy to shoot and print onsite using your portable printing equipment. Think about who is at most ribbon cuttings: the CEO, CFO, COO, marketing staff, other business leaders and owners, etc. By offering onsite printing to the attendees you can put a template with various logos around the photo commemorating the event and include a brochure showing all of the different photographic services you offer. These gigs are usually during the week so you won't be tying up your nights and weekends to shoot better-paying events.

"Look for sports leagues via the Parks and Recreation Departments in various areas. Web sites like www.eteamz.com and www.mysportsite.com can help or just Google words like *Sports, Team, and Web site* and you would be surprised as to what you find.

"The best way to find a rep is from within your own company. Usually that person knows your business and how to find and close those deals. The reps are responsible for finding the leads, making the presentations, and booking the leagues, but you have to supply all of the marketing materials. Never skimp on the marketing materials.

"Another idea is a *pitch* or *play book*. This is a booklet that you have designed and printed with an introduction from your company, what your capabilities are, how you do what you do, photos of your setups, photos of your products, your fundraising ideas, and several other pages explaining other vital areas of your business. These booklets are printed on our digital press and customized to the leagues. The look puts us above our competition in professionalism and creativity and is something else leagues like to look for in a photography company. Usually these are used the day you go and pitch to the league to get the job.

"We usually don't pay for advertising to book our events. By having a brochure available (and inserted in every order placed at the event) we can easily get two to four referrals for other shoots. By doing this technique it's pretty easy to fill up the calendar."

CASE STUDY: SUCCESS IN THE PORTRAIT MARKET, DAVIS FREEMAN (*WWW.DAVISFREEMAN.COM*)

"I believe there are distinct types of photographers specializing in creating family and individual portraits. In my years as a creator of artistic and individualistic family portraits, I've encountered several categories of commissioned portrait photographers who can be characterized in the following manner:

1. The award-winning photographer with unique vision and the artistry to carry it through in the images produced.

2. Solid image producers (the bulk of the market). Their work is often good quality but lacking the artistic quality evident in the first group. They tend to use the same formula with predictable results.

3. The group I call the 'mall photographers,' represented by studios and individuals with a playbook of poses, discounted prices, and quick turn around.

4. The same day photographers offering cheap, unexceptional images without distinction.

"When I decided to pursue commissioned portraits full time, I knew the conventional paradigms didn't fit my work. As a highly creative and original image-maker, I sought to provide a new type of family portrait on par with my work that is displayed in museums and galleries. This work is highly personal and creative. I did not want routine or traditional family poses with smiling faces but lacking in personality. I see my portraits as providing a unique artistic vision. I would place myself in the first category. My fees reflect my expertise and my final product. Some may consider my fees high, but I believe they reflect the quality of the artistry I bring to the subject.

"I provide quality work, offering artistically crafted images. The value is in the artistry of the portrait. There are few photographers who have the ability or the time to create this type of image. I will spend hours with the families I photograph seeking to define their uniqueness and then I capture that quality in the portrait.

"When I moved into the commissioned portrait market from commercial photography it was necessary to provide my clients with something uniquely identifiable with *Davis Freeman*. I developed the idea of the family triptych. My triptychs are unique when unique is defined as, 'being different from all others.' At the same time I offer classically beautiful studio portraits, usually black and white and location portraits, usually color.

"With this business refocusing, I realized my potential client had changed from the commercial client art director to a person, usually a mother, who has a history of buying photographs and discretionary income and is a much more difficult group to target. This has led me to see my marketing efforts as *more educating* than competing. I also realized my work needs to be seen full size or close to full size to be appreciated.

"For marketing over the last eight years I have used traditional direct mail, print ads, and promotions. Last year I created five targeted mailings, beautifully designed. I have used Google, Yahoo, and Cityseach Ads as well as a presence on Facebook and LinkedIn. I have a Web site and I am considering splitting off the commercial and fine art from the commissioned portraits as well as creating a blog.

"Lately, I have not found the traditional marketing tools to work for me, e.g., direct mail, Internet ads, and promo pieces. I have found the personal touch to be much more successful. Here are the primary ways my business has survived and thrived in this consumer market.

"I am on several local community boards for networking and I provide free photos for certain community occasions and speak to community groups about my work. As one example of the benefits of serving the community, I was granted a private session with the Dalai Lama.

"There have been displays of my photos in coffee shops (although this has become less effective), and now I am finding other venues where my targeted audience shops.

"Offering my work for charitable auctions has worked well for me. For silent auctions I use either a single portrait item or a fixed price with up to five bidders allowed to purchase, and then get the donor's info for mailings. For live auctions I use 'Cajun dinners with the artist' as my offerings.

"There are bi-annual house/studio parties with good food and wine and some entertainment. Usually I barter with the entertainment offering a professional portrait for their time.

"I get birthdates of clients and family members and send a 'happy birthday' message. This usually does not have a call to action as I want it to be more personal.

"For nearby cities, I hold photo parties where I photograph four to five different children and make large prints at no charge. Then I have a party to view the work; this usually sells the images and hopefully makes new client contacts.

"I do a quarterly newsletter, occasional special offering mailings, and for my fine art, I enter highly selected photo contests. I always ask for referrals and I provide a framed botanical fine art image if the referral results in a booking.

"Lastly, I have just begun to see the Queen Anne district where I live, a community of 30,000, as a small town within a big city. My marketing efforts are now designed to target this as my primary market."

CASE STUDY: GROWING YOUR WEDDING BUSINESS, ANDREW NIESEN (*WWW.LACOURPHOTO.COM*)

"At LaCour, we focus on our approach, rather than our style. Style, as we see it, refers more to the compositional and aesthetic elements of the images that we create. While this is important, what sets us apart from other wedding photographers is our approach to photography. Our reactive, documentary approach to wedding photography is funda-

mental to the experience that our clients, and future generations of their families, have with the images that we create for them.

"For marketing we rely on word-of-mouth referrals, and developing strong relationships with other vendors, such as wedding planners, is the best way to get referrals. When a lead comes in from a trusted wedding coordinator, we already know that the prospective client is pre-qualified to hire us. Good relationships are the key to good business. Taking a wedding planner out to lunch is a much better investment than advertising, in our experience. We also publish a mini-magazine two times per year, which we send to our mailing list. This is an effective form of marketing for us, since our mailing list is highly targeted.

"One of the best new tools for marketing is slideshow technology. From a marketing and branding perspective, slideshows are revolutionary. Since brides can conveniently e-mail slideshows to friends and family, they are a low-cost, high-impact method of spreading the LaCour brand name.

"Bookings based on referrals have increased dramatically since we started creating slideshows. We routinely receive calls from brides saying they were 'wowed' by their friend's slideshow and want to commission LaCour for their wedding, based on the emotional reaction they had to our slideshow! Slideshows are much more effective than print advertising because they are more specifically targeted. Most of our potential clients are pre-qualified to hire us, before they even contact us, since they have already viewed our slideshows. Many wedding photographers are realizing the power of slideshows and are including them as part of their standard packages.

"If you are just starting out or moving into the wedding business, first, write a good business plan. Articulating where you hope to be in twenty years is critical. In order to create a successful business, you must know your long-term goals. Also, foster good relationships with other photographers in your market. We believe that creating a community of colleagues is very important. When colleagues are booked, they can refer a job to you. Establishing strong relationships also allows you to collaborate with fellow photographers and learn from their experiences. It's easy to work in isolation as a photographer, but it impedes growth. Connecting yourself to colleagues will ensure that you always have a support network."

Selling Your Personal Work

There has always been a debate about reconciling the marketing of commercial work and personal work. In other words, can you pursue a personal commitment to a higher purpose of making a lasting contribution to human aesthetics or are you stuck just pursuing the more commercial goal of making money? And how do we define success—by making money or by enabling the creation of lasting works of beauty? Our reconciliation is simple: you don't need to ask the question; you do both when you sell your personal work as fine art.

As photographers, we contribute to human aesthetics. Making money by selling your personal work as art can be a natural outcome. The photographer who creates a lasting work of art contributes more to the human aesthetic by having the work seen by an audience and hopefully as large an audience as possible. You will see in the two case studies below very innovative ways to create markets for personal images!

So we can define success as you, the photographer, creating works of art and finding a client base in the fine arts photography market as well as the commercial markets. It is not unthinkable. The methods and techniques in this book have focused on a variety of photography markets, promotion tools, and techniques. Fine art photography and selling your personal work can be another market to add to your marketing message.

Who will buy your photos as art? There are many different kinds of fine art photography clients for your personal work. They can be the more traditional markets such as galleries, art dealers, art fairs, photo festivals, and individual collectors. They can be the more business type clients such as corporate fine art buyers, corporate art consultants, stock agencies, paper products, book publishers, and interior designers. They can even be institutions such as museums or associations such as nonprofits.

BUT IS IT ART?

Photography can usually be defined as art by style or subjects you are passionate about. This defining of your personal work will give you direction and help you target your markets and clients. You cannot successfully proceed without this step. When you know what you are passionate about, you are more likely to be able to identify who will buy it. Marketing your personal work as fine art depends on the importance of research and doing your homework.

Is your work art? The subjectivity of the question requires you to present a strong, relevant, and consistent message to clients that identifies your work in a unique way. Look at art clients' point of view. They will always want to verbalize or describe the visuals they want to buy as art, so you are best served by looking through their eyes. Defining your art photography by style or subject can be done by describing what it looks like using terms such as: contemporary art, conceptual art, traditional landscape, urban landscape, nature photography, documentary photography, and the photography of people, just to name a few.

Even these objective terms break down into subsets. For example, the photography of people can be *images of children at play* or nature photography can be *images of old-growth forests*. It is your job to find your passion and to find the words that will help the art market visualize your personal work so they can buy it.

ARE YOU READY FOR THE FINE ART MARKET?

The visual diversity of fine art photography sold today, from the completely unique to the everyday image created in an extraordinary way, gives you many opportunities. The clients, particularly licensing clients, look for images that have the widest range of appeal to the end-client. Then there are art consultants who specialize in serving collectors—for example, someone who only collects images of white picket fences, landscapes, or sunsets. That is the beauty of fine art; it could be any subject of interest to collectors.

So whether you have the once-in-a-lifetime shot of a sunset for a limited edition print sale to a private collector, or the most adorable image of a kitten in a clay pot, which can be broadly licensed in greeting cards, you *are* ready to start researching the possibilities. The diversity of opportunities to sell your personal work is available now. You're ready when you have images you think appeal to a wide range of possible customers.

THE CHANGING FINE ART MARKET

With the ability for clients to reach across borders to tap into art markets, the fine art market for your personal work has expanded from being local and regional to global. Your marketing plan will need to add a section to explore the ways and means to find your fine art market.

You can check the general news media; they now pick up stories about auctions and other art news. You can also check the fine art trade publications. In both the corporate and the consumer art photography markets, clients are more knowledgeable and aware that art can become valuable over time. Fortunately, fine art photography is not excluded from this trend.

Of course, the Internet and social media networks have changed the way all markets function and the art world is definitely included in this change. It levels the playing field when it comes to how clients search for art; they are not locked down to what can be found in a brick and mortar gallery.

Copyright issues that you are familiar with have become very relevant for both buyers and sellers in fine arts. The long-standing invisibility cloak fine artists have been under when it comes to copyrights and privacy rights has been torn away. In its place are lots of questions coming to the artists about derivative rights, fair use, and the difference between selling physical objects (real property) versus rights of usage in various media (intellectual property).

THE FUTURE

What all this means to you is an interesting mix of truths about the future. It will be easier to get your personal work viewed by many, many people using the Internet and social media networks. That being true, it will be no less difficult to get your personal work viewed by the right group of people at the right time. Protecting your personal work from unauthorized copying is an important step. People will want to see more of your personal work once it's identified as a truly original contribution to art. This is fun, rewarding and, for so many of us, a necessary step to personal and professional fulfillment.

CASE STUDY: SELLING YOUR PERSONAL WORK, DAVID DAVIS, FACEROCK PRODUCTIONS, LLC (*WWW.FACEROCKPRODUCTIONS.COM*, *WWW.SOUTHWESTPHOTOSAFARIS.COM/*, *WWW.ALWAYSGETGREATPHOTOS. COM/*)

Q: You have taken a fine art style and combined with a profitable photography business; please explain more about this process.

A: I've always believed that I should enjoy my photography whether it was at the studio or in the field. Since the majority of my portrait work is done outdoors, it is a natural transition to apply my fine art approach to clients who want something different. We always try to have fun and let our ideas work in concert to create a more interesting result than we initially planned.

Fifteen years ago I was presented with an advertising assignment that leads me into the world of the Native Americans in the Southwest. While working on that project,

I decided that it would be interesting to create images that combine our indigenous peoples with the dramatic landscapes of the Colorado Plateau. I included the people in my photographs to help tell a story and give a better sense of scale and personality to the location. Early in the project I challenged myself to create all of these images with available light. As the *Native Americans in the Landscape* collection continues I get to meet new people and find new locations to create images that keep appearing in my imagination.

For example, a few years ago I started working with a Navajo couture designer taking photos for his calendar. We worked with some talented and beautiful young women doing both that high fashion and traditional looks. When I learned about the Native American warrior women and their mostly forgotten history, I did some research and decided to bring these brave women to life through our photography. This type of collaborative project uses the talents of many people to benefit each of the participants.

The lessons learned from these projects have allowed me to create more interesting commissioned portraits. When our portrait clients see an expanded set of possibilities, they have confidence that we will consider all of their ideas no matter how far out they seem to be. I believe that the marriage of fine art style to the portrait business also affects the overall perceived value for our clientele. Signature portraits continue to be in high demand because they are personalized and collaborative.

Fundamentally, our portrait work is strengthened by the fine art, and the fine art is refined by the portrait work. In this exciting time using an expanded photographic toolbox, this marriage of fine art photography with portraits has made it more important than ever to know how the client intends to use the image—what the actual end product is going to be. Naturally, clients help control their finished product by providing input into the process, and I get to ask all the pertinent sales and journalistic questions to determine which set of tools to use.

The lessons I've learned in the field play a critical role in the process. Since I photograph in people's homes or any location they want, keeping the process simple and effective is important. This marriage is a process of checks and balances that actually increases the creative possibilities rather than becoming controlling or stifling. It keeps the photography process fun. This is one of the many reasons I sold my well known studio two years ago.

Q: Discuss the unique marketing product/process you are launching, what it is, how it is marketed, who are the best potential photography clients for it.

A: Facerock Productions, LLC is the realization of a dream to build a company that can produce and distribute a variety of photographic art. Native American style and subject matter is the primary focus of our product line. Our investors have pledged a portion of the profits be used to mentor and otherwise develop the talents of aspiring and non-traditionally trained photographers from the various reservations in our region, and give them an outlet for their work and teach them independent marketing as well.

Our first international product is a piece of *entertainment marketing*. It is a DVD that includes a multimedia show of Native American images created over a ten-year

period. Using interesting dissolves, zooms, pans, and other transition techniques, the *Native Faces—Desert Light* show moves along with narrative in the Navajo language and English subtitles. This gives the viewer an opportunity to hear the native language in a new context. The background music is licensed from and performed by several leading Native flutists. Many of the images featured in the program are available as fine art prints, posters, note cards, or in limited edition customized photo books. With the new HD video and software available we have started a new production to fit the format of a sixty-minute television broadcast.

The epilogue of the original production features an interview style infomercial that familiarizes the viewer with Facerock Productions and its variety of products. The most important feature of this segment defines fine art prints: what they are, why, and how to collect them. This infomercial segment of the DVD will be customized in the future to include each of our collaborators who wish to become a part of our strategic marketing alliance. This not only allows an increase in distribution, it also adds credibility to the entire project and opens a new dynamic for future productions. Our success in getting the story part of *Native Faces—Desert Light* broadcast regionally on PBS television helped bring attention to the images.

Circular marketing is our technique where each product promotes or educates the buyer about the project and the other available products. We realize that fewer people will purchase fine art photographs than posters, note cards, and books so having a complete product line gives people a choice of enjoying images from multiple price points.

Distribution also relies heavily on strategic marketing alliances with galleries, music and video distributors, blanket manufacturers, gift shops, Web sites (our own and linked with others), as well as family-owned Native enterprises. We are negotiating to participate in existing kiosks with looping audio/video programs so potential buyers can see what they are getting before they buy.

We are currently represented by the Camera Obscura Gallery in Denver, Colorado. The gallery's longtime membership in the Association of International Photography Art Dealers helps give our photographs greater credibility as collectible art. Our DVD is distributed worldwide by Four Winds Trading Company that was recommended by one of our supporters, Pendleton Woolen Mills. We meet gift shop owners at one or more of the national trade shows each season and are just testing one of the online art outlets.

CASE STUDY: SELLING YOUR PERSONAL WORK, ROBIN HILL (*WWW.ROBINHILL.NET*)

Q: How did you get started selling your personal work?

A: People saw my travel photography work at the MiMo (Miami Modern—architecture built in Miami from 1945 to 1971) and loved the funky, whimsical style in that work and wanted that applied to their buildings, so I started shooting architecture. That's how it all started; my business grew from there. I had forty-three pieces at the Museum in Fort

Lauderdale and 800 people on opening night, lots of buzz, made all the newspapers—but no sales (museums usually don't). Then a similar but much smaller exhibit in a local photo lab makes a great sale, a celebrity walks in and buys four pictures off the wall!

Q: How did your architectural work cross over to museum fine art?

A: Art-Basel in Switzerland is one of the biggest and most prestigious art fairs and it started coming to Miami Beach. The executive director picked one of my MiMo pictures for the cover of his program. Then at the MiMo photography exhibit, one of the attendees was Donald Albrecht. He is the curator for architecture at the Cooper Hewitt National Design Museum. He saw some of my photos of famed architect Morris Lapidus and asked me to exhibit a couple of the photos in his new exhibition called *New Hotels for Global Nomads.*

Q: How do you get museum exhibits in the first place?

A: You need a local theme, relevant to the museum, meaningful to the local community, personal relationships in the art community, actively working those relationships by making them organic (give and take), and giving back to the community. It is a circle of energy—what you put out comes back to you. I am not this terrific businessman that knows everything but for me it has always been about making genuine relationships and taking off from there.

Q: How do you make the transition from museum venue to exhibits and sales?

A: When your work goes up in value and prestige because of museums shows, then you get the attention of a private, commercial gallery for exhibits and sales.

Q: How has a new direction evolved for you?

A: The direction change was going from architectural photography and fine art being separate to architectural photography and fine art combined. I was shooting fine art all along but not crossing over into the architectural assignment client work. The clients I have now (the architects) not only hire me for architectural photos of their buildings but also buy prints to hang on the walls of the buildings they were designing and my art dealer sells to interior designers for spas and other interiors.

Q: How do market your personal work today?

A: Most of my marketing program is based upon relationships and connections. I see it as an integral part of my life. It's a holistic approach to business that depends upon authentic friendships and mutual collaboration. It is not a cold strategic operation. One or two genuine referrals are worth much more than 1,000 cold calls. Networking is the essential cornerstone of my business, but it is more like *netplaying* than *networking.*

Here's an example: I was at an opening at the Miami Art Museum (MAM) and had a short conversation with a woman called Brooke Minto. She is on the staff at MAM and at the time I was trying to promote my project and get an exhibition of my photos of Frank

Lloyd Wright's Florida Southern College. She mentioned that in her previous position at the Guggenheim Museum in New York she happened to know a curator working on an exhibition on Frank Lloyd Wright. So the next day (it's good to be decisive) I called this contact up at the Guggenheim and sent them my slide show. I heard back a few days later that both the Guggenheim and the Frank Lloyd Wright Foundation were interested in including my photos in the upcoming exhibit.

This happened two years before the show actually opened and there were numerous curatorial changes, which sometimes presented challenging obstacles, but each time there was a change I made sure that I started a new relationship with the new curator. Eventually I was invited up to New York and confirmed that seven of my pieces would be included. All of this was due to being out there, meeting people, and, most importantly, believing in both what I was doing and the quality of the photography. I think it's important to be aware of when opportunities arise and then to act on them.

RESOURCES FOR SELLING PERSONAL WORK

Please note that Web sites are in a state of constant change. Web sites in this book are intended as potential sources of information and, while they were live at press time, might be different today.

BOOKS
The Artist's Way, by Julia Cameron
Art Marketing Handbook, by Calvin Goodman
Selling Art Without Galleries: Toward Making a Living From Your Art, by Daniel Grant
The Artist's Guide to New Markets: Opportunities to Show and Sell Art Beyond Galleries, by Peggy Hadden

ONLINE
Art Network (*www.artmarketing.com*)
Art Scuttlebutt (*www.artscuttlebutt.com*)
ArtBusiness.com (*www.artbusiness.com*)
TheArtList.com (*www.theartlist.com*)
WetCanvas (*www.wetcanvas.com*)

INDEX

Books from Allworth Press

Allworth Press is an imprint of Allworth Communications, Inc. Selected titles are listed below.

Selling Your Photography
by Richard Weisgrau (6 × 9, 224 pages, paperback, $24.95)

The Business of Studio Photography, Third Edition
by Edward R. Lilley (6 × 9, 432 pages, paperback, $27.50)

ASMP Professional Business Practices in Photography, Seventh Edition
by American Society of Media Photographers (6 × 9, 480 pages, paperback, $35.00)

The Real Business of Photography
by Richard Weisgrau (6 × 9, 224 pages, paperback, $19.95)

The Law (in Plain English)® for Photographers
by Leonard D. DuBoff and Christy O. King (6 × 9, 224 pages, paperback, $24.95)

Business and Legal Forms for Photographers, Fourth Edition
by Tad Crawford (8½ × 11, 208 pages, paperback, $29.95)

Digital Stock Photography: How to Shoot and Sell
by Michael Heron (6 × 9, 288 pages, paperback, $21.95)

Licensing Photography
by Richard Weisgrau and Victor S. Perlman (6 × 9, 208 pages, paperback, $19.95)

Starting Your Career as a Freelance Photographer
by Tad Crawford (6 × 9, 256 pages, paperback, $19.95)

How to Succeed in Commercial Photography: Insights from a Leading Consultant
by Selina Matreiya (6 × 9, 240 pages, paperback, $19.95)

The Education of a Photographer
edited by Charles H. Traub, Steven Heller, and Adam B. Bell (6 × 9, 256 pages, paperback, $19.95)

Pricing Photography: The Complete Guide to Assignment and Stock Prices, Third Edition
by Michael Heron and David MacTavish (6 × 9, 160 pages, paperback, $24.95)

How to Grow as a Photographer: Reinventing Your Career
by Tony Luna (6 × 9, 232 pages, paperback, $19.95)

Photographer's Guide to Negotiating
by Richard Weisgrau (6 × 9, 256 pages, paperback, $19.95)

The Professional Photographer's Legal Handbook
by Nancy E. Wolff (6 × 9, 256 pages, paperback, $24.95)

art was made plain. The viewer was left in no doubt these were religious works designed to move us to faith. There was no apology for this or even any attempt to explain away the faith aspect of the exhibition; it was presented as the way things were. What made this material accessible was that it had been put together in a new way.

The church has a good deal in common with an institution such as the National Gallery. We too have a significant cultural heritage of music, literature, art, and spiritual expression. We also might be seen as perhaps a little stuffy and maybe at times out of touch or highbrow. The glories of the Christian church, like the pictures in any major art gallery, have been constantly on show and in the public gaze for generations. Our regular church services are a little like the public rooms in the National Gallery. Our wares are on show free to be viewed by the public, but on the whole most people stay away. What we need to learn to do is re-present the faith in ways that touch the imagination and fire the interest of the general public.

An example of how we might reimagine the church came to me when I visited the local gym. There on the notice board was a simple poster offering a fitness check-up. For those of us who have fallen out of a regular sport and exercise routine, this is a way back in to a more healthy lifestyle. Of course, the swimming pool, gym, and soccer fields have been there for years. What the fitness check offers is a chance to start again on this kind of activity. This got me thinking about the way we offer spiritual growth and renewal in the church. Maybe we should be developing ways back in to the habit of meeting with God on regular basis. A spiritual check-up with a personal counselor may be an interesting way to go! The problem with solid church is that it would turn this kind of idea into a routine, so it would suggest that everyone joining the church must have a check-up. Liquid church would see that the short term and an offer for a limited period only will be attractive and catch the eye of the discerning consumer. Keeping the run of an event short is an essential part of making it special. This is particularly the case when we are dealing with the press. The culture of media-based publicity relies upon what is new. The regular habits of solid church don't cause any great stir in the press.

Liquid church will need to adopt a regular cycle of new releases, events, and product launches. Of course not all new

things are new. A good many media events are a celebration of what is old. The thirtieth year of a Broadway show, for instance, becomes the reason for a makeover and relaunch. The anniversary of the death of a classical composer results in a rerelease of his music in a boxed CD set. Liquid church needs to present spiritual events and products in a similar form. In the liquid world the failure to produce a new product line eventually leads to death.

DREAM SIX: WORSHIP IN A LIQUID CHURCH

Worship is essential for any church, but as we have seen this could be in small groups or in much larger citywide festivals as well as in medium-sized congregations. But how can a liquid church offer worship without reproducing the problems of solid church? In this dream I set out in some detail some examples of what I call decentered worship, or worship that does not rely upon a congregational dynamic. Three quite different worship experiences have led me to feel that such imagining may be possible. The first is a contemporary example drawn from an experimental act of worship held during Lent 2000 in St. Paul's Cathedral in London. The second is based on a description of worship in a medieval church before the Reformation in England. The third is based on experience of midday prayers in an Orthodox church on the island of Tinos in Greece. Finally, I describe a worship event I helped to plan at Greenbelt Festival.

The St. Paul's Labyrinth

The labyrinth in St. Paul's Cathedral was organized by several informal worship groups based in London. It was made from a series of white lines on a carpet. The lines formed an intricate pathway along which people could walk. This kind of walkway was inspired by the labyrinth that can be found on the floor of the cathedral in Chartres, France. The Chartres labyrinth is an intricate walkway laid out in tiles on the floor of the nave of this ancient cathedral. In medieval times pilgrims to the cathedral would walk or crawl around the labyrinth as a spiritual exercise.[2] For the worshiper in the Middle Ages, the labyrinth may have represented a symbolic journey, possibly to the Holy Land.

In the St. Paul's labyrinth the symbolic journey was combined with a series of prayer stations. At various points on the walkway areas were set aside with activities for reflection, meditation, and prayer. Each worshiper was given a personal CD player on which there was accompanying music and a spoken meditative guide to the activities within the labyrinth. The prayer stations involved a number of different activities. One station had a bucket with water in it. Worshipers were invited to reflect on aspects of their life that they felt were less than perfect, sins committed, and wrongs experienced. Then they were asked to drop a small pebble into the bucket of water, as a sign of turning these experiences over to God. At another station there was a laptop computer. On the computer screen a number of images of candles were on display. By hitting the space bar on the computer it was possible to light one of these candles. The worshipers were invited to think for a time of a friend in need or a situation in the world. In the quiet they were asked to pray for what they had been thinking about and to light a candle on the screen to represent their prayer. The journey around the labyrinth could take from thirty minutes to an hour depending on the time spent at each station. Several people could walk the path at the same time, thus sharing a communal experience that also allows for considerable individual prayer and spirituality.

Worship before the English Reformation

Church worship has not always been congregational in the way that we experience it. In the fifteenth and early sixteenth century, immediately before the Reformation in England, a visit to the local church could be a much more decentered experience than we might imagine. Eamon Duffy describes how during this period receiving the communion was often limited to Easter only.[3]

Although people ate the host only annually, they were very often to be found in church "hearing the mass." The focus of such church attendance was the moment when the priest raised the host above their above their head. This was known as sacring. For the worshiper seeing the holy bread lifted in this manner was a considerable blessing. In many churches in England at this time as well as a central main altar there would be a series of chapels around the outside of the church, each with its own altar. Mass would be said simultaneously on

several of these altars by a large number of priests. Duffy describes how these services would be carefully timed so that the worshiper could see the sacred host elevated more than one time by the clergy at the various altars. A bell would be rung at each altar as the host was raised so that worshipers could catch a glimpse of it at this special moment.[4]

What Duffy describes is an experience of worship quite unlike the contemporary idea of congregational participation. The multiple nature of the altars means that being a participant in the service may mean a number of different things. Many people would come to church and engage in a series of private prayers, turning their attention to the activities at the central or side altars only as the bell was rung. Something about this notion of private and corporate spirituality is very contemporary in its appeal. This kind of experience has a good deal in common with some aspects of Orthodox worship.

Greek Orthodox Worship

On a recent holiday my family and I made a brief visit to an Orthodox church on a small Greek island. The church was a center of pilgrimage, and many of those making their way to midday prayer did so on their hands and knees. Inside the church a variety of activities was offered. Worshipers could kiss the sacred icon, light candles, eat the blessed bread that was available, fill small bottles with holy oil, and wander around the church—this offered the possibility of more icon kissing. The service was conducted while all of this took place. As the singing and chanting continued the priest read petitions quietly in front of the altar. At one side of the church people were writing prayers on small pieces of paper, and these prayers eventually found their way to the priest. Worshipers were therefore able to participate in a varied and individual way. This was a corporate moment, but it was also decentered. The static and largely passive congregation that is characteristic of solid church seemed a million miles away. Those attending the service appeared to do what ever they liked. A few stood and listened to the prayers, but most were engaged in one or more of the activities.

Decentered Worship at Greenbelt

Inspired by the St. Paul's labyrinth and the Orthodox service in Greece, I have tried to develop my style of liquid wor-

ship. One such service was prepared for a worship time at the UK-based arts and worship event, Greenbelt Festival. The service was designed around the idea of the face of God. Around the room we placed a number of different activity centers, each drawing on a different aspect of the theme. These included a picture of Christ and some candles that could be lit. There was a photocopier, and people were invited to make a copy of their face (taking care to close their eyes!). These pictures were then displayed during the worship. There was also a large mirror, and written on it were the words "And all of us, with unveiled faces, seeing the glory of the Lord as though reflected in a mirror, are being transformed into the same image from one degree of glory to another" (2 Cor 3:18).

When people arrived, they were shown the various activities, and then for around one hour we sang worship songs. People were free to sing the songs, pray quietly, or wander around the room and take part in the activities. This was again an attempt to get away from the congregational style of corporate worship that is characteristic of solid church. The worship was most appreciated by many children who came to the event. They found the possibility of activity liberating, yet they could do this while others were involved in deep, meditative prayer.

The Orthodox style of worship, and to some extent the labyrinth, represent premodern spiritualities and traditions. As such they perhaps represent a glimpse beyond the heavy, congregation-orientated life of many of our churches. In these examples the relationship to tradition, identity, spiritual discipline, and practice has been reorientated in ways that differ significantly from our solid social structures, and as such they indicate a way forward to a more liquid church. It might be possible to take our congregationally designed buildings and re-create them as imaginative and creative space where people explore a variety of worship practices. This kind of decentered spiritual space need not necessarily be always used for some kind of a worship service. The labyrinth is interesting in this connection because it offers a way of experiencing a deep encounter with God in an individualized but also communal experience. One way that this could be used might be as part of a café that could use the labyrinth to offer a place for spiritual exploration and experience as well as pastries and cappuccinos.

THE WAY FORWARD FOR LIQUID CHURCH

In this final chapter I have tried to offer some clues as to the way that a liquid church might develop. These dreams are only that at present. They will come to life only if church leaders and individual Christians want to take them up and bring them to life. This is much easier than it might first appear. In the first instance most of us are already part of several networks of relationship and communication. These networks exist because we want them to; they work for us. The next stage is to expand these connections by developing particular ways of meeting, products that can be circulated, and events that can provide a focus for communication. In all of this the priority must be upon relational connection rather than events or meetings. The products we develop are there to stimulate connection rather than the other way around.

The quality of relationships must connect to a spirituality that is rooted in our participation in Christ. Networked church must be connected to Christ. This is a mystical and spiritual reality that is based on the working of the Holy Spirit touching us and renewing us. Liquid church is not a program or a mission project; it is a community rooted in the fellowship of the Holy Trinity. The intimate dance of God can be experienced only by those who accept the invitation.

NOTES

NOTES TO INTRODUCTION

1. P. J. Hefner, "Ninth Locus: The Church," in *Christian Dogmatics*, ed. Carl E. Braaten and Robert W. Jenson (Philadelphia: Fortress, 1984), 2:191.

2. Ibid., 19.

3. Paul Tillich, quoted in Hefner, "Ninth Locus," 2:199.

4. G. W. Bromiley, *Theological Dictionary of the New Testament*, ed. Gerhard Kittel and Gerhard Friedrich (Exeter: Paternoster, 1985), 397.

5. J. D. G. Dunn, *The Theology of Paul the Apostle* (Edinburgh: T&T Clark; Grand Rapids, Mich.: Eerdmans, 1998), 539.

6. Ibid., 538.

7. Ibid., 541.

8. Ibid.

9. Ibid., 542.

10. Alfred Loisy, quoted in Hans Küng, *The Church* (London: Search Press, 1968), 43.

11. See the bibliography in G. E. Ladd, *A Theology of the New Testament* (London: Lutterworth, 1974).

12. Ibid., 111.

13. Ibid., 113.

14. Küng, *The Church*, 65.

15. Ibid., 64.

NOTES TO CHAPTER 1

1. Jon Pahl, *Youth Ministry in Modern America 1930—Present* (Peabody, Mass.: Hendrickson, 2000), 56–72; J. Raybury III, *Dance, Children, Dance* (Wheaton, Ill.: Tyndale House Publishers, 1984); Joel A. Carpenter, *Revive Us Again: The Reawakening of American Fundamentalism* (Oxford: Oxford University Press, 1997), 161–76; and Douglas L. Johnson, *Contending for the*

Faith: A History of the Evangelical Movement in the Universities and Colleges (Leicester: Inter-Varsity, 1979).

2. See Grace Davie, *Religion in Britain Since 1945: Believing Without Belonging,* Making Contemporary Britain (Oxford: Blackwell, 1994); and William K. Kay and Leslie J. Francis, *Drift from the Churches: Attitude Toward Christianity During Childhood and Adolescence* (Cardiff: University of Wales Press, 1996).

3. David Lyon, *Jesus in Disneyland: Religion in Postmodern Times* (Cambridge, UK; Malden, Mass.: Polity Press, 2000), 76.

4. Ulrich Beck, *Risk Society: Toward a New Modernity* (trans. Mark Ritter; London: Sage, 1992), 12.

5. Manuel Castells, *The Rise of the Network Society* (2d ed.; Oxford: Blackwell, 2000), 1–4.

6. Leonard I. Sweet, *Aquachurch: Essential Leadership Arts for Piloting Your Church in Today's Fluid Culture* (Loveland, Colo.: Group, 1999), 24.

7. Ibid.

8. Zygmunt Bauman, *Liquid Modernity* (Cambridge, UK; Malden, Mass.: Polity Press, 2000).

9. Ibid., 3–4.

10. Ibid., 25, 35, 57, 63.

11. Ibid., 57.

12. Ibid., 5, 7, 13, 29, 31.

13. In the UK there is a growing movement toward youth congregations. Some are attached to existing churches, some are church plants, and some have grown from incarnational mission.

14. Bauman, *Liquid Modernity,* 10.

Notes to Chapter 2

1. For a more thorough periodization, see David Bosch, *Transforming Mission: Paradigm Shifts in Theology of Mission,* American Society of Mission Series 16 (Maryknoll, N.Y.: Orbis, 1991).

2. Anthony Giddens, *Modernity and Self-Identity: Self and Society in the Late Modern Age* (Cambridge, UK; Malden, Mass.: Polity Press; Stanford, Calif.: Stanford University Press, 1991), 5.

3. Ibid.

4. Ibid.

5. Zygmunt Bauman, *Liquid Modernity* (Cambridge, UK; Malden, Mass.: Polity Press, 2000), 33.

6. Ibid., 34ff.
7. Ulrich Beck, quoted in Bauman, *Liquid Modernity*, 37.
8. Bauman, *Liquid Modernity*, 37.
9. Ibid., 200.
10. Ibid., 182.
11. This idea was suggested to me by Kester Brewin.
12. P. Scannell, "For Anyone as Someone Structures," *Media Culture and Society* 22, no. 1 (January 2000): 5–24; See 5–6.

Notes to Chapter 3

1. Timothy Bradshaw, *The Olive Branch: An Evangelical Anglican Doctrine of the Church* (Carlisle: Paternoster for Latimer House, 1992), 241.
2. Ibid., 6.
3. J. D. G. Dunn, *The Theology of Paul the Apostle* (Edinburgh: T&T Clark; Grand Rapids, Mich.: Eerdmans, 1998), 390.
4. G. E. Ladd, *A Theology of the New Testament* (London: Lutterworth, 1974), 482.
5. C. K. Barrett, *The First Epistle to the Corinthians* (London: A. C. Black; New York: Harper & Row, 1968), 72.
6. Dunn, *The Theology of Paul the Apostle*, 397.
7. Ibid., 397–98.
8. Ibid., 398.
9. Ibid., 400.
10. Ibid., 401.
11. Ibid., 548.
12. Ibid., 551; see also F. F. Bruce, *1 and 2 Corinthians*, The New Century Bible Commentary (Grand Rapids, Mich.: Eerdmans, 1971), 120; Hans Küng, *The Church* (London: Search Press, 1968), 228.
13. Dunn, *The Theology of Paul the Apostle*, 548.
14. Ibid., 551.
15. Ibid., 554.
16. Ibid.
17. Ibid., 559.
18. Barrett, *First Epistle to the Corinthians*, 288.

Notes to Chapter 4

1. Zygmunt Bauman, *Liquid Modernity* (Cambridge, UK; Malden, Mass.: Polity Press, 2000), 2.

2. Ibid.

3. Ibid.

4. Manuel Castells, *The Rise of the Network Society* (2d ed.; Oxford: Blackwell, 2000), 164.

5. David Lyon, *Jesus in Disneyland: Religion in Postmodern Times* (Cambridge, UK; Malden, Mass.: Polity Press, 2000), 38.

6. Castells, *Rise of the Network Society,* 500.

7. Ibid., 443.

8. Ibid.

9. Ibid., 444.

10. Ibid., 442.

11. Ibid.

NOTES TO CHAPTER 5

1. See John D. Zizioulas, *Being as Communion: Studies in Personhood and the Church* (Crestwood, N.Y.: St. Vladimir's Seminary Press, 1985); Colin E. Gunton, *The Promise of Trinitarian Theology* (2d ed.; Edinburgh: T&T Clark, 1997); Miroslav Volf, *After Our Likeness: The Church as the Image of the Trinity* (Grand Rapids, Mich.: Eerdmans, 1998); James B. Torrance, *Worship and the Triune God of Grace* (Carlisle: Paternoster; Downers Grove, Ill.: InterVarsity Press, 1996); David S. Cunningham, *These Three Are One: The Practice of Trinitarian Theology,* Challenges in Contemporary Theology (Oxford: Blackwell, 1998); Paul S. Fiddes, *Participating in God: A Pastoral Doctrine of the Trinity* (London: Darton, Longman & Todd, 2000).

2. Gunton, *The Promise of Trinitarian Theology,* 5.

3. Ibid., 6.

4. Torrance, *Worship and the Triune God of Grace,* 21.

5. Athanasius Incarnation of the Word 54.3, *Athanasius: Selected Works and Letters,* ed. Archibald Robertson, in *Nicene and Post-Nicene Fathers,* second series, vol. 4, ed. Philip Schaff and Henry Wace (Peabody, Mass.: Hendrickson, 1995).

6. Torrance, *The Triune God of Grace,* 21.

7. Ibid.

8. Gunton, *The Promise of Trinitarian Theology,* 6.

9. Cunningham, *These Three Are One,* 8.

10. Zizioulas, *Being as Communion,* 17.

11. Ibid.

12. Ibid., 112.

13. Cunningham, *These Three Are One*, 8; Gunton, *The Promise of Trinitarian Theology*, 6.

14. Cunningham, *These Three Are One*, 25.

15. Robert W. Jenson, quoted in Cunningham, *These Three Are One*, 26.

16. Jürgen Moltmann, *The Crucified God* (London: SCM Press, 1974).

17. Moltmann, quoted in Cunningham, *These Three Are One*, 30.

18. Fiddes, *Participating in God*, 36.

19. Ibid., 34.

20. Ibid., 38.

21. Ibid.

22. Ibid., 72.

23. Ibid.

24. Ibid., 75.

25. Torrance, *Worship and the Triune God of Grace*, 20.

26. Gunton, *The Promise of Trinitarian Theology*, 81.

27. Ibid.

28. Ibid., 82.

29. Cunningham, *These Three Are One*, 8.

Notes to Chapter 6

1. Stephen Fry, quoting G. K. Chesterton, on the BBC television show *Room 101*.

2. See Grace Davie, *Religion in Britain Since 1945: Believing Without Belonging*, Making Contemporary Britain (Oxford: Blackwell, 1994); David Lyon, *Jesus in Disneyland: Religion in Postmodern Times* (Cambridge, UK; Malden, Mass.: Polity Press, 2000).

3. Robert Wuthnow, *Loose Connections: Joining Together in America's Fragmented Communities* (Cambridge, Mass. Harvard University Press, 1998), 2.

4. Davie, *Religion in Britain Since 1945*.

5. Ibid., 2.

6. Wuthnow, *Loose Connections*, 6.

7. Ibid., 7.

8. Ibid.

9. Zygmunt Bauman, *Liquid Modernity* (Cambridge, UK; Malden, Mass.: Polity Press, 2000), 73.

10. Ibid.

11. Jean Baudrillard, *Selected Writings,* ed. and with introduction by Mark Poster (Cambridge, UK; Malden, Mass.: Polity Press; Stanford, Calif.: Stanford University Press, 1988), 22.

12. Mike Featherstone, *Consumer Culture and Postmodernism* (London: Sage, 1991), 13.

13. James B. Twitchell, *Adcult USA* (New York: Columbia University Press, 1996), 10.

14. Ibid., 11.

15. Ibid., 12.

16. James B. Twitchell, *Lead Us into Temptation: The Triumph of American Materialism* (New York: Columbia University Press, 1999), 57.

17. Pierre Bourdieu, *Distinction: A Social Critique of the Judgment of Taste,* trans. Richard Nice (London: Routledge, 1986).

18. Twitchell, *Lead Us into Temptation,* 57.

19. David Lyon, *Jesus in Disneyland: Religion in Postmodern Times* (Cambridge, UK; Malden, Mass.: Polity Press, 2000), 74.

20. Ibid.

21. Peter Berger, cited in Lyon, *Jesus in Disneyland,* 76.

22. Reginald Bibby, quoted in Lyon, *Jesus in Disneyland,* 76. See Roger Finke and Rodney Stark, *The Churching of America 1776–1990: Winners and Losers in Our Religious Economy* (New Brunswick, N.J.: Rutgers University Press, 1992) for an alternative view of the importance of ecumenism for market share in religion.

23. R. Laurence Moore, *Selling God: American Religion in the Market Place of Culture* (Oxford: Oxford University Press, 1994).

24. Ibid., 5–7.

25. Ibid., 6.

26. See Nathan O. Hatch, *The Democratization of American Christianity* (New Haven, Conn.: Yale University Press, 1989); Jon Butler, *Awash In a Sea of Faith: Christianizing the American People* (Cambridge, Mass.: Harvard University Press, 1990); Leonard I. Sweet, ed., *Communication and Change in American Religious History* (Grand Rapids, Mich.: Eerdmans, 1993); Finke and Stark, *The Churching of America 1776–1990;* and Harry S. Stout, *The Divine Dramatist: George Whitefield and the Rise of Modern Evangelicalism* (Grand Rapids, Mich.: Eerdmans, 1991).

27. Stephan Hunt, *Anyone for Alpha? Evangelism in a Post-Christian Era* (London: Darton, Longman & Todd, 2001), xi.

28. P. Simmonds, *Reaching the Unchurched: Some Lessons from Willow Creek* (Bramcott: Grove Books, 1992), 14.

NOTES TO CHAPTER 7

1. John Calvin, *Institutes of the Christian Religion*, ed. John T. McNeill, trans. Ford Lewis Battles, 2 vols., The Library of Christian Classics 20 and 21 (Philadelphia: Westminster, 1960), 2:1021–22, 4.1.7.

2. Ibid., 2:1023–25, 4.1.9–10.

3. Ibid., 2:1023–24, 4.1.9.

4. Ibid.

5. Eberhard Busch, *Karl Barth: His Life from Letters and Autobiographical Texts* (trans. John Bowden; London: SCM Press; Philadelphia: Fortress, 1976), 263.

6. Karl Barth, *Church Dogmatics 1/1*, ed. G. W. Bromiley and T. F. Torrance (2d ed.; Edinburgh: T&T Clark, 1975), 3.

7. Ibid., 11.

8. Ibid., 72.

9. Ibid.

10. Ibid., 88.

11. Ibid.

12. Ibid., 78.

13. Ibid., 81.

14. Ibid., 80–81.

15. Andrew Walker, *Telling the Story: Gospel Mission and Culture* (London: SPCK, 1996), 13.

16. Ibid., 13–14.

17. Ibid., 12–13.

18. Ibid., 13–14.

NOTES TO CHAPTER 8

1. Tony Walter, *All You Love Is Need* (London: SPCK, 1985), 4.

2. Ibid.

3. Ibid., 5.

4. See chapter 6.

5. Zygmunt Bauman, *Liquid Modernity* (Cambridge, UK; Malden, Mass.: Polity Press, 2000), 74.

6. Ibid.

7. Paul Heelas, *The New Age Movement: The Celebration of the Self and the Sacralization of Modernity* (Oxford: Blackwell, 1996), 18.

8. See James Davison Hunter, *Evangelicalism: The Coming Generation* (Chicago: University of Chicago Press, 1987); and Leslie J. Francis and William K. Kay, *Teenage Religion and Values* (Leominster: Gracewing, 1995).

NOTES TO CHAPTER 9

1. Jürgen Moltmann, *The Spirit of Life: A Universal Affirmation* (London: SCM Press, 1992), 2.

2. Ibid.

3. Ibid., x.

4. Ibid.

5. Jürgen Moltmann, *The Trinity and the Kingdom of God* (London: SCM Press, 1981).

6. Moltmann, *The Spirit of Life*, x.

7. Ibid., 18.

8. Abraham Kuyper, "Common Grace," pages 165–204 in *Abraham Kuyper: A Centennial Reader*, ed. James D. Bratt (Grand Rapids, Mich.: Eerdmans; Carlisle: Paternoster, 1998), 172.

9. Ibid.

10. Ibid., 166.

11. Ibid., 168.

12. Ibid., 173.

13. Ibid., 174.

14. Ibid., 176.

15. Ibid., 174.

16. Ibid.

17. Jonathan Edwards, *The Religious Affections* (Edinburgh: Banner of Truth Trust, 1961), 25.

18. Ibid., 27.

19. Ibid., 50.

20. Ibid., 121.

21. Ibid., 122.

22. Ibid., 59.

23. Ibid., 69.

24. Ibid., 126.

25. Ibid., 85.

26. Ibid., 120ff.

NOTES TO CHAPTER 10

1. Zygmunt Bauman, *Liquid Modernity* (Cambridge, UK; Malden, Mass.: Polity Press, 2000), 77.

2. Daniel Miller, *A Theory of Shopping* (Cambridge, UK: Polity Press; repr., Ithaca, N.Y.: Cornell University Press, 1998), 18.

3. Eamon Duffy, *The Stripping of the Altars: Traditional Religion in England 1400–1580* (New Haven, Conn.: Yale University Press, 1992), 93.

4. Ibid., 97.

BIBLIOGRAPHY

Athanasisus. "The Incarnation of the Word." Pages 36–67 in *Athanasius: Selected Works and Letters*. Edited by Archibald Robertson. *Nicene and Post-Nicene Fathers*, second series, vol. 4. Edited by Philip Schaff and Henry Wace. Peabody, Mass.: Hendrickson, 1995.

Barrett, C. K. *The First Epistle to the Corinthians*. London: A & C Black; New York; Harper & Row, 1968.

Barth, Karl. *Church Dogmatics 1/1*. Edited by G. W. Bromiley and T. F. Torrance. 2d ed. Edinburgh: T&T Clark, 1975.

Baudrillard, Jean. *Selected Writings*. Edited and with introduction by Mark Poster. Cambridge, UK; Malden, Mass.: Polity Press; Stanford, Calif.: Stanford University Press, 1988.

Bauman, Zygmunt. *Liquid Modernity*. Cambridge, UK; Malden, Mass.: Polity Press, 2000.

Beck, Ulrich. *Risk Society: Toward a New Modernity*. Translated by Mark Ritter. London: Sage, 1992.

Bosch, David. *Transforming Mission: Paradigm Shifts in Theology of Mission*. American Society of Mission Series 16. Maryknoll, N.Y.: Orbis, 1991.

Bourdieu, Pierre. *Distinction: A Social Critique of the Judgment of Taste*. Translated by Richard Nice. London: Routledge, 1986.

Braaten, Carl E., and Robert W. Jenson, eds. *Christian Dogmatics*. 2 vols. Philadelphia: Fortress, 1984.

Bradshaw, Timothy. *The Olive Branch: An Evangelical Anglican Doctrine of the Church*. Carlisle: Paternoster for Latimer House, 1992.

Bratt, James D., ed. *Abraham Kuyper: A Centennial Reader*. Grand Rapids, Mich.: Eerdmans; Carlisle: Paternoster, 1998.

Bromiley, G. W. *Theological Dictionary of the New Testament*. Edited by Gerhard Kittel and Gerhard Friedrich. Abridged in one volume. Exeter: Paternoster; Grand Rapids, Mich.: Eerdmans, 1985.

Bruce, F. F. *1 and 2 Corinthians.* The New Century Bible Commentary. Grand Rapids, Mich.: Eerdmans, 1971.

Busch, Eberhard. *Karl Barth: His Life from Letters and Autobiographical Texts.* Translated by John Bowden. London: SCM Press; Philadelphia: Fortress, 1976.

Butler, Jon. *Awash In a Sea of Faith: Christianizing the American People.* Cambridge, Mass.: Harvard University Press, 1990.

Calvin, John. *Institutes of the Christian Religion.* Edited by John T. McNeill. Translated by Ford Lewis Battles. 2 vols. The Library of Christian Classics 20 and 21. Philadelphia: Westminster, 1960.

Carpenter, Joel A. *Revive Us Again: The Reawakening of American Fundamentalism.* Oxford: Oxford University Press, 1997.

Castells, Manuel. *The Rise of the Network Society.* 2d ed. Oxford: Blackwell, 2000.

Cunningham, David S. *These Three Are One: The Practice of Trinitarian Theology.* Challenges in Contemporary Theology. Oxford: Blackwell, 1998.

Davie, Grace. *Religion in Britain Since 1945: Believing Without Belonging.* Making Contemporary Britain. Oxford: Blackwell, 1994.

Duffy, Eamon. *The Stripping of the Altars: Traditional Religion in England 1400–1580.* New Haven, Conn.: Yale University Press, 1992.

Dulles, Avery. *Models of the Church.* Dublin: Gill and Macmillan, 1976.

Dunn, J. D. G. *The Theology of Paul the Apostle.* Edinburgh: T&T Clark; Grand Rapids, Mich.: Eerdmans, 1998.

Edwards, Jonathan. *The Religious Affections.* Edinburgh: Banner of Truth Trust, 1961.

Featherstone, Mike. *Consumer Culture and Postmodernism.* London: Sage, 1991.

Ferguson, Everett. *The Church of Christ: A Biblical Ecclesiology for Today.* Grand Rapids, Mich.: Eerdmans, 1996.

Fiddes, Paul S. *Participating in God: A Pastoral Doctrine of the Trinity.* London: Darton, Longman & Todd, 2000.

Finke, Roger, and Rodney Stark. *The Churching of America 1776–1990: Winners and Losers in Our Religious Economy.* New Brunswick, N.J.: Rutgers University Press, 1992.

Francis, Leslie J., and William K. Kay. *Teenage Religion and Values.* Leominster: Gracewing, 1995.

Giddens, Anthony. *Modernity and Self-Identity: Self and So-ciety in the Late Modern Age.* Cambridge: Polity Press; Stanford, Calif.: Stanford University Press, 1991.

Gunton, Colin E. *The Promise of Trinitarian Theology.* 2d ed. Edinburgh: T&T Clark, 1997.

Hatch, Nathan O. *The Democratization of American Christian-ity.* New Haven, Conn.: Yale University Press, 1989.

Heelas, Paul. *The New Age Movement: The Celebration of the Self and the Sacralization of Modernity.* Oxford: Blackwell, 1996.

Hefner, P. J. "Ninth Locus: The Church." Pages 183–241 in *Christian Dogmatics.* Edited by Carl E. Braaten and Robert W. Jenson. 2 vols. Philadelphia: Fortress, 1984.

Hunt, Stephan. *Anyone for Alpha? Evangelism in a Post-Christian Era.* London: Darton, Longman & Todd, 2001.

Hunter, James Davison. *Evangelicalism: The Coming Genera-tion.* Chicago: University of Chicago Press, 1987.

Jenkins, Henry. *Textual Poachers, Television Fans, and Partici-patory Culture.* London: Routledge, 1992.

Johnson, Douglas L. *Contending for the Faith: A History of the Evangelical Movement in the Universities and Colleges.* Leicester: Inter-Varsity Press, 1979.

Kay, William K., and Leslie J. Francis. *Drift from the Churches: Attitude Toward Christianity During Childhood and Ado-lescence.* Cardiff: University of Wales Press, 1996.

Küng, Hans. *The Church.* London: Search Press, 1968.

Kuyper, Abraham. "Common Grace." Pages 165–204 in *Abra-ham Kuyper: A Centennial Reader.* Edited by James D. Bratt. Grand Rapids, Mich.: Eerdmans; Carlisle: Paternos-ter, 1998.

Ladd, G. E. *A Theology of the New Testament.* London: Lutter-worth, 1974.

Lyon, David. *Jesus in Disneyland: Religion in Postmodern Times.* Cambridge, UK; Malden, Mass.: Polity Press, 2000.

Miller, Daniel. *A Theory of Shopping.* Cambridge, UK: Polity Press, 1996. Repr., Ithaca, N.Y.: Cornell University Press, 1998.

Moltmann, Jürgen. *The Crucified God.* London: SCM Press, 1974.

———. *God in Creation: An Ecological Doctrine of Creation.* London: SCM Press, 1985.

———. *The Spirit of Life: A Universal Affirmation.* London: SCM Press, 1992.

————. *The Trinity and the Kingdom of God*. London: SCM Press, 1981.

Moore, R. Laurence. *Selling God: American Religion in the Market Place of Culture*. Oxford: Oxford University Press, 1994.

Pahl, Jon. *Youth Ministry in Modern America 1930—Present*. Peabody, Mass.: Hendrickson, 2000.

Rayburn, J., III. *Dance, Children, Dance*. Wheaton, Ill.: Tyndale House Publishers, 1984.

Scannell, P. "For Anyone as Someone Structures." *Media Culture and Society* 22, no. 1 (January 2000): 5–24.

Simmonds, P. *Reaching the Unchurched: Some Lessons from Willow Creek*. Bramcott: Grove Books, 1992.

Sweet, Leonard I. *Aquachurch: Essential Leadership Arts for Piloting Your Church in Today's Fluid Culture*. Loveland, Colo.: Group, 1999.

Torrance, James B. *Worship and the Triune God of Grace*. Carlisle: Paternoster; Downers Grove, Ill.: InterVarsity Press, 1996.

Twitchell, James B. *Adcult USA*. New York: Columbia University Press, 1995.

————. *Lead Us into Temptation: The Triumph of American Materialism*. New York: Columbia University Press, 1999.

Volf, Miroslav. *After Our Likeness: The Church as the Image of the Trinity*. Grand Rapids, Mich.: Eerdmans, 1998.

Walker, Andrew. *Telling the Story: Gospel Mission and Culture*. London: SPCK, 1996.

Walter, Tony. *All You Love Is Need*. London: SPCK, 1985.

Ward, Pete. *God at the Mall*. Peabody, Mass.: Hendrickson, 2000. Rev. and adapted from *Youthwork and the Mission of God: Frameworks for Relational Ministry*. London: SPCK, 1997.

Wuthrow, Robert. *Loose Connections: Joining Together in America's Fragmented Communities*. Cambridge, Mass.: Harvard University Press, 1998.

Zizioulas, John D. *Being as Communion: Studies in Personhood and the Church*. Crestwood, N.Y.: St. Vladimir's Seminary Press, 1985.